Special effects in the camera

John Wade

Focal Press
London & Boston

Focal Press
An imprint of the Butterworth Group
Principal offices in London, Boston, Durban, Singapore,
Sydney, Toronto, Wellington

British Library Cataloguing in Publication Data

Wade, John
Special effects in the camera.
1. Photography – Special effects
I. Title
778.8 TR148

ISBN 0-240-51184-0

First published 1983

Series designed by Diana Allen
Book designed by Roger Kohn
Cover photograph by John Wade
Photoset by Butterworths Litho Preparation Department
Origination by Adroit Photo Litho Ltd Birmingham
Printed in Great Britain by Robert Stace Ltd,
Tunbridge Wells, Kent

Special effects in the camera

Contents

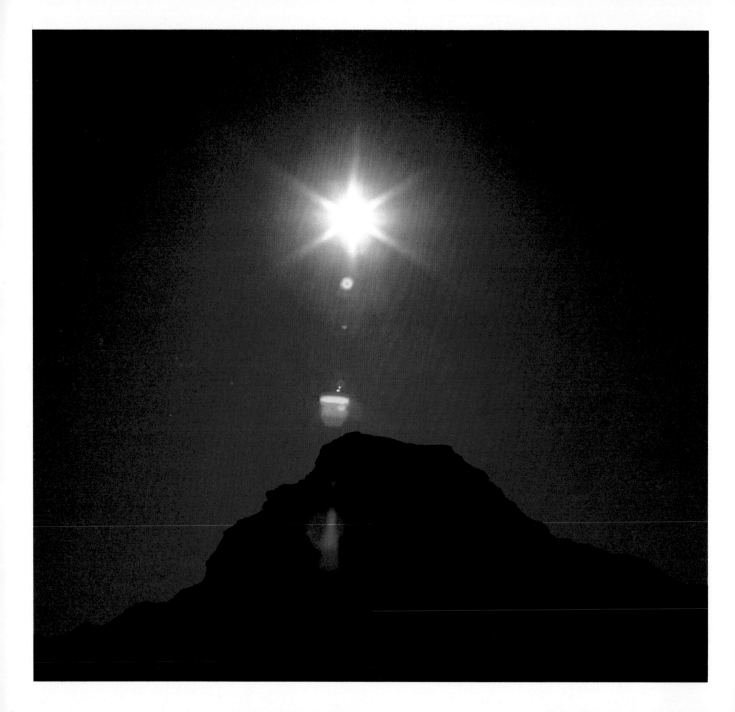

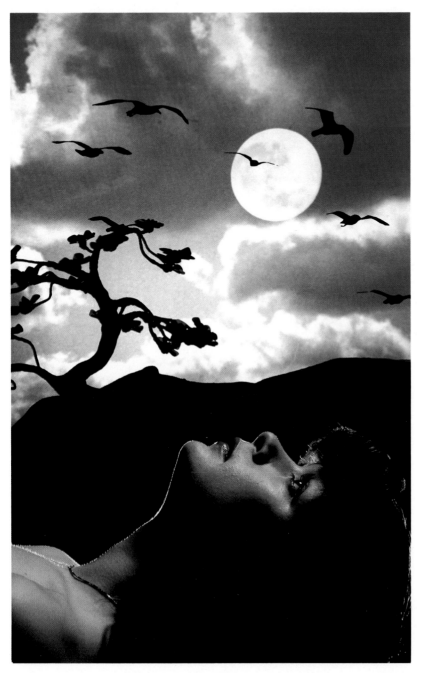

Introduction

The camera, it has been observed, never lies. On the face of it, a perfectly valid statement . . . or is it? The camera takes a three-dimensional subject and turns it into a two-dimensional image. It reduces a multi-coloured landscape to black, white and a range of greys. It destroys all sense of scale, turning the highest building into an image of no more than a few centimetres, or enlarging a microscopic insect to the size of a monster from another world. It destroys perspective. It freezes action so that the fastest racing car might appear to be standing still, and it reverses the procedure to give a blurred impression of speed in a subject moving at no more than walking pace. The camera never lies? The more you think about photography, the more you come to realise that it really does little else.

What is more, all the above examples are found in what might be termed 'ordinary' photography. When we enter the world of special effects, anything and everything is possible. Filters introduce colours and patterns that could never exist in reality, lenses distort and exaggerate, special film produces red foliage and green skies, and unusual lighting turns the mundane into the macabre. Everyday objects become abstract designs; images are multiplied, distorted and blurred; pictures are combined with each other, stretched into panoramic formats and softened at the edges. It isn't until you begin to delve into the secrets of special-effect photography that you realise just how much is possible.

This book is about special effects in the camera. A book of equal length could almost certainly be written on special effects in the darkroom, but that is not our purpose. Darkroom work is involved in a few places where necessary, but mostly indirectly where, for instance, a lith positive might be made as part of the subject for a camera effect, or a print

might need to be enlarged to the correct scale for making a montage. Equally, in the chapter on unconventional films, you will find details of recommended developers for some of the more unusual emulsions. What you won't find within these pages are details of darkroom derivatives such as solarisations, exaggerated grain or special printing techniques. The special effects described in this book are all made directly in the camera, either by using it in a special way or by the use of mostly simple, inexpensive accessories.

Special effects are all around you. Some rely on no more than understanding the workings of your camera: images grow larger as they blur so that the sun, when photographed out of focus against a sharply-focused foreground object, can appear as a gigantic ball of fire, even when shot with a standard lens; point sources of light will follow the shape of the lens's aperture as it is stopped down, and so using the smallest stop on a lens will often give a starburst effect on the right subject without the use of any filter. Other times, special effects rely on no more than keeping your eyes open; for instance, seeing and photographing the rainbow that appears in the spray from a sunlit fountain.

Anyone who was brought up on an old-fashioned box camera, or any simple snapshot model that had no double-exposure prevention device, has probably already taken one of the special effects mentioned in these pages purely by accident: taking two pictures on the same frame without winding the film between shots. That mistake, very common in years gone by, but less so in these days of more sophisticated equipment, forms the basis of multiple-exposure photography, a technique which, when used correctly rather than accidentally, can lead to some amazingly unusual pictures.

As we shall see throughout this book, some effects are so simple in their conception that you can't always believe how easy it is to produce them. So when you are thinking out a special-effect picture,

don't go about the most difficult way of producing it just for the sake of a technical exercise. When you really think about it, you might find that there is often a simpler way of achieving the same effect.

Special effects should be used with care. This is especially true when using some of the effect filters that are currently available. If the technique you are using is one that adds a certain effect to an existing picture, it should never be used in an attempt to make a bad shot good. Rather, it should be used to add something extra to a picture which is already good in its own right. Conversely, some special-effect pictures show nothing more than the effect itself, and those should be worked on to make them as technically perfect as possible. Remember that *different* doesn't necessarily mean *good*.

The photographer about to embark on special-effect work must have patience. He or she must be prepared to waste time, and often a lot of film, on pictures which don't quite come off. Many a time, a picture will need no more than a slight adjustment in some factor to make it work. If you see that in a finished picture, don't try to fool yourself, or anyone else for that matter, into thinking it has worked when it hasn't. Learn by your mistakes, go back and start again. For that very reason, one of the most useful items the special-effect photographer can have is a notebook. As you go through each phase of a complicated process, make brief notes about exactly what you are doing: exposures, lighting etc. If, then, you have to go back and start again, much of your groundwork will already have been covered and it will take far less time to set up your equipment in accordance with your notes and make the necessary adjustment to ensure the right result the second time around. Or the third. Or the fourth. Never be afraid to learn from your mistakes.

Many areas of special-effect photography cross over other areas and, in writing this book, it was sometimes difficult to know where to put certain

Page 6: who needs a cross-screen filter when the aperture on your camera can give the same effect when stopped right down? This picture was taken at *f*/16 on a standard lens.

Page 7: a picture that uses many of the techniques described in this book. The girl was first photographed standing upright against a black background and with the camera on its side. Other images were made by multiple exposure (page 83). The sky was first back-projected against a silhouette of a potted plant and 'hills' made from a tablecloth (page 112); the moon was added in a dark part of the sky, also by back projection. The colour of the clouds resulted by copying (page 96) a straight slide of a blue sky on to infra-red film (page 45), using tungsten light and a green filter (page 11). The moon was originally shot with an 800 mm telephoto lens (page 34). The birds were on a separate piece of lith film (page 49), which was finally bound with the original image as a sandwich (page 162).

effects. Soft focus could have been covered when dealing with filters, lenses, multiple exposures, or controlled blur, all of which offer methods of diffusing the image. There is a chapter devoted to abstracts, but abstract photography can also be produced by methods which have chapters of their own, such as lighting, blur and distortion. Other times, there are certain techniques which are involved in different special effects, and which crop up time and time again. Close-up photography, for instance, is used in making multiple exposures, abstracts, print montage, slide sandwiches, even certain types of back projection. It would be superfluous to explain the techniques of using close-up devices every time the subject was mentioned, and so the techniques are mentioned only once, and then cross-referenced throughout the book.

Similarly, there are cross-references to subjects such as soft focus, abstracts etc. that might be produced by varying methods in different chapters. This way, anyone flicking through this book, picking out certain chapters and ignoring others, should be able to get the full information on a chosen topic. Besides that, there is a full index at the end of the book which will refer you to all the pages on which your chosen technique is mentioned. There is also a glossary of many common, and some less common, terms used in the book. The experienced photographer will probably have little use for it, but the newcomer to the hobby, who might still be confused by many of its terms, can refer to it as and when needed.

Special effects are scorned by many as not being 'real' photography. But, as we saw at the start of this chapter, very little about photography is real. All we are doing when we enter the world of special effects is exaggerating reality, bringing in a little fantasy. The purist might put this branch of photography down as nothing more than a handful of tricks. But it's more than that. Carrying out many of the techniques described in this book will teach you a lot about straight photography.

Special-effect photographers who work at their craft are often a lot more knowledgeable than their 'straight' counterparts. They rarely rely on automation, but really come to know the theory of not only *how* a picture is taken, but also *why* it comes out the way it does. This means they learn all the rules, and then learn how to break them. Very often, the people who take only straightforward pictures have never even learned the rules in the first place. Instead, they have been relying on some complicated modern marvel of electronics to do the work for them.

All of which perhaps sounds a little too serious. We must not overlook what is perhaps the biggest reason of all for taking this type of picture. Special-effect photography is *fun*! Once you have tried one effect, you won't be content until you have tried them all. And then you still won't be content until you have tried several variations on all the popular themes, going on to invent your own ideas, dreaming up special techniques that might never have been seen or tried before, and producing pictures that are unique to you and your way of working. If you photograph landscapes or portraits or still-life or any of the million-and-one subjects available to the straight photographer, you can exercise creativity and add your own personal touch to the picture but, at the end of the day, you are restricted by your subject. When you are a special-effect photographer, you have no such restrictions. Nothing is impossible.

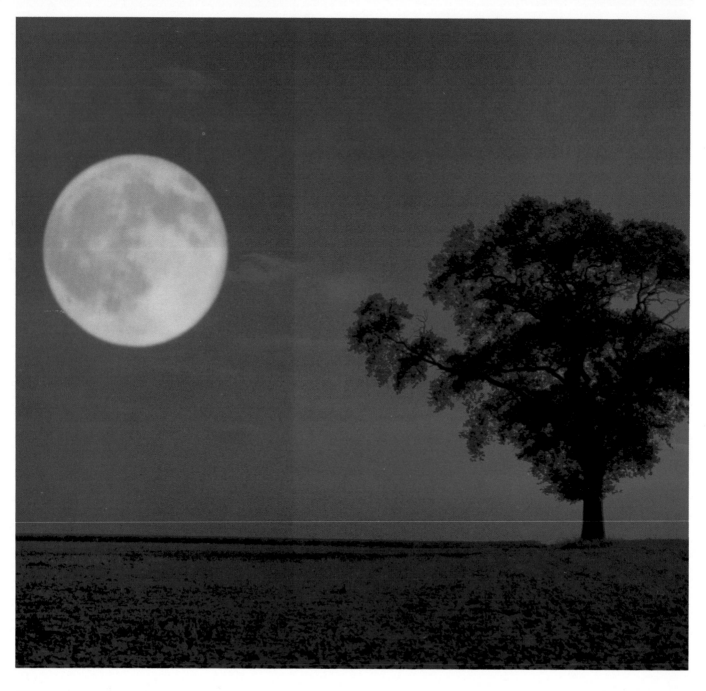

Filters

A filter – any type of filter – is a device for removing a specific element from a mixture of any number of other elements. A photographic filter, in its true sense of the word, is no exception. It removes part of the light passing through it, leaving that which remains to give a particular effect. It should be borne in mind, however, that many so-called filters are nothing of the sort. A glance through any manufacturer's catalogue will show a high percentage of 'filters' that should more properly be termed 'optical devices'. Rather than filtering light, they are made specifically to produce special effects such as the splitting of an image into several parts or producing multi-coloured, star-shaped patterns from a point-source of light. Even close-up lenses, by virtue of the fact that they are often manufactured and sold by filter companies, are tending, these days, to be referred to as 'filters'. Hence the reference to a photographic filter *in its true sense of the word*.

Filters, in their many styles, colours and combinations, are probably among the most widely-used special-effect accessories. They must also rank among the oldest. Many photographers who might claim never to have taken a special-effect picture in their lives would be extremely loath to admit to never having used a filter at some time. And from the moment they screwed the most basic piece of coloured glass to the lens of their camera in an attempt to (say) make more of a spectacular cloud formation, they were adding something extra to their photograph, putting an image on to the film that wouldn't ordinarily be there – entering, in fact, the world of special effects.

Types of filter
A filter might be made from any one of a number of different materials, glass, gelatin and plastic being

the most common. The colours are usually produced by dying or coating the base material. Filters can also be made by sandwiching gelatin between glass. However they are produced, their effects are the same. Most good-quality filters are multi-coated in the same way as camera lenses, to reduce flare that might otherwise come from surface reflections. While some lenses have built-in filters and others are designed to be used with filters fitted to the rear element, by far the most traditional place to fit a filter is over the front of the lens. There are four ways of doing this:

1 Screw-in filters are held in their own special ring, designed to screw into the camera's lens mount. Although there are many different makes of cameras and an even greater number of makes of lenses, most manufacturers keep to standard diameters of mount and the filters are made in these sizes. The mount of a screw-in filter has a male thread to screw into the camera lens and a female thread of a similar diameter on its opposite side. Thus several filters can be screwed together if the desired effect demands it. The thread can also be used for fitting other accessories such as lens hoods. Step-up and step-down rings can be used for fitting filters of one size to lenses of another.

2 Some camera manufacturers build their lenses with a bayonet fitting on the front of the lens mount instead of the more traditional screw thread. With these, it is invariably necessary to use the camera maker's own filters which are, of course, designed to bayonet onto the lens.

3 Filters can also be designed to push on to the lens. The outer diameter of most lens barrels is usually around 2 mm more than the inner diameter. If, then, your lens takes 55 mm screw-in filters, it is a fairly safe bet to assume that it will take 57 mm push-on filters.

4 The fourth method is somewhat different. The most noticeable difference is that the filter is square, rather than circular, as is the case with all the above types. Also, it is supplied without a mount of its own. Instead, a separate holder is provided as part of a system. The filter slots into this holder which, in turn, screws into the front of the lens by way of an adaptor, interchangeable for different diameters of lens. This method of attachment is probably the most versatile for the special-effect photographer. The filter holder features several slots, allowing a number of different filters to be used in conjunction and, because those filters are square rather than round, they can be moved up and down in the holder as required, particularly useful when using two-tone or graduated filters. With the circular type, the division between the tones always falls in a fixed place within the picture area, usually straight across the centre; with movable square filters, that division can be shifted to coincide with, for instance, the horizon which, for the sake of better picture composition, might have been placed off-centre.

Filters are made for many different purposes: changing certain tones in black-and-white photography, correcting casts in colour photography, providing special optical effects in either colour or mono, colouring portions of pictures, polarising light, reducing its intensity without colouring it, absorbing ultra-violet radiation, controlling and correcting casts in colour printing, changing the effective paper grade in variable-contrast black-and-white printing, governing the colour of darkroom safelights . . . those are just some of the more common uses. It would take a great deal more space than is available in this short chapter to expound in detail on how and why all these different filters work. What we are concerned with here essentially is the use of filters for creating special effects in the camera. To that end, we will concentrate only on those that are of use to the special-effect photographer.

Filters for mono
White light is composed of a mixture of seven colours: red, orange, yellow, green, blue, indigo

Page 10: a blue filter, used with colour film can turn day into night. Here, to enhance the effect, the moon has been added, using multiple-exposure techniques.

Page 11: filters intended for mono photography can be used to dramatic effect on colour film.

How different filters affect colours. The girl is standing in front of a blue background, wearing a red top and green skirt. In the first picture (top left), the colours register as similar tones of grey. In the following pictures, those tones have been changed by the use of red, green and blue filters in, respectively, top right, bottom left and bottom right pictures.

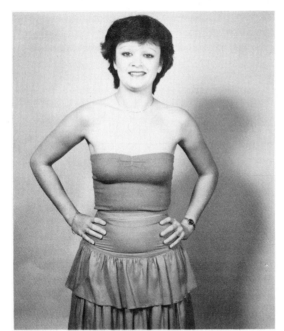 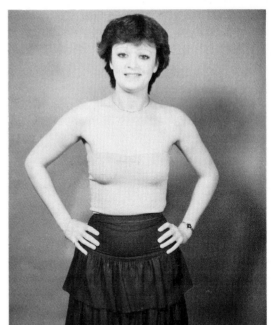

and violet. The reason the world looks yellow when you look through a piece of yellow glass is because the glass, or filter, transmits mostly light of its own colour while absorbing all the others, especially the complementary colour. Put the same yellow filter in front of a camera lens and, because it is transmitting more light of its own colour than of any other, yellow objects in the picture are better exposed than anything else, while objects of the complementary colour, in this case blue, receive less exposure. If the camera is loaded with black-and-white film, those yellow objects will record darker on the negative and therefore lighter on the print. The blue objects naturally will record lighter on the negative and so darker on the print. From this, we can see that a filter, when used in black-and-white photography, lightens its own colour and darkens its complementary.

Mono photography filters come in several different colours. The most common are yellow, green, orange, red and blue. They also come in different shades of those colours, and the stronger the shade the more pronounced the effect. Because these filters absorb a certain amount of light, their use requires extra exposure. Unfortunately it is not enough merely to screw the filter to the front of your lens and leave it to through-the-lens (TTL) metering to compensate for the difference. That should work in theory of course, but in practice you are up against the fact that meter cells, unlike film and the human eye, read colours differently. Cadmium sulphide cells in particular are more sensitive to the red end of the spectrum than to the blue end. So when using an orange or red filter, the meter will be misled into giving the wrong exposure. For this reason, manufacturers sell their products with a quoted filter factor.

If a filter is designated, for instance, as a $2\times$ Yellow, twice the normal exposure will be needed when it is attached to the lens. That means opening up by one stop or adjusting the shutter speed accordingly. Similarly, a $4\times$ Orange would mean opening up by two stops, since each stop effectively doubles the exposure. So if your normal scene needs an exposure of $1/125$ second at $f/8$ and you are using a filter with a $4\times$ factor, you must adjust your exposure to $1/125$ second at $f/4$ or $1/30$ at $f/8$, whichever is more convenient for that particular picture.

Let's now look at the practical side of using coloured filters for special effects in mono photography. Probably the most frequent use is to help put clouds back into a scene where they have been wiped out by the difference in exposure needed for a typical landscape and the sky above it. A yellow filter used here will darken the blue in the sky (yellow's complementary colour), allowing the white clouds to stand out better by comparison. The yellow filter will also help reduce distant haze to the level of that seen by the human eye, rather than the way it would normally be recorded on film. Substituting an orange filter for the yellow strengthens the effect. Whereas yellow makes skies look natural, orange exaggerates the effect, making them more dramatic. It also helps to reduce distant haze. An orange filter darkens violet, green and blue; at the same time it lightens yellow, orange and red, while increasing the contrast between yellows and reds.

For really special effects, turn to a red filter. With this, blue skies turn almost black, making white cloud formations stand out by stark comparison. Contrast is increased over the whole picture but, if you remember the rule of thumb we began with, you are in for a surprise when it comes to the effect on grass and trees. Because green is near enough the complementary colour to red (cyan is the actual complementary; green's complementary is magenta), you would expect grass and leaves to register darker than normal. In fact, any foliage, photographed in mono through a red filter, registers as nearly white. This is known as the 'wood effect' and here's why it happens.

Green objects in general are seen to be that colour because they absorb the other colours of the

A normal sky becomes far more dramatic with the addition of a red filter in mono photography. Notice how the same filter has lightened the green of the grass rather than darkening it as might, at first, be expected.

spectrum, especially the complementary colour. Most green objects therefore absorb a lot of red. Plants are green because they contain a chemical called chlorophyll. Although this is green, it has the unusual property of failing to absorb all red light, reflecting the longest red rays at the far top end of the visible spectrum, as well as infra-red (see the chapter on unconventional films, page 45). Although the effect can't be seen by the human eye, the film picks up the fact that a lot of red is being reflected from leaves etc. and, with a red filter, leaves naturally record as lighter than usual.

Landscape photography, however, is not the only use to which coloured filters can be put in mono photography. They are useful too for portraiture.

Here, a green filter, darkening its complementary colour, will darken flesh tones and lips. A light-orange filter, lightening its own colour, will help hide freckles or slight skin blemishes, providing you remember that it will also give your subject an apparently pale complexion and lighten lips perhaps a little too much. When using an orange filter for this purpose, therefore, it is often a good idea to ask your model to wear a darker-than-usual shade of lipstick. A blue filter will also give your model an apparent tan, with the added bonus of lightening blue eyes; an effect that works particularly well with male portraiture.

Filters are also useful for copying purposes. Often, the subject to be copied might be old and worn,

15

perhaps with a bad stain across it. To remove the stain in the copy photograph, simply fit a filter of a similar colour, thus lightening it to the point where it disappears on the negative. Documents that might be on paper which has yellowed over the years can be copied with a yellow filter to lighten the paper and so put back some of the contrast that age had destroyed. If you are copying an old photograph where the image has yellowed and so lacks contrast with the base paper, use a blue filter to darken the yellow. The permutations are endless, just so long as you remember the basic rule about filters lightening their own colour and darkening their complementary.

Filters for colour

All the filters mentioned above can equally be used with colour film, though the effects they give obviously differ tremendously from those obtained with mono film. It takes only the palest of colours to add a cast to a colour picture, and the filters made for black-and-white are far from pale. Nevertheless, they can be used with colour film to give strong, overall casts to pictures. Filter factors and the increased exposures they necessitate hold true for both mono and colour.

Orange and red filters can be used effectively when shooting sunsets, though it must be said that if the sky you are photographing is a particularly spectacular one, the use of these filters is liable to destroy the effect rather than enhance it. It is better to reserve them for use when the sun is setting in a clear, cloudless sky. Try using a green filter here as well. Unlike orange and red, the result will be extremely unlifelike, but realism has never had to be the aim of the special-effect photographer. Blue filters, used with colour film, can turn night into day, or sunlight into moonlight. The effect works best when the shot is also underexposed by around two stops.

There are, of course, a number of filters made specially for use with colour film, not so much for creating special effects, but more as a means of

correcting colour casts that might occur under certain conditions which the special-effect photographer might encounter along the way. Here, briefly, are the uses of some of the more popular types. UV filters are practically colourless, but actually filter out the ultra-violet light that causes the slight blue haze in sea and landscapes. A skylight filter is a light-pink colour and helps eliminate the blue cast that might be present when shooting in fine weather under exceptionally clear blue skies.

There are six filters in the straw-coloured 81 series, the most popular being 81A, 81B and 81C. They can be used with daylight-balanced colour film in cloudy or rainy weather, taking out the blue cast that these conditions induce, or for warming shadow areas in fine weather. The 81A can also be used with Type B film, balanced for tungsten light, when shooting with Photofloods. The 81A and 81B are also useful in colour photography for giving a tanned look to a model with pale skin or for warming skin tones that might appear too cold when shooting with electronic flash. The 80B is a strong blue filter for using daylight film in Photoflood lighting. The 80C is a slightly lighter-blue filter which corrects the light from clear flashbulbs when used with daylight flash. The 82A is a light-blue filter for use with daylight film in early morning or evening light, correcting the warm cast evident when shooting at these times. The 85 is an orange filter for shooting Type A film, balanced for Photofloods, in daylight. The 85B is a slightly stronger orange filter for use with Type B film, balanced for tungsten light, when shooting in daylight. All these filters have their own filter factors that apply and are used in the normal way.

Polarising filters

Polarising filters can be used with colour or mono film. Their two most common uses are for darkening blue skies, and for minimising reflections in glass or water. To understand how the filter does that, you must first understand a little of the nature of light itself. Imagine light rays as a series of long,

A simple colour wheel, showing how the three primary colours (red, green and blue), together with the three secondaries (cyan, magenta and yellow) can be arranged in a circle. Each secondary colour is made from a mixture of the primary on each side. Each colour is positioned on the wheel directly opposite its complementary.

Right: the effect of a polarising filter. Normal light vibrates along its line of travel at random (top). A polarising filter acts like a grid, restricting the direction of some vibrations (bottom).

The two most common types of filter are those that are round and screw directly into the front of the camera lens (far right), and the square variety which slot into a special holder which, in turn, screws into the lens (right).

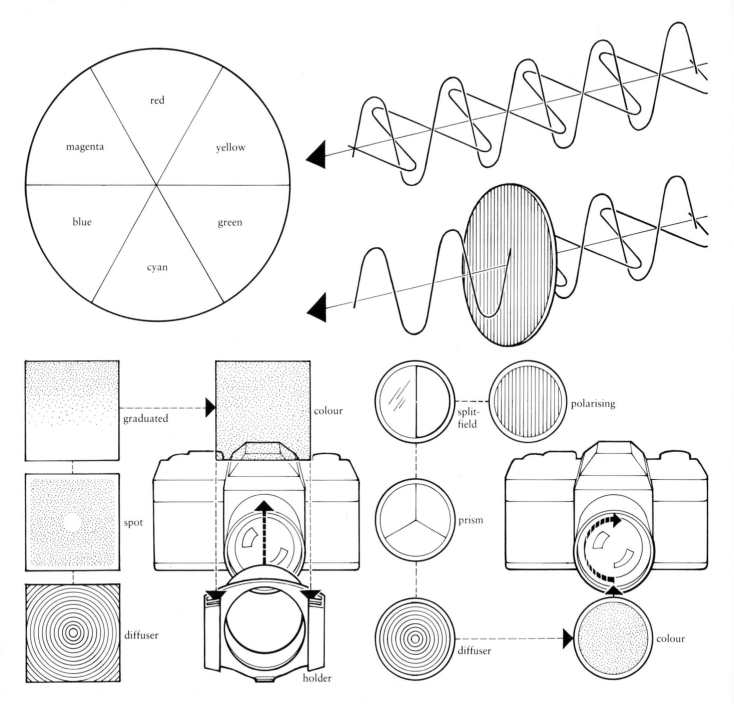

red

magenta

yellow

blue

green

cyan

graduated

spot

diffuser

colour

holder

split-field

polarising

prism

diffuser

colour

A polarising filter can be used to darken the sky, both in mono and in colour.

Another use for the polarising filter is to subdue reflections. The little girl was photographed from outside through a large picture window. The first picture is a straight shot; the second was taken from the same position, using a polarising filter.

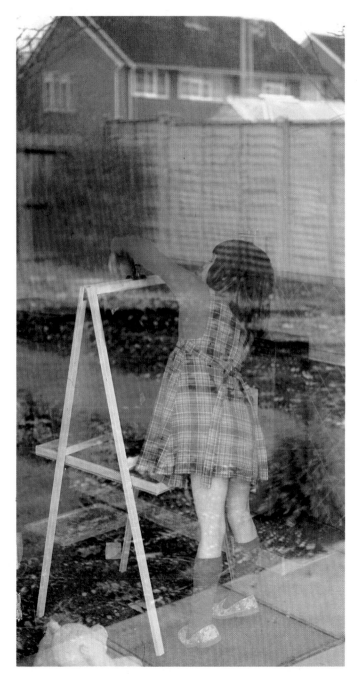
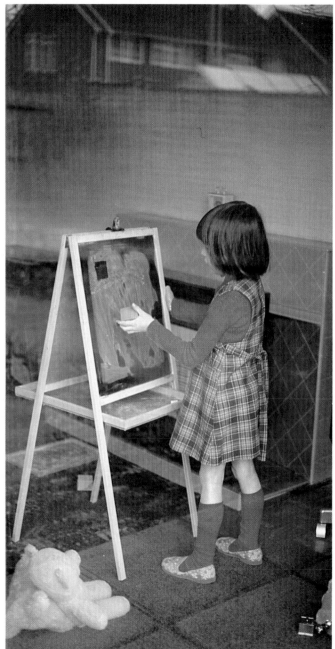

thin, straight tubes. Within these 'tubes' light vibrates back and forth across the direction of travel in different random planes. When those vibrations are restricted to one plane only, the light is said to be polarised. Polarised light occurs naturally by reflection from non-metallic surfaces like glass or water. A blue sky is a major source of polarised light, since its light is made up from reflections of the sun off particles in the atmosphere. Light can also be polarised by filters. If such a filter is pointed at a source of polarised light and slowly rotated, there must come a point where the filter is blocking light rays in the same and *only* plane as those from the source. At that point the filter absorbs all the polarised light.

Here is a practical example. Supposing you want to photograph the contents of a shop window, but you are being hampered by reflections of buildings opposite in the glass. The contents of the window are being lit by direct light whose rays are vibrating at random. The image of the buildings, however, is brought to you by reflected light which is polarised and whose rays are vibrating in one plane only. A polarising filter can now be fitted to the camera lens and rotated until its effect matches and cancels the one plane in which the reflected light is vibrating. The reflections then disappear. The filter also, of course, cancels the same plane in the direct light which is illuminating the objects beyond the glass, leading to a certain light loss. That can easily be compensated for by an increase in exposure, dictated as always by the filter factor.

The same applies when photographing objects underwater and when surface reflections need to be minimised. Also, when photographing shiny objects such as wet landscapes, a polarising filter can be used to minimise the reflections from objects like leaves or grass. Reflecting the light will have subdued the colours, but the reduction of these reflections gives the picture a cleaner, brighter look. By the same token, a polarising filter pointed at a blue sky can kill many of the reflections that are part of its make-up, rendering the sky much darker.

The degree of polarisation varies with the angle of reflection, and is at its height when you are looking at a surface from an angle of around 30–40 degrees. For that reason, not only the position of the filter on the lens but also the camera angle in relation to the subject must be carefully chosen for the best effect. By the same token, polarised light in the sky is at its lowest near the sun and at its maximum at 90 degrees. Keeping the sun to your side when you are shooting, therefore, gives the best results. If you are using a polarising filter on a single-lens reflex, you can simply fit it and watch the effect through the viewfinder until maximum polarisation occurs. On a non-reflex camera, you will have to turn the filter in front of your eye until the desired effect is found and then carefully, without rotating it any more, transfer the filter to the camera.

Neutral-density filters

The task of a neutral-density filter is simply to absorb and so reduce any light that passes through it, without colouring it in any way. To look at, they are various shades of grey and can be used equally effectively for black-and-white or colour photography. They come in a range of densities, usually designated by a figure that denotes the percentage of light transmitted by the filter. Hence ND50 would signify that 50 per cent of the light is absorbed and 50 per cent transmitted, effectively cutting the light in half and demanding a light increase of one stop – a filter factor of 2. The filters can be combined to give stronger effects. Exposures are then calculated by adding the density factors together or by multiplying the filter factors.

Most filters are chosen for their effect, and the factor by which exposure must be increased is an inconvenience which must be remedied. With neutral-density filters, the reverse is true. They are chosen for their filter factors and are used specifically to cut down unwanted light, allowing the use of wider apertures or slower shutter speeds than would otherwise be feasible. So with the appropriate filter, you can use extra-wide apertures

to reduce depth of field where necessary. You can also use extra-slow shutter speeds when, for instance, you might want to blur motion on a bright day when only a fast shutter speed would normally be feasible. Taking things to their logical extreme, you could use two or more neutral-density filters together to give exposure times of almost hours even in bright sunlight. That way you could photograph a busy street, making all moving objects effectively vanish by virtue of the fact that they would not have stayed in one place long enough to register on the film.

Calculating exposures with neutral-density filters is not always a straightforward task, since reciprocity failure plays its part when exposure times start to get lengthy. Trial and error is therefore recommended before an important picture is attempted, but as a starting point, try opening up one extra stop for exposures of 1 second, 2 stops for exposures between 1 and 10 seconds and three stops for exposures of up to 100 seconds.

Special-effect filters

Now we come to that branch of 'filters' of which some are actually optical devices. Nevertheless, for the sake of simplicity, we will refer to them all here simply as filters. There are many different types, each giving its own individual effect. Here are some of the more popular, together with the effects they create.

Cross-screen Finely-etched lines in the filter glass (or plastic) produce flare patterns in the form of long, straight lines from any point-source of light. The number and pattern of the rays so produced varies with the way the lines are etched. In some, only two lines of flare emanate from each side of the light source; in others four, six or eight lines might be produced, leading to the filters often being referred to as 'star' or 'star-cross' filters. The same filter can also be used as a form of soft-focus device on a subject that contains no point-source of light. The effect works best when the light source is in a position for the flare to be spread across dark areas

of the picture, e.g. the sun coming out from behind stormy clouds. A cross-screen works best at medium to large apertures. Stopping the lens down reduces the intensity of the cross-flare and, with some wide-angle lenses in which the depth of field at small apertures is especially large, the lines on the filter itself might start to appear on the picture.

Diffraction-gratings These are similar to cross-screen filters, but in this case the filter is etched with a series of extremely closely spaced V-shaped lines. Flare is caused across the lines, the light rays interfering with one another and splitting into the colours of the spectrum. The effect is of a series of multi-coloured lines which, as with the cross-screen filter, emanate from any point-source of light. According to the way the lines are etched, these flares can take the form of any number of lines from two upwards. When the patterns show 16 or more lines, the effect becomes that of a circle of rainbow-coloured spears. Again, the effect works best against a dark background.

Rainbow Made by cutting minute grooves in one side of a piece of optical glass, usually leaving a centre spot clear. The effect is to record a central image sharply, with ghost-like, rainbow-coloured images around the edges. The filter is often mounted in a rotating frame that enables the photographer to position the ghost-images in any desired position within the picture area.

Graduated colour The colour on a graduated filter changes in density from a saturated tone at one edge, growing lighter to completely clear on the opposite edge or rim. They are available in a choice of colours and can be used to tone selectively part of a picture: turning a grey sky blue, for instance, or adding a pink tinge to an otherwise clear sky to give the impression of sunrise or sunset. Graduated filters work best in the square type that can be moved up and down in their holder to position the densest part of the colour exactly where it is required in the picture. As well as traditional colours, they are also made with graduated neutral

A cross-screen filter makes stars of point-light sources, such as the highlights in this close-up of black-lit water droplets.

There are several types of diffraction gratings. The more lines that are etched into the filter, the more pronounced the effect. Here and opposite are the effects of three such filters.

1 Just using one etched line repeated across the filter's face practically duplicates the principal image on each side.

2 When the lines are crossed, star-shapes emanate from light sources, as seen by the picture of the sun coming up over the rock formation.

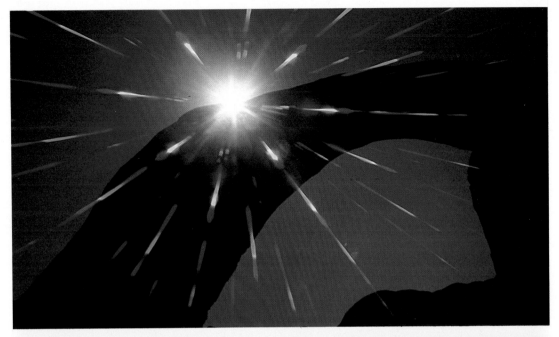

3 Adding even more crossed lines to the etching results in a complete circle.

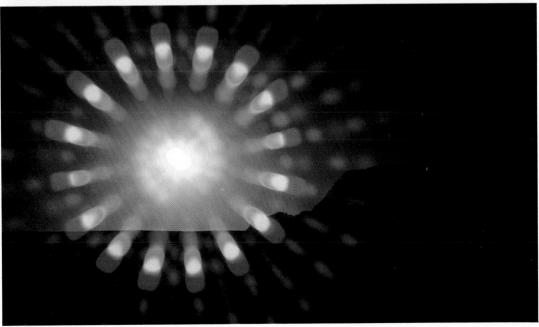

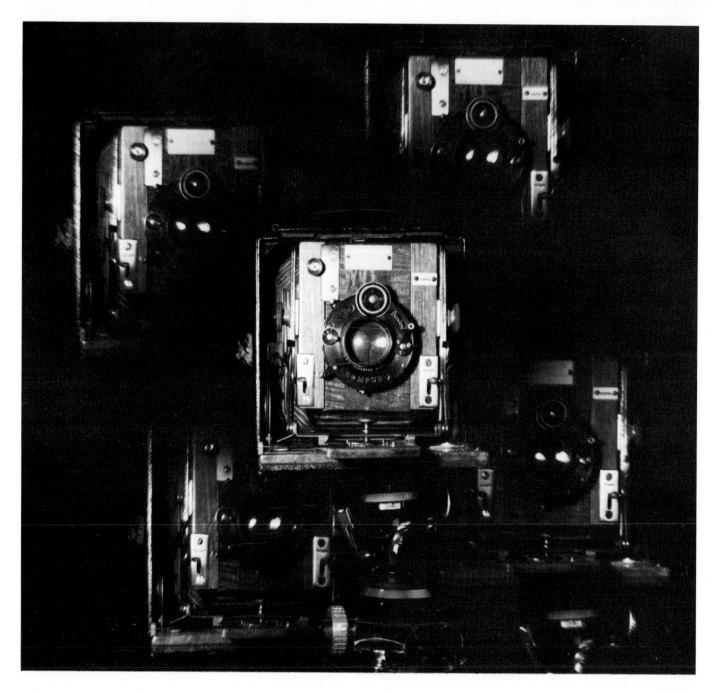

A multi-image filter repeats the subject in straight lines or in circles. This picture shows the effect of one with five facets.

density areas which can be used to reduce the effective exposure in selected parts of a picture such as a backlit scene which might normally be much brighter than a foreground subject.

Duo-tone These are similar to graduated filters but the separation between two colours or one colour and plain glass is sharply defined, making them much less versatile.

Tri-tone This time three colours are coated on to the filter to colour corresponding sections of a picture. The colours might be arranged in parallel strips, or in equal segments of a circle.

Multi-image A variety of facets make up the filter, splitting the picture into several, identical images. The number of images produced depends on the type of filter and the way the facets are cut. Depending too on which particular filter is used, the images might be arranged in a circular or parallel pattern. In some types, half the filter is clear and the remaining half split into several parallel facets. A subject photographed with its principal point of interest in the clear half will then be seen with repeating images of itself trailing across the picture area from the faceted half, giving the impression of 'speed lines'. A typical subject for such treatment might be a racing-car shot to show the repeated images in a horizontal pattern, or a trampoline-jumper shot to show the repeated images falling away vertically from his feet. Multi-image filters work best when the main subject is fairly small in the picture area and clearly defined against a dark background. Too light a background, as it is repeated by the filter, will tend to overlay and wash out the subject matter.

Colour multi-image A combination of duo- or tri-tone filters with multi-image types. In some, the effect might be of several images and two different colours overall; in others, each image might be independently coloured a different shade. Similar effects can be obtained by combining separate multi-image and multi-coloured filters.

Centre spot Filters of different colours or neutral density with a centre, clear spot. They work well with portraits, still-lifes, flowers etc. when the subject matter can be recorded as normal, but surrounded by a halo of the appropriate colour.

Vario-colour Actually three polarising filters in one. Two are of different colours and are mounted with a grey filter between them. By rotating the mount, the colour of the filter can be varied. If, for instance, the two colours used are red and blue, an infinite number of shades between those two colours can be produced. Other variations might include yellow-blue, yellow-green, yellow-red, or red-green.

Red/green/blue Three filters sometimes sold in a set. They can be used to shoot three exposures on the same frame (see the chapter on multiple exposures), each through a different filter. Since red, green and blue are the main constituents of white light, anything in the picture area which remains stationary between exposures will record normally; anything which has moved between exposures will record in one of the three colours. The effect works particularly well with subjects such as waterfalls, sun sparkling on sea, and clouds. To determine exposure, take an initial reading without any filter in place and divide this by three. An exposure of $1/250$ second at $f/11$, for example, divided by three gives an effective exposure of $1/750$ second at $f/11$. Since that speed is impossible to set on a normal camera, you must compensate with the aperture, making the exposure $1/500$ at between $f/11$ and $f/16$ or $1/1000$ second at between $f/8$ and $f/11$. Taking this as your basic exposure, adjust each individual exposure as normal, according to the appropriate filter factor.

The theory sounds complicated, but as is so often the case, the practice is a lot simpler. In fact, the filter factors tend to compensate for the division of the original exposure and, as a general rule of thumb, follow this method. Simply take an initial reading without a filter in place, open up one stop

Graduated filters are most often used on sky areas. The first picture (top left) was taken with no filter at all. The second picture (top right) has used a graduated blue to deepen the sky's natural colour. The third picture (below left) uses a graduated tobacco to distort tones completely, taking the shot further into the realms of special effects.

Facing page: coupling a multi-image with a multi-colour filter allows you to repeat *and* colour an image.

and use *that* exposure for each shot. The first time you try it, bracket by half to one stop to compensate for slight mistakes, but once you have tried the effect a few times, you'll be surprised at how easy and straightforward it is. An alternative method of achieving a similar effect is to have the three filters mounted in a strip that is designed to fall across the front of the lens as the shutter is opened. This is known as a Harris Shutter. Using colour transparency film for such pictures requires very accurate exposure measurement. A slight increase in exposure on any one filter will give a bias of that colour to the final picture. Shooting on colour negative film is easier, since a bias can often be corrected at the printing stage.

Filters and flash

The camera isn't the only place where filters can be used. Certain special effects, not possible with any other method, can be achieved by filtering a flashgun. Obviously, if a coloured filter is placed over the gun, the image will register on the film as that colour. But that's an effect that could easily have been produced by filtering the camera lens. The more interesting effects are achieved by using a filtered flash as a fill-in light source outdoors, so that its light affects only those objects within its limited range. To understand the various techniques, therefore, it is advantageous first to understand the basics of using fill-in flash.

It is a process which is most often used when working in conditions in which the foreground and background are at two different levels of brightness: subjects shot against the sun, models in the shade against brightly-lit backgrounds, etc. Without fill-in flash, it would be impossible to expose correctly for both subject and background; with it, the shadows can be lit to match the exposure for the light behind, thus giving a correctly-exposed picture from foreground through to background. Taking, as an example, a model shot in the shade against a bright background, the first step is to determine the exposure for the background. Let us say that this is $1/125$ second at

$f/11$. If you are using a single-lens reflex with a focal-plane shutter, you must adjust this to an equivalent exposure for no more than $1/60$ second, the maximum speed at which the majority of focal-plane shutters synchronise with flash. We now have a basic exposure of $1/60$ second at $f/16$.

To fill-in the shadow areas (in this example, the model's face), the flashgun must now be placed at a distance from the subject that demands that particular aperture. Work that out by using a manual gun or an auto gun in the manual mode. The quoted guide number for that particular model, divided by the aperture in use, will give you the distance at which the flashgun must be placed from the subject. Use of an extension cable will ensure that you can move the flashgun without having to move the camera at this stage. In theory, this should slightly overexpose the subject, since he or she is now being lit by both natural and flash light. In practice, however, guide numbers tend to be calculated for using the flashgun indoors in an average-sized room, taking into account reflections from walls and ceilings. Outside, there are no such reflections. The effective guide number is therefore less and the exposure tends to be about right. Nevertheless, a little experimentation and bracketing of exposures never comes amiss.

With that little bit of theory under your belt, we can now look at ways to produce special effects with filters on the flashgun. A straight filter (which can be a square of gelatin or coloured glass, or even a piece of coloured Cellophane) fitted over the flashgun will give you a picture in which the subject, lit by the flash, takes on the colour of the filter, while the background, too far away and therefore untouched by the flash, will record as normal. To find the correct exposure, work out what you would be using for a traditional fill-in flash shot, adjust the aperture for the filter factor, then adjust the shutter speed to match the new aperture and so record the background correctly. Keep the exposure to $1/60$ second with focal-plane shutters.

A different effect, but one that is based on similar principles, can be obtained by shooting tungsten-balanced colour film outdoors and filtering the flash with an amber 85B gel. This is a correction filter designed to change the colour temperature of the flashgun (normally balanced for daylight) so that it can be used with artificial light film. The effect is an apparently normally-lit model against a blue-biased background, the result of using tungsten film in daylight.

Taking things another step forward, let us now examine the effect of using two filters, one on the camera and the other on the flashgun. Used the correct way, this can give the effect of a normally-lit subject, posed against a background that has been tinted any one of a number of different colours. Such filters are available commercially and are sold in sets of two, each colour being the complementary of the other: yellow coupled with blue and mauve coupled with green. Here's the theory, using a yellow/blue set. The yellow filter is placed on the camera lens and the blue filter is fixed to the flash. The main subject, lit blue by the flash and corrected by the filter on the lens, now records normally, while the background, unaffected by the flash, records as yellow. If the filters are switched, the background records as blue. With the mauve/green set, the background can obviously be tinted either of these colours, according to which filter is used on the lens.

Exposures are again worked out along the lines associated with fill-in flash, while allowing for filter factors. But since we are now dealing with *two* filters, a little extra thought is needed. Here's an example. Coming back to our original situation, let us assume that we have a background exposure, measured without filtration of $1/60$ second at $f/16$. If the yellow filter is placed on the camera and has, for instance, a factor of $\times 2$, that means opening up one stop. Our exposure is now $1/60$ second at $f/11$. The blue filter would now be placed over the flashgun and might be noted to have a factor of $\times 4$. Its distance from the subject must now be worked

out as before but, allowing for that $\times 4$ factor, the distance must be calculated, based on an effective aperture of $f/5.6$, even though the *actual* aperture in use is still $f/11$.

A final warning
Many of the effects described in this chapter result in colouring all or part of the picture with a seemingly unnatural tone. If you are using colour negative film and having prints commercially produced, that could lead to problems, as automatic colour-analysers try to correct what appears to be an unwanted cast. The result could be a print in which your carefully-contrived special effect has been neutralised or completely wrecked. So if you are trying special effects on colour negative stock, it is advisable to slip a note of explanation in with your film when you send it to the processor. The problem, of course, does not arise if you are making your own colour prints or if you are using colour reversal material.

Three exposures, each through a red, green and blue filter respectively. Where the subject is stationary, the image records as its natural colour. Where the subject moved, each movement is recorded in the colour of the filter in use at the time.

Right: two filters of complementary colours used on the camera and flash render the subject normally, while tinting the background blue, the colour of the filter on the camera.

Far right: a red-filtered flash affects the subject in the foreground, while leaving the background to record normally.

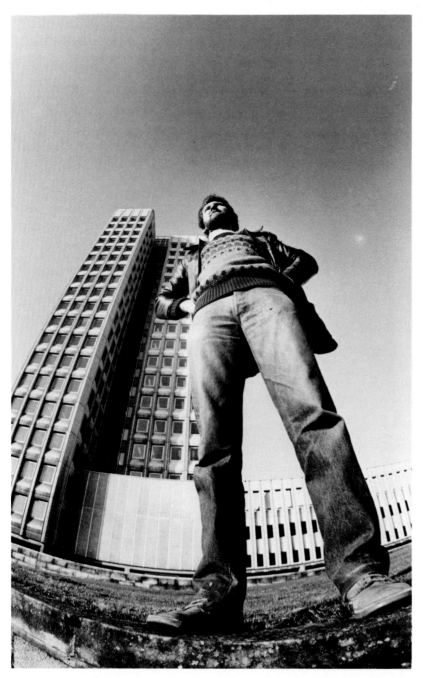

Special lenses

A standard lens, the type that is normally supplied with the camera, has come to be accepted as one whose focal length is approximately equal to the diagonal of the film format. Hence, a full-frame 35 mm camera, taking 36 × 24 mm negatives, will have a standard lens of around 50 mm; a medium-format camera, taking 6 × 6 cm or 6 × 4.5 cm negatives, uses a lens nearer 80 mm; while a 110 camera with a 13 × 17 mm negative size will have a standard lens of about 25 mm; and so on for other formats larger or even smaller than these. Either side of the standard focal lengths, there are wide-angle and telephoto lenses.

For the purposes of this chapter, we will now refer only to focal lengths as they apply to 35 mm, undoubtedly the most popular format among many professional and most amateur photographers. For that, a normal wide-angle lens would have a focal length of 35 mm or perhaps 28 mm. In the opposite direction, medium telephotos start at 80 mm or 100 mm while perhaps the most popular 'first telephoto' is the 135 mm. After that, there are lenses of all focal lengths, with zooms covering a stepless range between up to 400 mm. This overall range, from 28 mm to 400 mm, is probably the most commonly used. Either side of these focal lengths, we are into the realm of special lenses.

Extra wide
The shortest focal length that could be considered as a 'normal' wide-angle is probably around 15 mm, about the widest that a rectilinear lens can be made. A rectilinear lens is one with corrections that ensure straight lines in the subject appear equally straight in the picture. There is, however, another type of wide-angle lens in which no such corrections are made. This is the fisheye lens, whose longest focal length will be around the 16 mm mark but whose shortest is more likely to be 8 mm or

even 6 mm. A fisheye lens is complex in design. It features two large curved elements at the front which 'see' a view that can be as much as 220 degrees across. Light rays from this wide expanse are collected by these elements and brought to a point between other elements, from which they diverge in a more conventional way to meet a normal width of film. There are more elements in a fisheye than in a standard lens and their actual shapes are difficult to compute, grind and assemble in exactly the right way, making the lenses very expensive. Fisheyes work best at small apertures and, for the special-effect photographer, they are most useful for the distortion they produce. More details of how to exploit this feature will be covered later in the chapter on distortion and reflection.

Extra long

At the other end of the scale, there is the extra-long telephoto lens. Early examples, which were termed 'long focus' rather than 'telephoto', were simply lenses of long focal lengths that were mounted in a tube of the appropriate size to separate the lens from film plane. It was necessary, therefore, for the physical length of the lens to be at least the same as its focal length: a 400 mm lens would be at least 400 mm long. A true telephoto lens uses a number of elements to produce the same focal length in a shorter size. Another long-focus lens uses not only conventional lens elements, but also concave mirrors to 'fold' the light. A concave mirror reflects light as would a normal mirror, but also focuses it in much the same way as a convex lens would. With one of these mirror lenses, light enters through a plain glass disc at the front, is reflected off a concave mirror towards the back of the lens barrel, hits another small mirror on the back of the glass disc and passes back through a hole in the centre of the first mirror to be diverged and focused on the film by more conventional lens elements. Such lenses are much shorter than a normal telephoto, though a lot broader.

The advantage of any type of long lens is that it brings far objects closer to fill the frame. Such a lens is of use to all types of photographer, but of particular advantage to the special-effect photographer are a couple of optical illusions that become apparent at the same time. The first is that perspective appears to diminish so that objects some way apart are seen to be squashed closer together than in reality. The reason for saying the perspective *appears* to diminish is that the lens isn't actually responsible for the effect. Perspective diminishes with distance, not with focal length. If a picture of the same scene were to be taken with a standard lens from the same view point, and the appropriate part enlarged from the centre of the negative to match the field of view taken in by the telephoto, the perspective would be seen to be the same in each picture. All the telephoto lens does is bring that distant scene, *and the perspective associated with it,* closer to fill the frame. The second optical illusion that the special-effect photographer will find useful is the way small objects in the distance can actually be made to look

Page 32: a fisheye lens gives an ultra-wide angle of view, distorting straight lines in the original subject and producing a circular picture.

Page 33: perspective goes totally awry with super wide-angle lenses. This picture was taken with a 15 mm lens close to the man's feet.

Perspective becomes contracted with distance, so long-focus or telephoto lenses, picking out only subjects that are at a distance, give the impression of squashing perspective. This shot was taken with an 800 mm lens on a 35 mm format.

larger than life. Again, it is all a matter of perspective. You expect distant objects to look small, compared with nearer objects. With a long lens, the nearer object can be kept the same size in the frame, while the distant object is brought closer and so enlarged.

A perfect example of this effect can be seen when shooting the moon over a building. With a standard lens, the building can be arranged to fill the foreground, but the moon will record as no more than about 0.5 mm in diameter on a 35 mm negative. Switching to a 500 mm lens, the photographer can move back so that the building occupies the same position in the foreground, but the moon will now record as a massive 5 mm across. When using any type of long lens it is advisable to have a tripod handy, since the lowest speed at which it is feasible to hand-hold a lens gets faster as the lens gets longer. A good rule of thumb

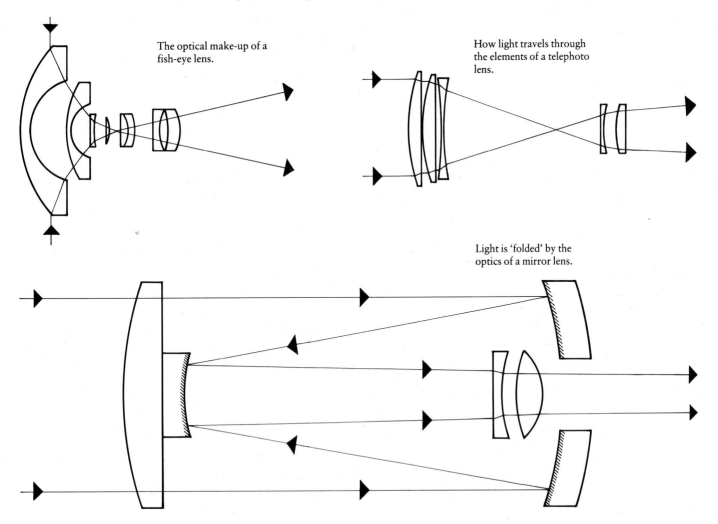

The optical make-up of a fish-eye lens.

How light travels through the elements of a telephoto lens.

Light is 'folded' by the optics of a mirror lens.

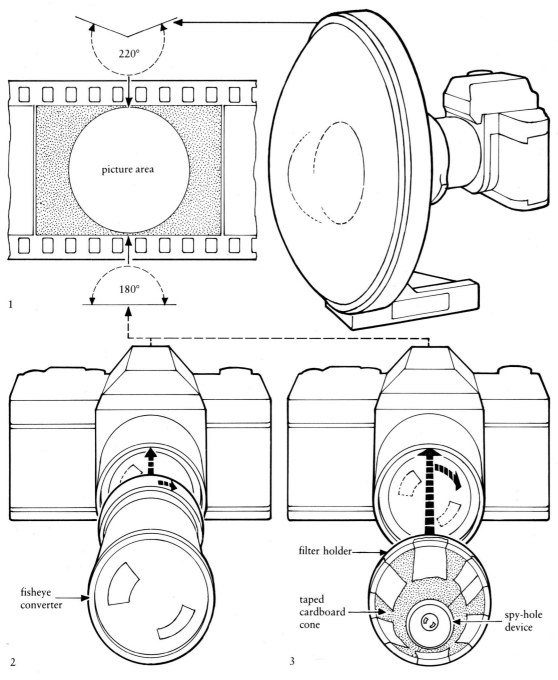

220°

picture area

180°

1

2

fisheye converter

3

filter holder

taped cardboard cone

spy-hole device

1
A fisheye lens which gives the ultimate in short focal lengths.

2
The inexpensive alternative to a fisheye lens is the fisheye converter which, when fitted to the front of a 28 mm lens, gives a similar effect to a true fisheye. The quality isn't as high, but it is perfectly acceptable.

3
A spy-hole device, normally used for security purposes, can be fixed to the front of a standard lens by means of an old filter holder. The results given are low quality, but similar to that obtained with a fisheye or fisheye converter.

4
A perspective-control lens can correct converging verticals on a rollfilm or 35 mm camera where no technical movements would otherwise be possible.

5
A split-field lens is actually half a close-up lens that covers only part of the frame.

6
A cardboard tube, one end covered in metal foil with a small pin-hole in it, can be fixed to a single-lens reflex in place of the lens to make pin-hole pictures.

7
An anamorphic lens, attached to the front of a standard. It is used to 'squeeze' the image laterally.

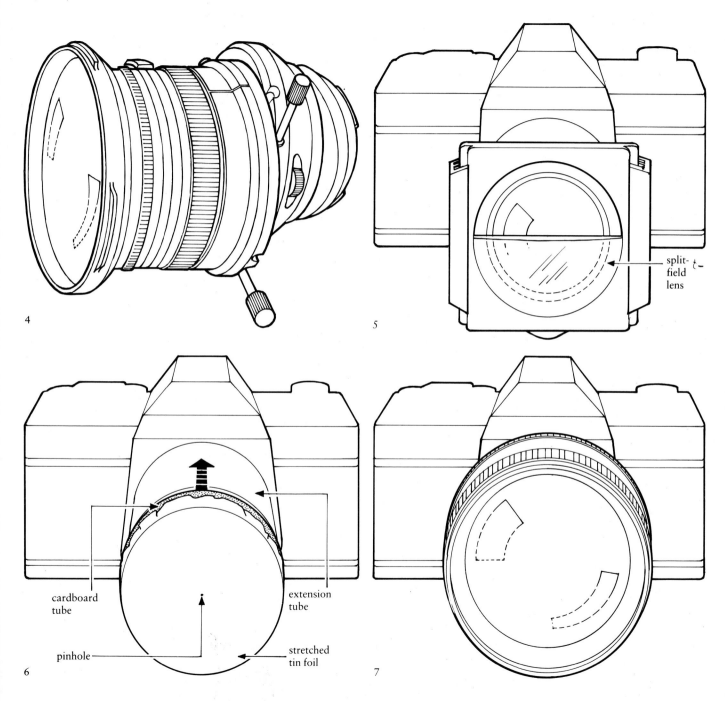

4

5

split-
field
lens

6

cardboard
tube

extension
tube

pinhole

stretched
tin foil

7

is to think of your slowest hand-holdable speed as the reciprocal of the focal length. Hence, a 500 mm lens should not be hand-held at anything lower than $1/500$ second, a 1000 mm lens at $1/1000$ second and so on.

Zoom lenses

A zoom lens is one in which some of the elements have been made to move in relation to others, changing the lens's focal length, according to their positions. This gives a stepless range of focal lengths, usually in a ratio of around 1:3, such as 28–85 mm or perhaps 75–210 mm, though there are many more choices of focal length than these. For straightforward photography, a zoom lens provides the photographer with a handy range of focal lengths without the necessity of changing lenses. The special-effect photographer is more likely to use these lenses with slow shutter speeds, actually changing the focal length during the exposure for adding a degree of controlled blur to a shot (see chapter on controlled blur), or as one way of producing abstract images (see chapter on abstracts).

Macro lenses

Some method of taking close-ups is often needed by the special-effect photographer. There are many methods, one of which is with a macro lens. This is one that has been made so that the focusing mechanism will extend its distance from the film plane to obtain a 1:1 magnification of the image on the film. More details of these lenses and how they are used will be found in the chapter on abstracts.

Anamorphic lenses

An anamorphic lens contains a system of prisms or, more often, a combination of cylindrical mirrors, both convex and concave, to give the effect of a lens with two different focal lengths. These are at right angles to each other and also to the lens axis. The effect is to give two different magnifications of the image on the same piece of film: one horizontally across the frame, the other vertically from top to bottom. The result is a picture that, while retaining its correct proportions in one direction, is 'squashed' in the other. The lens is usually used on the camera to 'squash' the image in the horizontal plane. Another anamorphic is then used at the enlarging or projection stage to 'squash' the image in the vertical plane, so that the final result is a correctly-proportioned image, but in a panoramic format. More details of the range of anamorphics available and their use can be found in the chapter on panoramic pictures. The lens can also be used without correction to produce different degrees of distortion, as described in the chapter on distortion and reflection.

Perspective control lenses

When a camera is pointed upwards at a tall building, the picture so produced will show the structure appearing to taper towards its top. This effect, which becomes more pronounced the shorter the focal length in use, is known as converging verticals. It can be corrected by camera movements ('Distortion and reflection' chapter), and also by a perspective control lens, sometimes known as a shift lens. The lens fits a standard single-lens reflex. Its unusual property is an ability to shift vertically, while remaining parallel to the film plane. With this, the camera can be aimed straight at the building needing to be photographed, and the lens shifted vertically. The top of the building can then often be brought into the frame without the verticals converging.

Soft-focus lenses

These utilise varying degrees of aberration to diffuse the image, giving a soft effect. More details of how they work and how to use them can be found in the chapter on soft focus.

Lens attachments

Wide-angle and telephoto effects can be simulated with various attachments that fit either to the front or behind of a prime lens. Perhaps the most common of these is the teleconverter. This takes the form of a small extension tube, fitting between the camera body and the lens and containing perhaps

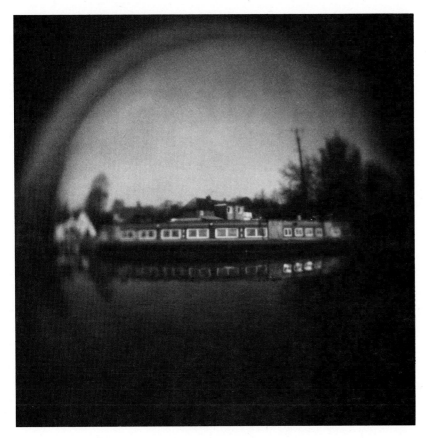

a medium telephoto lens like a 135 mm can be increased to a focal length of as much as 1215 mm. It must be admitted, however, that the quality produced by these front-fitting accessories often leaves a lot to be desired.

Of more interest to the special-effect photographer is the converter that screws into the filter thread of a standard or normal wide-angle lens, giving all the effects of a fisheye lens. Compared with the real thing, these accessories are extremely inexpensive and, while the quality doesn't match that obtained from a true fisheye, the results can be very impressive, especially when small apertures are used. With a standard 50 mm lens, the fisheye attachment gives an angle of view of around 100 degrees, the image being in the shape of a circle with the top and bottom cropped. Attached to a 28 mm lens, the accessory will give an angle or view nearer 150 degrees with a completely circular image.

For an even less expensive fisheye effect, pictures can be taken through a spy-hole device, the type sold for fitting to front doors so that the person inside can see who is outside through a small peep-hole. Such a device can be easily mounted in a piece of matt black cardboard and fitted to the front, and in the centre, of a standard or normal wide-angle lens by way of a conventional filter holder. The effect, though by no means optically perfect, is similar to using a fisheye converter. Use it at the smallest aperture possible for maximum definition. For an effect that goes beyond the fisheye, there is another type of adaptor known sometimes as a bird's eye attachment. This is little more than a small convex mirror in a transparent tube that fits over a standard lens, the mirror pointing back towards the camera. Pictures produced with it are circular, give a massive angle of view and actually show the photographer at the centre.

Another attachment of use to the special-effect photographer is the close-up lens. This usually

An extremely cheap (though not necessarily high quality) way of producing a fisheye effect. This picture was taken through a spy-hole device, more normally used in doors to see from the inside who is on the outside.

six elements. It works in conjunction with the prime lens to double or treble its focal length. A 2× and 3× teleconverter cuts the light down by two and three stops respectively. They can be used with standard lenses to give equivalents of 100 mm or 150 mm lenses, but since for special effects we have been referring to extra-long lenses, they would have to be used with medium telephotos to give the results we need. Hence, a 200 mm lens could be turned into a 600 mm lens with a 3× converter or a 500 mm could be turned into a 1000 mm with a 2× converter – a particularly interesting lens for special effects. There are also teleconverters made to screw into the filter thread on the front of a lens, some extending the focal length by as much as 9× so that

takes the form of a weak, single-element lens with a long focal length which, when fitted to the front of the camera lens, reduces its focal length, thus giving greater magnification. Close-up lenses are measured in dioptres. The higher the number, the greater the magnification. The most commonly-used are +1, +2 and +3 dioptres, all of which can be coupled for greater magnification. Not surprisingly perhaps, a +1 added to a +3 gives the equivalent of a +4. Close-up lenses are also available in a more complex design of several elements that can be moved to vary the magnification, not unlike a kind of auxiliary close-up zoom. The theory behind why these lenses work and how to use them is explained more fully in the chapter on 'Abstracts'.

There is one other type of special lens that is useful for the photographer who cannot afford a true macro. This is the macro converter and, like the teleconverter, it fits between the standard lens and the camera body. It is around the same size as a teleconverter and, once fitted, turns a standard into a macro lens, allowing focusing from about 1:10 down to 1:1.

Split-field lenses

A split-field lens is no more than half a close-up lens. It fits to the front of a standard lens and allows two different subject distances to be accurately focused on the same frame. So, with the camera lens focused at infinity and the split-field lens in place, a picture might show, for instance, a flower sharply focused in the foreground with trees equally sharp in the distance. With a little skill, the appearance of a picture sharp from a few centimetres to infinity can be given. What the picture actually shows is a sharp foreground, a blurred centre portion due to the close-up lens being aimed at a more distant part of the picture on which it cannot focus, and a sharp background from the camera lens without the close-up device. For best results, the camera should be positioned so that the boundary between close-up and normal lens falls along a natural dividing line in the picture.

'Unsuitable' lenses

Lens manufacturers go to a lot of trouble to design lenses which are as near perfect as it is possible to get. Compound lenses, consisting of many elements, are put together so that each element works in conjunction with the others to cancel out aberrations and so produce the best possible image. But, for the special-effect photographer, such imperfections can often make interesting pictures. And so there are a number of lenses which would normally be considered totally unsuitable to photography, but with which you can make fuzzy, less-than-perfect images that are nonetheless successful in their own way. Perhaps the easiest way is to use an old-fashioned snapshot camera with a simple meniscus lens. This lens finds it impossible to focus all wavelengths of light at the same point and, using the camera with modern colour film, gives the picture a soft-focus effect.

Lenses not ordinarily meant for photographic purposes can also be used, providing they are mounted on a camera with a focal-plane shutter, without which there would of course be no way of controlling exposures. A simple magnifying glass can be made to work quite well, but you can also use certain objects that were never, ever, intended to be thought of as lenses. The curved side or bottom of a bottle, a marble, the plastic disc out of the centre of your telephone dial, even a glass full of water . . . they are all capable of focusing an image and so all can be used to make pictures.

The first thing you need is a method of mounting your 'lens' on to a camera body. You can do that with cardboard tubes painted matt black inside. The 'lens' naturally must be mounted so that no light reaches the film other than through its surface. To focus the lens, two tubes can be used, one sliding inside the other. For a more sophisticated method of focusing, a bellows unit can be attached to the body of a single-lens reflex and the 'lens' mounted in a black card support on its end, at the point where the camera lens would normally be fitted.

The second problem is to decide how far to mount the 'lens' in front of the camera. To ascertain that, think back to how normal lenses are mounted. Their distance from the film when focused at infinity is the same as the focal length. To focus closer, they are then moved marginally further away from the film plane. Follow the same procedure, mounting your 'lens' at the same distance from the film plane as its focal length, allowing movement in front of this distance, away from the camera, for closer focusing. To find the focal length, hold the 'lens' in front of a piece of white paper inside a room and in front of a convenient window, then focus the image of some infinity-based subject outside the window on the paper. At the point where the image is sharpest, the focal length is equal to the distance between the centre of the 'lens' and the paper. For something like a magnifying glass, that could be quite a long focal length, and so a tube must be constructed to separate it from the body. With something like a marble, the focal length will be so short that it will, in all probability, have to be pushed back into the camera body with a suitable cardboard holder until it is only a matter of millimetres from the film. For that reason, if you are using a single-lens reflex the mirror must be locked up, if possible. Failing that, the alternative is to use an interchangeable-lens, non-reflex camera with a focal-plane shutter.

To focus, the camera should be set on a tripod, the back opened and a piece of ground glass or tracing paper spread across the film plane. The 'lens' is adjusted until the image is as sharp as possible, the tracing paper is removed and the film inserted in the normal way. Exposures present your next difficulty. If your camera is the aperture-priority type, it should be able to handle them automatically, choosing and setting the correct shutter speed accordingly. Otherwise, you must calculate the shutter speed yourself. That means first finding the working aperture of the 'lens' in use. Find that by dividing the diameter of the 'lens' into its focal length. A marble, for instance, might have a diameter of 20 mm and a focal length of

15 mm. Its aperture, then, would be $15 \div 20 = 0.75$. Smaller apertures can be made by masking the 'lens' with pieces of card, in which circular holes have been cut. The diameter of each hole is then used for the calculation in the same way as any normal lens. Exposures are made in the usual way, coupling the found aperture with an appropriate shutter speed.

Pictures without lenses
Pictures can even be taken without any lens at all. In fact, the very first 'cameras' had no lenses, simply small holes through which an image was focused onto some convenient surface. We are speaking here of camera obscuras, the forerunner of today's cameras and devices that date back as far as the 11th century. But long before photographic cameras arrived, camera obscuras were being fitted with lenses and so, when the chemistry for recording and keeping an image was perfected, the physics of producing it were ready and waiting. Nevertheless, it is the theory of those ancient camera obscuras that gives us today's method of producing pictures without lenses.

If a pin-hole is made in one end of a light-tight box, light rays will converge through that hole much the same as they do through a lens, to diverge on the other side and project an image on any surface opposite the hole. If a piece of film is placed there, the image can be captured in the same way as it might be via a lens, providing the exposure is long enough. So a pin-hole camera can easily be made with no more than a box, a minute hole at one end and a method of holding film at the other. The pin-hole itself has a cleaner edge when made in something like aluminium foil or a milk bottle top, rather than in cardboard or any similar material. The foil is then mounted on the 'camera' front with another larger hole behind. The 'focal length' of the pin-hole varies with its distance from the film. Hence, if a long camera is made, the picture will be similar to that made from a telephoto lens. With a small hole-to-film distance, a more wide-angle effect is obtained. There are no depth-of-field

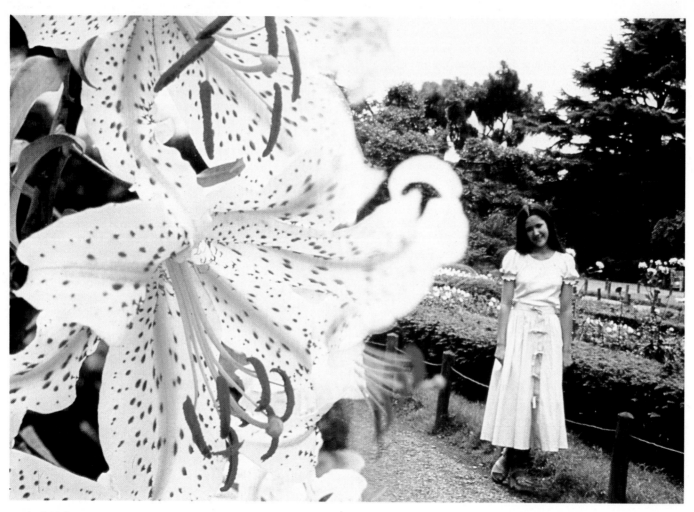

A split-field device gives the
impression of limitless
depth of field. It is actually
half a close-up lens that
affects only part of the
picture area. *Hoya*.

A picture taken with no lens at all. For this shot, a minute pin-hole was made in the front of a tube that was fixed in place of the standard lens on a normal single-lens reflex.

problems; pin-hole images will be sharp from a few centimetres to infinity, irrespective of the 'focal length'. Exposures must be by trial and error, but will often be counted in minutes rather than fractions of a second.

A more sophisticated method of making a pin-hole picture is to make the hole in the end of a tube and mount that in place of the lens on a conventional camera. Again, the longer the tube,

the longer the effective 'focal length'. If, in these circumstances, your camera is an aperture-priority type whose automatic shutter speeds run into the more lengthy times, you can use that to find the correct exposure. In all these instances, it should be borne in mind that the lengthy exposure times will undoubtedly involve reciprocity failure and so exposures should be liberally bracketed, often multiplying what would seem to be the correct exposure by as much as eight times.

Unconventional films

What is a normal film? It can be either black-and-white or colour; if it is colour it is negative or reversal; if it is reversal, it is daylight-balanced or tungsten-balanced. Maybe 99 per cent of pictures taken use a film that falls into one of those basic categories. But for certain specialist uses, there are other films which produce unique effects, either by the use of the film alone, or by coupling it with some other element like filters or lighting.

Infra-red film
What we think of as white light is actually made up of seven different colours: red, orange, yellow, green, blue, indigo and violet. The light rays that convey these colours have different wavelenths, of which the above seven are visible to the human eye. But the rays continue outside the range of what we can see. At the violet end of the spectrum, there are short-wavelength rays that give, at first, ultra-violet which can't be seen, but whose effects can be photographed (see the chapter 'Unusual lighting'), then X-rays and gamma rays.

At the red end of the spectrum, the first 'colour' outside the range of the human vision is infra-red. As these rays get longer, they give way to wavelengths used for broadcasting radio, television, radar etc. Infra-red film is one that has had the sensitivity of its emulsion extended so that it can record the rays beyond the red end of the spectrum and into infra-red. Because of its characteristics, you may have heard it said that infra-red film can be used to take pictures in the dark. This does not mean that it needs no radiation at all. Where *no* energy reaches it, there can be no image recorded on the emulsion. What infra-red film *can* do is take pictures in conditions that *appear* to be dark. If the subject is lit by infra-red rays, the eye cannot see it, but the film can, and it will appear to have recorded a subject in total darkness.

There are two types of infra-red film, one designed for black-and-white photography, the other for colour. Much of the theory behind each is the same, but naturally the results produced are different. Neither film has good keeping properties and it should be stored in a freezer before and after use. The colour film comes from Kodak in standard 35 mm cassettes, the mono version in cassettes and sheet form. It is often recommended to load cassettes in pitch darkness, though experience shows that this is not strictly necessary. Lighting can be from natural daylight, flash or tungsten bulbs. The latter are particularly useful as they are extremely rich in infra-red radiation, thus effectively increasing the film speed. Focusing can present difficulties because infra-red rays do not come to focus at the same point as those from visible light. Most cameras have a red mark on the lens barrel a few degrees to the side of the normal focusing mark, against which the usual distance figures must be aligned when using infra-red. With a single-lens reflex, that means focusing as normal, noting the distance against the normal mark and then shifting the lens so that that distance is against the infra-red mark. If your camera has no such mark, use the $f/4$ point on the lens's depth of field scale. If the lens turns left to right for close focusing, use the $f/4$ mark on the right and vice versa if the lens turns the opposite way. It is wise to work at the smallest possible aperture to extend the depth of field and so cover any small discrepancies in focusing.

Infra-red for mono

The film is not only sensitive to infra-red. It is, in fact, quite sensitive to blues as well. So for results that show predominantly the effect of infra-red film, a dark-red filter should be used to take out the blue. It is not possible to give accurate speed ratings for infra-red film, but suggested exposure times are given with the instructions which, when followed with the usual degree of bracketing, give perfectly acceptable results. In dull weather, it is advisable to open up an extra stop on the recommended exposure because such conditions cause a drop in

the ratio of infra-red to visible light. The way we see objects around us varies with the way those objects reflect visible light. But when they are reflecting invisible light, such as infra-red, the results in the final picture are vastly different to the way we have seen the original subjects. Until you come to know what to expect, the results will seem completely unpredictable, particularly since the amount of infra-red reflection has little or no bearing on the amount of visible light being reflected. Vegetation like grass and leaves tends to reflect a lot more infra-red than visible light, and therefore shows up as white on the final print. Paint and make-up also give results very different to those produced with normal film. Contrast of the picture is increased as the longer wavelength of infra-red records distant objects without the haze that is often associated with normal monochrome landscapes. But don't confuse this haze with fog. Infra-red can't 'see' through fog any more than it can 'see' in the dark.

The film can be processed in standard black-and-white developers, but some plastic developing tanks might give trouble by leaking infra-red and so fogging the film. It is often advisable to develop in a tank and also in the dark, although infra-red can be masked by shielding the tank with aluminium foil, shiny side out to reflect all light rays. Developers recommended by Kodak are D-76, HC-110, D-19 and Microdol-X.

Infra-red for colour

The most widely-available infra-red colour film is Kodak's Infra-red Ektachrome. The film has three emulsion layers, one sensitive to green, one to red and the third to infra-red. Used straight, without filtration of any kind, most objects in the picture will take on a strong, blue cast, although blue skies will record as magenta. To counteract this, Kodak recommends the use of a yellow filter. Pictures taken with that will record most reds as yellow, green foliage takes on a magenta cast, but skies remain blue. A green filter will weaken the strength of the blue in the sky and foliage begins to appear

Page 44: in mono, infra-red film, used with a red filter, gives a strange ghostly effect as buildings and trees turn white and blue skies turn black. *Frank Peeters.*

Page 45: the use of lith film reduces the image to black-and-white, destroying all intermediary shades of grey.

Right: using infra-red colour film with different filters radically changes the look of everyday scenes. This picture was taken on Infra-Red Ektachrome, using an orange filter.

Far right: colour film, balanced for tungsten light, used in daylight gives a blue cast. This shot has been overexposed by one stop to make the blue into a pastel shade and to accentuate the effect on the child's eyes.

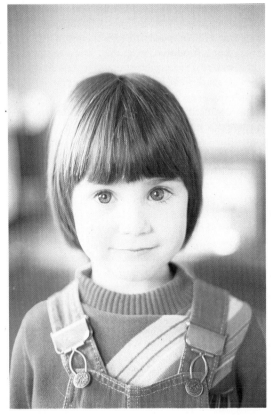

purple. Orange and red filters give perhaps the most striking effects, turning foliage orange and making clear blue skies green; any white highlights, and that includes clouds, will turn yellow. One drawback of Kodak Infra-red Ektachrome is that it must be processed in the now-outdated E-4 chemicals, rather than the current E-6 process. Few laboratories will undertake E-4 processing these days, but Kodak still supply E-4 kits for home use and, providing the instructions are followed carefully, the film is almost as easy to develop as black-and-white.

Recording film
This is a Kodak black-and-white emulsion, whose full title is Kodak Recording Film 2475. It is available in 35 mm cassettes and its most obvious difference to other films is its extra-high speed, brought about by an extended sensitivity to red. The film can be rated at ISO 4000/37°, ten times the speed of Kodak Tri-X or Ilford HP5, two films which are normally regarded as being at the top of the speed scale. The film is designed primarily for available-light photography where existing light is especially low and cannot be boosted by artificial means, or for all types of photocopying in which shadow detail and grain are unimportant.

For the special-effect photographer, the very fact that the film gives such grainy results can be used to

a major advantage. It should be used on subjects with strong, compositional lines: cityscapes featuring modern tower blocks seem to suit the image that is produced better than landscapes with soft lines and a more subtle range of tones. And yet, rules *are* made to be broken and the film can equally be used to bring a harsh contrast to what would normally be considered a 'softer' scene. Surprisingly perhaps, it works well with portraits of pretty girls, where the break-up of the image can be printed hard to give a sharp, modern look to a lively model, or softer for a dreamy, almost soft-focus effect. The film's contrast will give a restricted range of tones, bordering on a soot-and-whitewash effect and, with portraiture, skin tones will record particularly pale.

Outdoors, the film's speed can make exposures a difficulty. On a bright summer day, you could find yourself needing something in the region of $\frac{1}{4000}$ second at f/16, and there aren't many cameras that can provide that! Because of this, and because of the film's inherently high contrast, it is best to shoot on dull days, when the sun is obscured by cloud. Such conditions give flatter lighting and allow the photographer to use slower shutter speeds and/or wider apertures. Even so, it can still be difficult to find a workable combination and, for that reason, neutral density filters are advisable when working outdoors. In the studio, low-wattage tungsten bulbs can be used, but if flash is being considered, then neutral density filters might again be needed. (See first chapter.) Kodak recommend that 2475 is processed in DK-50, HC-110 or D-19 developers.

Photomicrography film

Here's another specialist film that could be considered the direct opposite of the previous example. Where 2475 is mono and extra-fast, this film is colour and extra-slow. Its full title is Kodak Photomicrography Colour Film 2483 and, as its name suggests, it has been designed to be used primarily through a microscope, though it is also used for copying mono or colour artwork. What it isn't designed for is general photography of landscapes, portraits and the like. Which is the very

This picture was taken one hour after sunset. The sea is illuminated by the faint glow from the sky and the fisherman is lit by low light from the quayside a few hundred metres away. Yet the shot was taken with a hand-held exposure, courtesy of Kodak Recording Film. *Terry Scott.*

reason that it can often be of interest to the special-effect photographer who will use it for just that. Its speed is only ISO 16/13°; thus on a bright, sunny day, it requires an exposure of around $\frac{1}{125}$ second at $f/5.6$. That doesn't give you a great deal of versatility, either outdoors or in the studio. However the film gives extremely high contrasts and very high definition, coupled with a degree of colour saturation seen in few other films. Used for conventional photography, the resulting pictures appear much brighter and more contrasty than the original subjects. Photomicrography Film 2483 is a reversal emulsion, available in 35 mm cassettes. Like infra-red Ektachrome, it must be processed in E-4 chemicals.

Lith films

These films are most often associated with special effects in the darkroom, rather than in the camera. Easily available in sheet form, they can be used for making internegs with a complete absence of grey tones. Prints made from these show only black and white, soot-and-whitewash effects, with no other tones in between. What isn't always appreciated is the fact that similar effects can be made by using the film in the camera. The sheet film can, of course, be used in film holders with large-format cameras, but the film is also available in 35 mm. It is not, however, available in standard cassettes, but must be bought in bulk lengths of 30 metres and loaded into an empty cassette by the photographer. It is also available in 30-metre lengths of 46 mm width. Kodalith Ortho Film 2556 Type 3, with an Estar base and Kodalith Ortho Film 6556 Type 3, with an acetate base, can both be handled in the darkroom in a red safelight and processed in Kodalith Super Liquid or Super RT developers.

Duplicating film

Elsewhere in this book, in the chapter on multiple exposures, we shall be dealing with ways and means of copying slides. One of the problems involved is an increase in contrast, which is why special low-contrast colour films are produced specifically for copying purposes. Kodak Ektachrome Slide Duplicating Films 5071 and 6121 are both balanced for tungsten light and are each suitable for making high-quality duplicates. The first is available in 30-metre lengths of bulk 35 mm and 46 mm widths, the second only in sheet form. Both are processed in E-6 chemicals.

The wrong cast

All the films mentioned until now have used special emulsions. But the emulsion of normal, straightforward slide films can also exhibit special properties in the right circumstances – or rather, when used in the *wrong* circumstances. Although it is not immediately obvious to the naked eye, artificial light is actually a different colour to daylight. Tungsten light is more red, daylight is more blue. These differences are measured on a colour-temperature scale in Kelvins. Daylight is 5500 K, tungsten light is 3200 K. Our eyes adapt from one to the other, seeing both as what we have come to think of as white light. Film isn't nearly so versatile and so must be balanced for one or the other. Hence, colour reversal films are either daylight-balanced or tungsten-balanced. The tungsten-balanced film is known as type B. There is also a type A balanced at 3400 K for Photofloods, but this is something of a rarity in the UK, although it is still very popular in the USA.

There is, of course, much more to colour temperature than described here, but it is sufficient for the purposes of this book to know only that the different types of film exist. Used with their appropriate lighting conditions, or with the right filters (see earlier chapter on filters), they will give a correct rendering of all tones. Used in the wrong lighting conditions, they give interesting special effects. Type A or type B film, used in daylight gives a cold, blue cast to the whole picture, but one in which strong colours such as red still come vividly through. On the other hand, if daylight film is used in artificial light (not electronic flash, which is balanced at 5500 K), the picture takes on a warm, yellow cast. Again this confirms the old axiom: learn the rules first, then learn how to break them.

Unusual lighting

The most important ingredient in any photograph is not the subject; nor is it the camera, the lens, or any other item of equipment. The thing that no photograph can be produced without is light. The strength of the light, its direction, whether it is hard or soft, how it balances between different parts of a picture, whether it is constant or pulses in a series of flashes, if it is inside or outside the range visible to the human eye . . . all these factors and more affect the picture. Many are solely responsible for certain special effects.

Direction of light

Front lighting gives a flat look to the subject, side lighting shows more texture; those are two of the most elementary lighting rules that the beginner to photography encounters. But the special-effect photographer very soon learns that rules are made to be broken; and there are few places where this is more apparent than in the use of light. Portraits, we are told, should never involve a light from below the subject's face. Yet placing one in that very position and making it the *only* light in the picture, can be an extremely simple way of producing a strikingly macabre effect. With the light anywhere below face level, shadows are directed upwards. The features fall into a pattern of dark shadows with patches of light on the mouth, cheeks and eyes, giving a mask-like effect. When shooting in colour, the addition of a gel to the light enhances the ghostly circumstances. The addition of another light directly behind your model gives a glowing rim around the hair which can add to the eerie look of the picture.

Mention of this backlight introduces us to another example of unusual lighting. With a subject placed against a black background and a single light placed directly opposite the camera so that the subject hides the actual source, a rim of light will be

seen, following exactly the subject's profile. The effect works best on rough-textured surfaces, rather than smooth, and so can be seen best around hair and clothing, if the subject is a person. If this type of picture is set up in a studio, the rest of the room is best blacked-out so that no detail registers in the subject itself and the picture shows only the profile of light. This technique can also be used as the basis for an unusual form of portrait lighting, using a reflector to bounce light back into the subject's face and then exposing for the skin tone. The result is an even, shadowless light on the face with a bright halo of light around the hair.

Against a white background, this rear light can be turned away from the subject and shone directly on to the background itself to render the subject as no more than a silhouette. For the best effect, the room should be blacked-out so that no light falls at all on the actual subject, and then the background should be overexposed by two or three stops. If you are using this technique as part of a double exposure (see chapter on multiple exposures), the background needs to be overexposed by at least five stops to wipe out completely any detail in the secondary image. That makes it even more important to ensure that no light falls on the subject.

Painting with light

If the shutter of a camera is opened and a point source of light is moved around within the picture area, it will record on the film as a series of lines or streaks that follow the path of the light. This can be used to particularly artistic effect in the making of physiograms (see chapter on abstracts), but the technique is by no means confined to the making of such regular patterns. A light such as that obtained from a torch beam or even a naked light bulb can be moved in other ways for different effects. It can, for instance, be used to trace around the outline of some object such as a chair in an otherwise darkened room to give a picture showing the chair's shape in a pattern of glowing lines. Another variation is to use the light to trace around the

outline of a live model, after first making a flash exposure of the subject. Here, a dark room and a black background are essential.

Both these techniques rely on direct light pointed towards the camera. But reflected light can also be moved during exposure for its own effect. If the camera is on a tripod outdoors at night, the beam of a strong torch can be used to 'paint' a subject with light. The shutter is opened with the aperture set to a medium stop, and light from the torch is moved slowly across the subject. Every part of the subject that the light strikes will be recorded on the film. The light can be used to illuminate the whole of the subject or maybe just a part. A surreal landscape can be built up by illuminating some parts, while leaving others in darkness: a tree here, a house there, perhaps part of a road, the light being moved around while the camera stays on its tripod.

Judging exposures isn't always easy and so a certain amount of bracketing is advisable. One way to ensure that exposure *is* near the mark is to substitute a flashgun for the torch. If it is an auto gun, you do no more than set the appropriate aperture for the speed of film in use and then, with the flashgun off the camera, fire it at your various subjects, allowing the sensor to control the amount of light needed for that aperture in the normal way. If you are using a manual flashgun, work out your aperture as usual by use of the guide number and the flash-to-subject distance, then open up one stop to allow for the fact that guide numbers are calculated taking into account a certain amount of reflection from walls and ceiling in an average room, all absent outdoors. To enhance the effect further, whether you are using a flashgun or a torch, filters can be used on the light source or on the camera to add different colours to the subject.

Polarised light

We have already dealt briefly with the way light is polarised by reflection (chapter on filters) and how the use of suitable filters affects that light to change

Page 50: the simplest of all unusual lighting techniques – shooting a silhouette by exposing for a bright background and allowing the foreground to fall into shadow. *John Woodhouse.*

Page 51: the worst place for a light in conventional portraiture is below the face. But for the special-effect worker, the position gives an interestingly weird effect to features as all the face's shadows are directed upwards.

An unusual lighting treatment for a portrait. The only light comes from directly behind the model, heavily highlighting her hair. The girl's face was lit by the same light, reflected from a gold reflector close to the camera.

tones and images within the picture. But there is more to polarised light than that. It is used in industry to show how various materials behave under stress, and a similar technique can be used by the special-effect photographer to produce strikingly-beautiful, multi-coloured patterns that could never be seen with the naked eye. The effect works well with plastics which, due to their methods of manufacture, are continually under stress. Examples include transparent plastic drawing instruments such as set-squares and protractors, adhesive sticky tape that has been stretched as it is bound around some object, acetate sheeting, even the wrapping from cigarette packets. It *won't* work with glass, because any stresses applied in the manufacturing process relax as glass cools. The effect relies on the fact that the refractive indices of these materials change with the amount of stress that is applied, either by the photographer or by the manufacturing process. When viewed by transmitted polarised light, these changes break up the light into its spectral components. The effect is known as birefringence. On black-and-white film it shows up as different shades of grey; on colour it is recorded as a pattern made up from the colours of the spectrum.

To make it work, you first need a subject. Try using a small plastic set-square, the sort that is used in schools. Next, you need two polarising filters: one for the camera, the other for the light. You could use a projector as the light source, in which case a normal filter designed for the camera might fit over the lens. But for more versatility, it is better to buy a larger sheet of plastic polarising material from a specialist scientific supplier. Since it will be used to filter light, rather than for photographing through, it need not be optically flat like a camera filter and small examples of the material can be bought relatively cheaply. Place the polarising material over the light source, and back-light the subject, preferably through some diffuser such as a sheet of tracing paper. The second filter is of the normal camera type and that is fitted in its conventional place over the lens. That's all there is to it. Viewing

the result through the viewfinder of a single lens reflex, or with the second filter held to your eye if you are using a non-reflex camera, the colours will immediately be apparent. As you turn the filters, the colours of the object will change; as you turn one filter relative to the other, the background will grow dimmer, then brighter. When the two filters are at right-angles to each other, the backlight appears to vanish completely, leaving the object being photographed to stand out vividly against a dark background. This is because the light from the backlight has been polarised by its filter to vibrate in one plane only and that plane has then been cancelled out by the camera's filter. The light on the subject of course has been broken up and is vibrating in random directions. The camera filter cuts out some of these, but leaves enough for light through the object and the colours to record on film.

All kinds of subjects can be photographed this way. Abstract designs or sculptures can be made with various materials and photographed; close-ups can be taken of small areas of stressed plastic. If slides are being taken, the results can be bound as sandwiches with other slides or lith masks (see chapter on montage), projected on to faces or figures (chapter on using projectors) or just used in their own right as colourful abstracts (chapter on abstracts).

Ultra-violet radiation
First a warning: ultra-violet radiation can be dangerous to use. Do not try any of the following effects unless you are absolutely sure of what you are doing. The UV source should be screened so that you do not look at it directly. For complete safety, goggles of the type used with sun-ray lamps can be used. It is, after all, the five per cent of UV in natural sunlight that burns your skin and gives you a tan. Imagine, then, what a concentrated dose over a long period of time can do. Having prepared yourself for the dangers, you need to find a source. Sun-ray lamps are suitable, but by their very nature they will burn the skin if you expose yourself to the

direct beam for too long. Safer is the black light used in theatres and discos. This has a longer wavelength than the light from a sun-ray lamp and is less harmful, though care should still be taken with its use. This latter type of lamp can be hired at a reasonable cost from a theatrical supplier. It gives off less visible light than the sun-ray type, hence the term 'black light'.

A typical UV picture shows objects glowing with what might seem to be impossibly-bright colours against a dark background. Unlike colours seen normally, these colours are not coming from either direct or reflected UV. Ultra-violet radiation itself is invisible to the human eye, but when it strikes certain substances it causes them to glow, as though they are being lit from within and often in a colour that is different from their own. This characteristic is known as fluorescence. Household materials such as detergents, powdered chalk and some toothpastes all fluoresce under UV. Many chemicals such as aluminium hydroxide, magnesium carbonate and zinc sulphide, to name just three, also fluoresce and while they are not as easy to come by, many of them are constituents of dyes and paints that can be bought in any good art shop. Certain papers and felt-tip pens also work well, because of the dyes in their make-up. But not *all* dyes fluoresce, and those that do will not always give off their own colour. The result is as unpredictable as it is fascinating. Bearing in mind the dangers mentioned above, a model can be wrapped in a costume that owes its colour to fluorescent dyes, fluorescent patterns can be added to the costume with appropriate paints or felt-tip pens, even the model's teeth will probably glow! Abstracts can also be made with fluorescent paper or dyes dissolved in water.

The pictures should be taken in a dark room, but although you will see only the light reflected through fluorescence, colour film will pick up a certain amount of the invisible UV, recording it as blue. You can use a yellow filter to absorb that if you want to make the background darker. The UV can also be absorbed by use of a normal UV filter to give a black background. Since the objects being photographed are glowing with normal light, rather than UV, their image will remain unaffected. No special film is needed to make UV-lit pictures, but if you are working in colour, best results are obtained on daylight-balanced film rather than tungsten. Exposure might be unexpectedly long since the fluorescent effect gives the impression of being brighter than it really is. A tripod, then, is almost a necessity for this work. Exposures are measured in the normal way but, as always with any experimental photography, it is wise to bracket.

Lightning

There is nothing difficult about photographing lightning. The difficulty is being in the right place at the right time and, if the storm is raging around you, keeping your equipment dry. Very often, however, lightning can be photographed from afar as the storm approaches, making it unnecessary to actually be out in the rain at the time the photograph is taken. There are two common forms of lightning: fork and sheet. Fork lightning makes the better picture by far. Sheet lightning tends to light up the whole sky and the impression on a picture taken by this light is of a normal landscape on a day when the sun is diffused by cloud.

Lightning is a lot more predictable than it might at first seem. It may never strike in the same place twice, but when viewed from a few miles distant, it certainly plays around one area. That area might be several miles across but, from the camera position, the distance can usually be accommodated within the angle of view of a standard lens. Once you have seen one streak of lightning it is easy to position your camera in anticipation of catching the next.

The pictures must be taken at night. The camera is mounted on a tripod, a medium aperture chosen and the shutter opened. As soon as the lightning flashes, the shutter is closed again, and that really is all there is to it. The picture can be enhanced by

The stresses in three plastic set-squares are shown as coloured patterns when the subject is lit by polarised light and photographed through a second polarising filter. The effect is known as birefringence.

A slightly surreal effect is produced by 'painting with light'. The camera was set on a tripod and the shutter opened on 'B' with the lens set at f/4. The tree was illuminated by a normal flashgun fired from one side and the lines of light were made by moving a torch around the area with coloured filters over its beam.

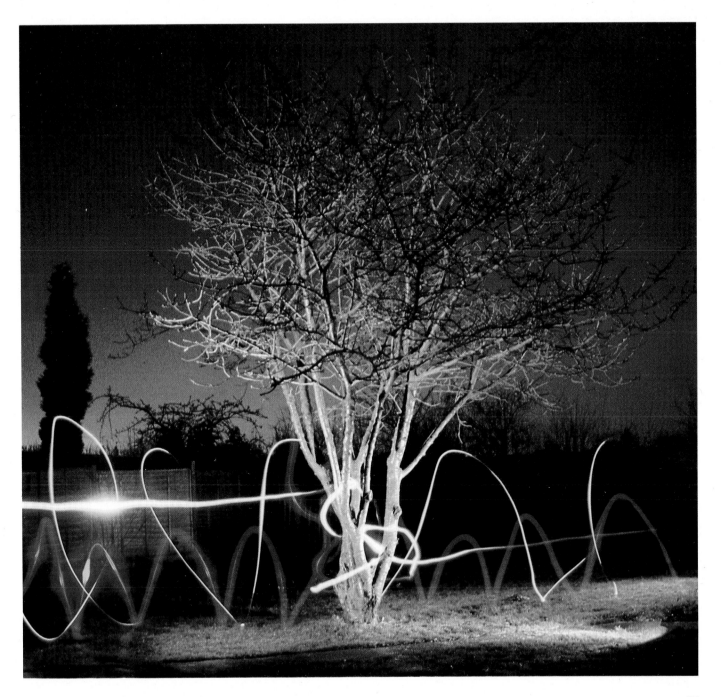

perhaps making multiple exposures, capturing several streaks on one frame. The photograph will also look better if the lightning streak isn't the *only* thing in the picture. A hillside overlooking a town or city would make an impressive location for shooting lightning. That way, the shutter could be opened as normal to record the flash, but left open long enough also to record the lights of the buildings on the same frame. Failing that, a similar picture could be faked once you have some decent lightning shots by double exposing them with other pictures: those city lights taken from a hillside or maybe a straightforward country scene that has been underexposed and taken through a blue filter to give the impression of night. (Techniques for producing double exposures are explained in more detail in the chapter on multiple exposures.)

Moonlight

The only real difference between shooting by sunlight and shooting by moonlight is the length of the exposure. Because the moon is a lot less bright than the sun, exposures are that much longer. Shooting by the light of a full moon on a cloudless night can give a result almost indistinguishable from a daylight shot when using black-and-white film. Even the sky will appear light if the exposure is long enough. On colour, moonlight gives a blue cast that would not be present in sunlight. To take a moonlight picture, first select a suitable subject such as a landscape in which there will be little or no movement during the lengthy exposure. If you want to focus on anything but infinity, use a small torch beside your subject and focus on that. Set the camera on a firm tripod and open the shutter for the required length of time. Exposures will be minutes rather than seconds and, as always, a certain amount of experimentation will produce the best results. As a guideline, make a start with an equivalent of 25 minutes at f/5.6 on ISO 100/21° film, shooting at full moon.

Don't try to include the moon itself in the picture because its movement across the sky during the exposure will record only as an oblong blur. If you want it to appear realistically in the final picture, expose to keep the sky dark and then, when you have your first exposure, make a second on the same frame to expose the moon in an appropriate area of sky. Switching to a lens with a longer focal length will give a bigger image to the moon, making it actually look more natural in the final photograph, since a standard 50 mm lens will give an image size on a 35 mm format of no more than 0.5 mm. A lens of 300 mm will give an image size of around 3 mm, making the picture look far more dramatic. An average exposure for recording a full moon with no other detail around it is $\frac{1}{60}$ second at f/5.6 on ISO 100/21° film.

Fluorescent lighting

Tungsten-balanced film is balanced for tungsten light, daylight-balanced film is balanced for daylight, but no film is balanced for fluorescent light. Only filters will correct the colour balance of this light for a true rendering. But when did the special-effect photographer look for a true rendering of anything? It's for that very reason that fluorescent light can make another example of an unusual light source. Use it much the same way as you would normal lighting, but shoot subjects that will be enhanced by the cast so produced. Fluorescent light gives a blue cast to film which is balanced for tungsten, not unlike the effect of using that film in daylight; the same light gives an eerie green cast to pictures shot with daylight-balanced film. Exposures are measured in the normal way.

Unusual flash lighting

The biggest difference between flash and any other type of light is its duration. It is, quite simply, the fastest form of light available to the photographer. And here lies its first use for anything other than straightforward pictures. Used as the only light source, a flashgun will freeze action, showing moments in time that might never otherwise be seen with the naked eye. A balloon full of water bursting, a light bulb shattering, droplets of water frozen as they hit a flat surface, even maybe a bullet passing through some object. This latter example

Surprisingly perhaps, this picture was not taken during the hours of daylight. The exposure on a snow-covered garden was 15 minutes at f/5.6 on ISO 400/27° film; the only light was from a full moon.

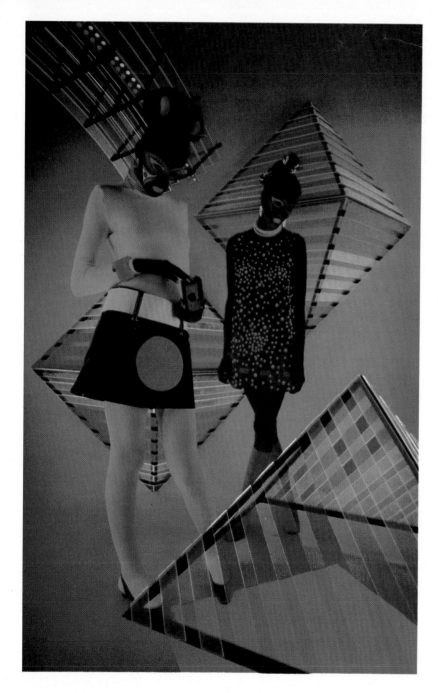

When ultra-violet light strikes certain subjects they seem to glow from within. The glow (as opposed to the actual UV light) can be captured on colour film as it was in this shot for the Kodak 1980 Centenary Calendar. *Andreas Heumann.*

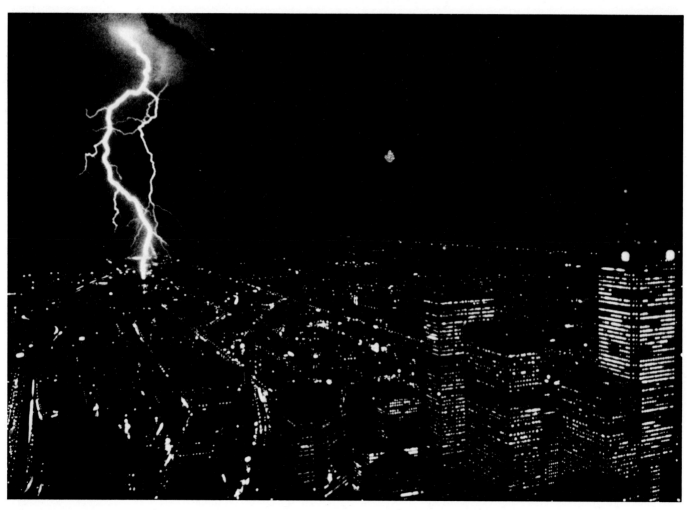

Lightning over a city,
captured during a 4 second
exposure at *f*/16. *Duncan
Bulmer*.

A ringflash is a special type of flashgun whose tube encircles the camera lens.

High-speed flash can record moments otherwise invisible to the human eye. This sequence of pictures shows what happens when an ordinary drop of milk falls from a height into a saucer of milk. Contrary to what might at first be believed, the picture needed no specialist equipment. An ordinary flashgun was set up at 45 degrees to, and about 50 cm from, the subject. With the gun on auto, the closeness ensured an extra-fast flash. The milk was dropped from an eye-dropper about 1 metre above the surface and, as the drop left the tube, the shutter was pressed, the photographer relying on his own reactions to capture the shot.

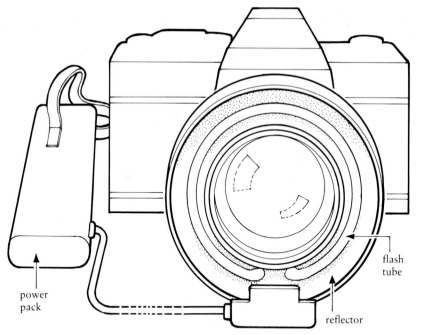

power pack

flash tube

reflector

would, of course, need certain specialised equipment unavailable to the average photographer, but it is often surprising just what effects can be produced with nothing more than a straightforward flashgun. Such a gun will have a flash duration of less than $1/1000$ second. An automatic gun that quenches its beam as the flash-to-subject distance decreases might, at its closest distance, give out a light whose duration is no more than $1/50000$ second. When the flash is the only light source used, that, in effect, is your shutter speed.

With some subjects, you can rely on your own reactions to press the shutter and so fire the flash at the right moment for capturing the action. Indeed, it is surprising how much you can achieve in this way. But when reactions simply are not fast enough, it is relatively easy to fix up some sort of device to fire the flash for you at exactly the right moment. Let's say, for instance, that you want to photograph the effect of a light bulb shattering

when shot with an airgun. Take a flash extension cable and remove the plug from the end which normally fits into the camera's synch socket. Bare the wires and tape them to the light bulb as close as possible without actually touching. They must be so close that the slightest movement of the bulb will cause them to touch. Fit the flash to the other end of the lead in the normal way and position it at a suitable angle to light the subject. Switch on the flashgun and test the set-up by tapping the light bulb with your finger. The movement should cause the wires to touch and so fire the flashgun. Put the camera on a tripod, focus and set the aperture required for the flash-to-subject distance or, if you are using an auto gun, set the right aperture for the film in use. Switch the camera's shutter-speed dial to B. Darken the room, but leave enough light to see your subject. Open the camera's shutter, fire the airgun at the bulb and close the shutter again. As the pellet hit the bulb and shattered it, the flashgun should have been fired, and the effect of the exploding bulb will have been recorded on film.

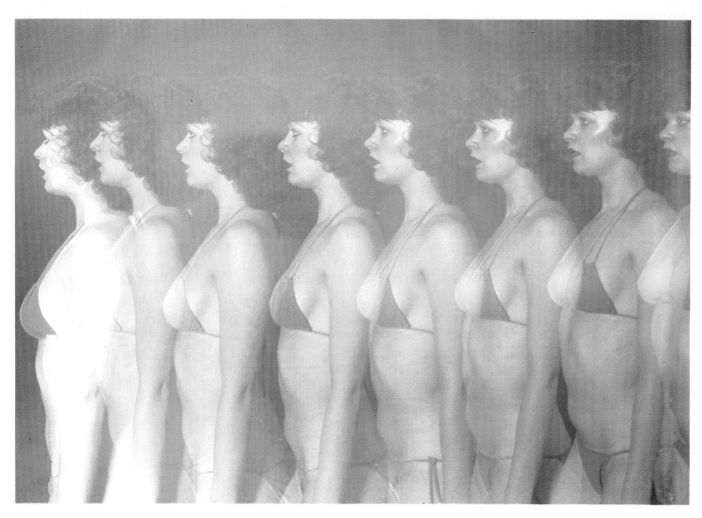

The model for this shot
moved across the frame as a
strobe was flashed on her.
The camera was set for a
shutter speed of 1 second,
allowing her to record at a
different place in the frame
each time the flash fired.

Snapshooters with built-in
flashguns try to avoid
red-eye; but the effect can
be accentuated for its own
effect, as in this shot, by use
of a ringflash.

Synchro-sunlight is the art of balancing flash with natural light outdoors. But used out of balance, it again gives an unusual lighting effect of interest to the special-effect photographer. For correct rendition of the background, here, an exposure of 1/60 second at $f/11$ was needed. Instead, the aperture was set at $f/22$ and the flash-to-subject distance adjusted to make this the correct exposure for the face.

Once you have tried the idea a few times, you will begin to see how positioning the wires different distances apart will cause the flash to fire at different times, thus getting a varied range of effects on film. The technique can, of course, be used on all sorts of subjects as they break up, and methods other than airguns can equally be used to shatter the subject.

Another way to use a flashgun for unusual lighting is to take the theory of fill-in flash and use it with the two light sources out of balance. We have already seen how fill-in flash is used (in the chapter on filters). For this effect, you make the same calculations but, instead of exactly balancing the flash with the background light, you underexpose the background, while using the flash to expose the subject correctly. The result is a picture in which your subject seems to glow against a mysteriously dark landscape. Here's the technique. Take an exposure reading for the background, using $1/60$ second or less as your shutter speed if you are using a camera with a focal-plane shutter. Say this reading is $1/60$ second at $f/8$. Set your camera to an exposure of $1/60$ at $f/16$ so that the background will now be two stops underexposed, but position your flashgun so that it is at the correct flash-to-subject distance for $f/16$. (Switch to manual and divide 16 into the guide number for the correct distance.)

Flash can also be used in the studio to give a person weird, monster-like red eyes. All that's needed is to position the flashgun as close as possible to the lens and ask your subject to look directly at the camera as the picture is taken. The flash hits the red retina at the back of the eyes and, with the flash on practically the same axis as the lens, this red is reflected back straight out of the pupils to record on film. One way of achieving this red-eyed effect is to put a flashgun in the hot-shoe of the camera, usually close enough to the lens for the effect to work. A better way is to use a ring flash. This is a special type of flashgun whose tube is in the shape of a ring that screws into the filter thread and so surrounds the lens.

Strobe lighting is another specialised form of flash that can give very different pictures. Unlike a straightforward flashgun, a strobe flashes continuouly at varying speeds. Used to photograph a moving subject, it will produce a different image with every beat of the flash on the same frame of film for as long as the shutter is open. It can, for instance, be used to photograph a golfer swinging at a ball, showing his arms and the club in perhaps twenty different positions between the start and finish of the movement, depending again on how many flashes per second the strobe has been set for. Pictures are taken in the dark with the shutter open and with the various flashes of the strobe used for each separate exposure. At one time, a strobe was considered a scientific tool and was consequently difficult for the average photographer to come by. These days, they are used in the theatre and in discos and can be hired from theatrical suppliers. Also, some of the latest studio flash outfits feature a built-in strobe function. Alternatively, if you know someone who works in a garage, you might be able to borrow a strobe light that mechanics use for wheel balancing. Its light output will not be as strong as the real thing, but it will be quite adequate for photographing small objects with a short flash-to-subject distance.

Distortion and reflection

In this chapter, we will examine the many different types of distortion. And, because some techniques involve reflecting the subject in various materials, we are also going to look at reflections; not just as a means of distorting the shape of an image, but also as a means of distorting the truth with multiple images and the combination of two separate pictures in one shot.

Distortion by transmission
In normal, straightforward photography, when there is nothing but air between the subject and the camera, light rays travel in a straight line from the subject to the lens. If a transparent but irregular-shaped object is placed between the subject and the lens, those rays will be 'bent' so that they leave one side of the object, still travelling straight, but in a different direction from that at which they entered. This 'bending' of light is known as refraction. It follows, then, that if something such as a piece of patterned glass, made up from many different segments all facing in slightly different directions, is placed between the subject and the camera, the light rays will be refracted at as many angles as there are segments, reaching the lens at the wrong points for accurate rendition of the image. The picture therefore appears distorted.

Patterned glass, in fact, makes an excellent starting-point for experiments in distortion. Place a subject such as a vase of flowers behind a sheet with the camera on the opposite side, then move the subject back and forth until a suitable degree of distortion becomes apparent from the camera angle. The further you move the subject from the glass, the more distorted it will appear. A different way of using patterned glass is to lay it flat on a print and copy the picture through the glass. Similarly, a transparency can be taped to one side,

lit from the rear and the effect photographed from the other. There are many different types of patterned glass and also different sizes of pattern. A visit to your local glass dealer will provide you with plenty of ideas and enable you to buy small squares for experimentation. Other objects worth experimenting with include glass bottles and jars, photographing through both the sides and the thicker bottoms; lenses like the condensers found in many enlargers and crystal balls, both of which will spread the image to give a wide-angle effect; cut-glass, which breaks the image up into hundreds of smaller images; and, on a slightly different tack, through the heated air rising from a fire. This has the effect of 'bending' light rays to give anything beyond a wavy, mirage-like appearance.

In general, the closer the camera is to the distorting medium, the further the subject must be from the opposite side. A large piece of patterned glass, for

Page 68: a two-way, semi-silvered mirror combines two images, giving an effect almost indistinguishable from a double exposure. For this picture, the little girl was shot against the dark background of a building in shadow, while the bed of marigolds was at right angles to her. A two-way mirror was held at 45 degrees in front of the camera lens to record both, the use of a small aperture allowing for a large depth of field that covered discrepancies in the two different subject distances.

Page 69: a cylinder of mirror plastic placed around the lens allows the subject to record normally in the centre of the image, while spreading an array of distorted reflections outwards towards the edges of the frame.

floodlight

patterned glass

Photographing through patterned glass to distort the subject.

Top right: an ordinary drinking tumbler held in front of the camera lens distorts an otherwise traditional landscape.

Bottom right: reflections in rippled water give a degree of distortion, made more interesting by inverting the original picture.

instance, could be positioned about two metres from the camera with the object as close as 30 cm on the other side. With a small object like a jar or bottle used as the distorting medium, the camera might need to be positioned close to one side, so the best degree of distortion in that case would be at an infinity-based subject such as a landscape.

Distortion by reflection

Much of the theory mentioned above applies equally to subjects which have been distorted by reflection. The range of objects available for causing the distortion is, however, much larger, since you are not restricted to transparent substances. Anything with a glossy surface capable of reflecting an image will work. Before mentioning actual samples of reflective material and the pictures they produce, it might be worthwhile looking briefly at a couple of the laws of reflection. Understanding them will help you make more of any pictures that involves reflected images.

The first thing you should know is that the angle of incidence always equals the angle of reflection. In simple terms, that means that the angle at which light hits a reflective surface (angle of incidence) is the same as the angle at which it is bounced away again (angle of reflection). If you want proof of that theory, do no more than stand in front of a mirror and look at the reflection. Standing directly in front, you will see a reflection of yourself. That's because the angle of light that is leaving your face is hitting the mirror at 90 degrees and coming straight back at the same angle. Now move to the left of the mirror and look into it at an angle of, say, 45 degrees. The reflection you now see is not of yourself, but of objects at 45 degrees to the right of the mirror.

Now move back in front of the mirror again, this time with a reflex or rangefinder camera at the ready. Put the camera to your eye and focus on your own image. When you come to look at the focusing scale you will find that you have actually adjusted the focus, not to the distance between

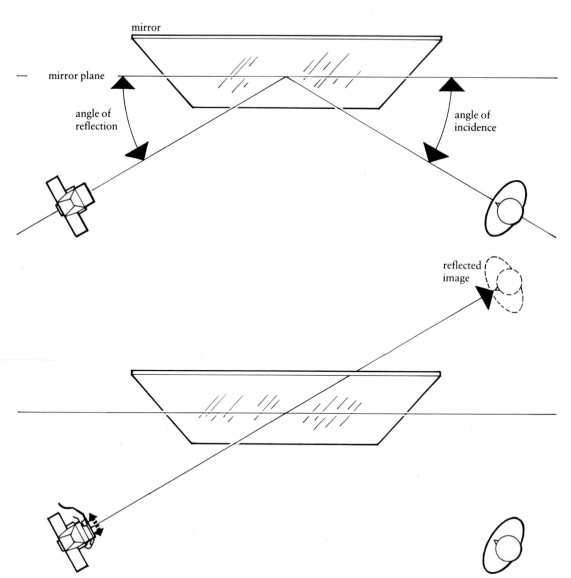

reflected
image

When photographing in a
mirror, the angle of
incidence always equals the
angle of reflection.

mirror

mirror plane

angle of
reflection

angle of
incidence

A reflection is as far behind
the mirror as its subject is in
front, a fact that must be
allowed for when focusing.

reflected
image

yourself and the mirror, but to *twice* the distance. And that illustrates another law of reflection: the reflected image of an object is as far behind the mirror as the object is in front. Armed with these two pieces of information, you can now begin looking for suitable surfaces in which to photograph distorted reflections. If the surface has a regular curve, such as might be found in the hub-cap of a car, the reflection will be distorted but in a predictable sort of way. It will probably give an effect similar to using an ultra wide-angle or fisheye lens. If the surface has a more irregular distortion to it, then the image will have similar irregularities, appearing to be more broken up.

One of the most useful accessories for the photographer out to produce distortion by reflection is a length of mirror plastic. This is highly reflective plastic sheeting that can be bought by the metre in standard widths. Held straight or stuck down to a flat surface, it acts like a normal mirror. But it can also be bent and moulded to practically any shape desired and even the smallest divergence from a flat surface will begin to make interesting images. More about the uses of mirror plastic later. Water is another natural medium for this type of photography. A calm lake or a river will mirror the scenery around it exactly. But ripple the surface with a stick and the image breaks up, turning the reflected image into a series of wavy lines. Alternatively, a stone thrown into the centre of the reflection produces circular ripples that gradually spread out from the point where the stone enters the water. That will give another shape to your distorted image.

Reflective surfaces don't necessarily have to be bright. Black glossy plastic can also reflect an image to a fairly high degree, and it is easy to mould for any desired effect. Distorting mirrors in fairgrounds are also a natural medium. Other useful surfaces include flexible metal sheets, metal pots and jugs, cooking foil, a magnifying shaving mirror, puddles, curved windows, or indeed anything that will reflect an image and which is any shape but flat.

Choose your subjects to match the type of distortion you are after and remember the two laws of reflection that will help you take better pictures: place the subject to be photographed at an angle to the mirror, and position yourself at an equal angle on the other side; always focus on the reflections, not on the mirror itself.

Distortion through a slit shutter
When we come to look at panoramic pictures, we will see that there are cameras designed to revolve in a complete circle and to use a slit shutter, otherwise known as a linear shutter, to 'spray' an image on to moving film. Such cameras are very expensive, but there is a way to adapt a normal camera to produce similar results. In this case, the slit shutter is placed in front of the lens. Accessories are available commercially that take the form of a vertical gap of around 1 mm across in a piece of thin plastic, designed to fit into one of the recognised makes of filter holder. Alternatively, a similar device can be made from thin, opaque card fixed to the front of a lens hood, a clear filter such as a UV, or even by cutting a slit in a lens cap. Or two pieces of thin metal foil can be carefully taped across the film plane, leaving a suitably-sized slit between them.

To make an exposure, the film is first wound all the way through the camera, the shutter being fired with the lens cap (not the one with the slit in it!) in place so that the film remains completely unexposed. With the camera preferably mounted on a tripod and the slit shutter in position, the camera's normal shutter is then opened on B and the exposure made by winding the film back again by way of the rewind mechanism. The faster the film is wound, the faster the effective shutter speed. Exposure is a matter of trial and error and it is a good idea to practise the technique with a standard aperture and several different speeds of wind before attempting the picture proper.

Using this technique for some of the effects mentioned above, it is often necessary to make

some attempt at synchronising the movement of the subject or camera with the speed of the film movement. The whole point of *this* variation on the technique is to shoot the two out of synchronisation. The film must still move at the correct speed for the appropriate exposure, but if the subject is moving at a different speed, its image will appear distorted. Traffic on a busy road or runners on a race track, moving across the frame, make suitable subjects. Anything in the picture area that moves at the same speed as the film will record normally against a blurred background, but objects moving at a different speed will appear stretched and curved like rubber. A runner might appear with long, spidery arms and legs that stretch right across the elongated frame. Alternatively, some subjects might be equally distorted but take up only a small part of the overall image area. They can be cut out as standard 24 × 36 mm frames and enlarged or projected as normal.

Distortion through camera movements

In a conventional 35 mm or rollfilm camera, the lens panel and film path are fixed so that the lens is parallel with, and central to, the film. A ray of light travelling through the centre of the lens should meet the exact centre of the film. But with certain more specialised cameras, the lens panel and the back can be moved in different directions for adding various effects to the picture. These are technical cameras and the most versatile is known as a monorail camera, the name derived from the fact that it is built on a rail, along which the front and back panels, joined by bellows, slide for focusing. There are four basic movements through which the lens panel and the camera back can move to produce their various distortions:

1 Swing. This is movement of either panel about a central axis, either to the left or to the right. Swinging the back alters the shape of the image; swinging the front alters the focus.

2 Tilt. A similar movement to swing, but this time, instead of the panels moving left or right,

horizontally, they swing vertically about a central axis at right angles to the previous one. Shape and focus of the image are again affected.

3 Shift. With this movement, both lens and back panel remain parallel, but are slid either to the left or to the right. There is no distortion in the image, but the subject is shifted left or right in the frame relative to other objects in front and behind.

4 Rise and fall. A similar change in the image takes place here, but in a different direction. This time the subject can be shifted up or down in the frame without distortion. The movement is most often used for including the tops of tall buildings that could not otherwise be accommodated without tilting the camera, an exercise which would inevitably cause verticals to converge.

If that all sounds a little complicated, take a look at the accompanying diagrams, which show the camera movements and the results they give. You will soon see that, although the movements are designed for *correcting* images that might otherwise appear distorted in the final picture, they can also be used for inducing distortion for its own sake. And, of course, any or all of the four basic movements can be combined. Camera movements can also be used to alter the image for the convenience of composition, without the distortion being readily apparent in the final picture. For example, supposing you are photographing a beautiful landscape which, for the sake of composition, must be taken from one specific point. And suppose, from that very viewpoint, there is a view of some obstruction such as a huge rock to the left of the picture that is ruining the scene. The camera can of course be moved to the right, so that the rock is now out of the picture area. But from this new position, the composition of the landscape might be wrong. That can be corrected by shifting the lens panel left and the back panel right. The result is a view of the landscape as it would have been from the original position, but with the rock missing.

The movements of a technical camera are designed to correct distortion but, by the same token, some can be used to induce it too.

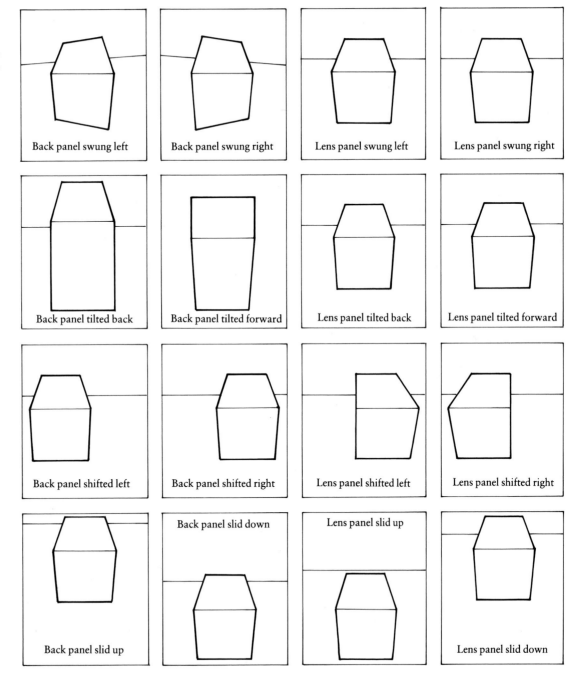

Back panel swung left

Back panel swung right

Lens panel swung left

Lens panel swung right

Back panel tilted back

Back panel tilted forward

Lens panel tilted back

Lens panel tilted forward

Back panel shifted left

Back panel shifted right

Lens panel shifted left

Lens panel shifted right

Back panel slid up

Back panel slid down

Lens panel slid up

Lens panel slid down

Lenses for distortion

A lot of special-effect photography is the result of using standard equipment in what would normally be considered to be the wrong way. The way you use lenses for deliberate distortion is no exception. Many different types are made for specific jobs. But use them for a different purpose and you enter the world of special effects.

One of the most popular lenses after the standard 50 mm on a 35 mm camera is the wide-angle. They start at around 35 mm, go to 28 mm and then get *really* wide-angle with focal lengths like 20 mm, 15 mm and even 8 mm or 6 mm, although, by the time you reach these latter focal lengths, you are more into the realms of the fisheye lens. Wide-angle lenses are designed for covering a wider angle of view than a standard. For normal results, they should be focused on middle-distance to infinity-based subjects. But use them for close-ups and the image becomes distorted. You can start with an average wide-angle lens, with a focal length of around 28 mm. Try a picture of a person side-on to the camera, a hand outstretched towards you. The hand nearest the lens looks gigantic compared with the one further away. Close-ups of faces become grotesque caricatures of the subject's real features. And the wider the lens, the greater the distortion.

When you get to the wider angles of around 15–16 mm, there are two different types of distortion, depending on whether you are using a rectilinear lens or a fisheye. A rectilinear lens is one which has been corrected so that straight lines in the subject appear straight in the picture. The distortion produced from such a lens will be only from perspective changing as the camera moves closer to the subject. A fisheye lens makes no attempt at correcting the image. Objects at the centre of the frame record as much larger than those at the sides, and straight lines therefore appear curved, to such an extent that, with the widest fisheyes, the entire image appears as a circle in the middle of the frame. Sometimes the degree of distortion presented by these lenses can be made to look even weirder by enlarging only a part of the image, preferably that towards the edge of the picture area where distortion is at its greatest. For the special-effect photographer who wants distortion, therefore, a fisheye lens is a better bet than a rectilinear lens. The drawback of fisheyes is their expense, but for a cheaper way of producing the same effect (though admittedly, without a similar quality), fisheye attachments can be purchased which screw into the front element of a standard or average wide-angle lens. These, and do-it-yourself attachments for similar effects, were covered in the chapter on special lenses.

Another lens that can be pressed into service for controlled distortion is the anamorphic. As we have already seen (see chapters on special lenses and panoramic pictures), this lens is designed to compress its image in one plane, while allowing it to remain normal in another. For purposes of distortion, it can be used in its normal way and then the result enlarged or projected without any form of correction. That will show the image squashed laterally. Turned at 90 degrees, the image becomes squashed vertically. But perhaps the most interesting form of distortion produced by this lens is when it is turned at an angle between the two. The image then takes on a 'drunken' look, with horizontal and vertical lines sloping at crazy angles that are particularly apparent in pictures of buildings which the viewer knows should really be straight.

Distortion through texture screens

Texture screens are most often used in the darkroom, but they can also be used in the camera for distortion of a kind. The technique involves taping a screen across the film plane in the back of the camera, then loading the film as normal and shooting pictures *through* the screen, allowing extra exposure because of the reduction in light so caused. The image is be recorded in the parts of the screen that are clear and the texture pattern itself is recorded in black, overlaying the image.

An anamorphic lens, normally used for making panoramic pictures, can also be used to distort the image. The top picture shows the image squeezed laterally, the way it would be when used for the lens' normal purpose. For the centre picture, the lens has been turned through 90 degrees to squeeze the image vertically. The picture below was taken with the lens at 45 degrees between the two previous positions.

Mirror plastic

The second part of this chapter is about a different type of distortion, one that uses mirrors and mirror-like objects both to distort and to combine two or more different images in one picture. One useful accessory for this latter technique is a length of mirror plastic, mentioned briefly in the section on distortion by reflection. But here, rather than moulding it, we are using it first as a straightforward mirror, laying it flat or sticking it to card. That way it can be used for simply doubling an image, standing the subject on a piece of the material or beside it. With enough, you can even lay a model full-length on the plastic. Or a subject can be placed behind a horizontal length of the material at waist-height and both the subject and the image photographed to give a two-headed figure similar to the illustration on playing cards.

With the length of mirror plastic rolled into a cylinder, a completely different effect can be obtained. With the cylinder made to the right diameter, it can be slipped over the camera lens and taped into position for a tight fit. Use it that way to take medium close-ups of subjects like flowers. The flower itself will then appear in the centre of the frame with an array of colours around it from the distorted and out-of-focus reflections along the length of the cylinder. Alternatively, the plastic can be made into a cone. With some object introduced at the smaller end, pictures can be taken at the mouth, to show a different pattern of distorted reflections emanating from the central subject.

Two-way mirrors

A semi-silvered mirror is one that has been coated so as to reflect a certain percentage of the light reaching it as normal, while allowing the rest to pass straight through. It can be used in front projection (chapter on projectors) but, used on its own, it can be the starting point for a lot more special effects. Using a semi-silvered or two-way mirror, two images can be combined if they are positioned and lit in the right way. Say we are out to combine a flower with a face. The mirror is first

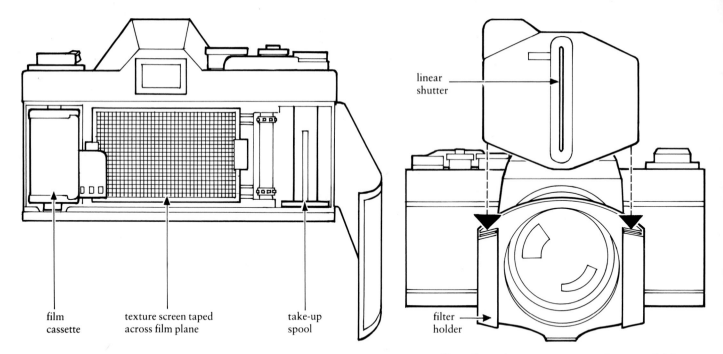

film
cassette

texture screen taped
across film plane

take-up
spool

linear
shutter

filter
holder

positioned at 45 degrees to the camera and the flower placed at 90 degrees. Its image is now reflected by the mirror into the camera lens. But the lens is also looking *through* the mirror so that the face can now be positioned in the normal way and the two adjusted until the camera is seeing both in the same place. That's the theory. In practice, there are a few extra tips that will help you make a better picture out of this particular example.

Place the flower in front of a black background so that *only* the flower is reflected and therefore combined with the face. Light the two subjects so that the flower falls into a dark area of the face for maximum impact. Make sure the subject-to-lens distance is the same for both subjects, otherwise one will be out of focus. In the case of the flower, that distance is equal to the subject-to-mirror distance, plus the mirror-to-lens distance. Outside, a similar set-up can be used for making what appears to be ghosts, shooting perhaps a landscape *through* the mirror with a person against a dark

Above left and below: a texture screen is taped into the film plane and the picture shot through it, once again distorting the truth.

Above: linear shutters can be inside or outside the camera. This example is made by a filter

manufacturer and slides into their holder attached to the lens.

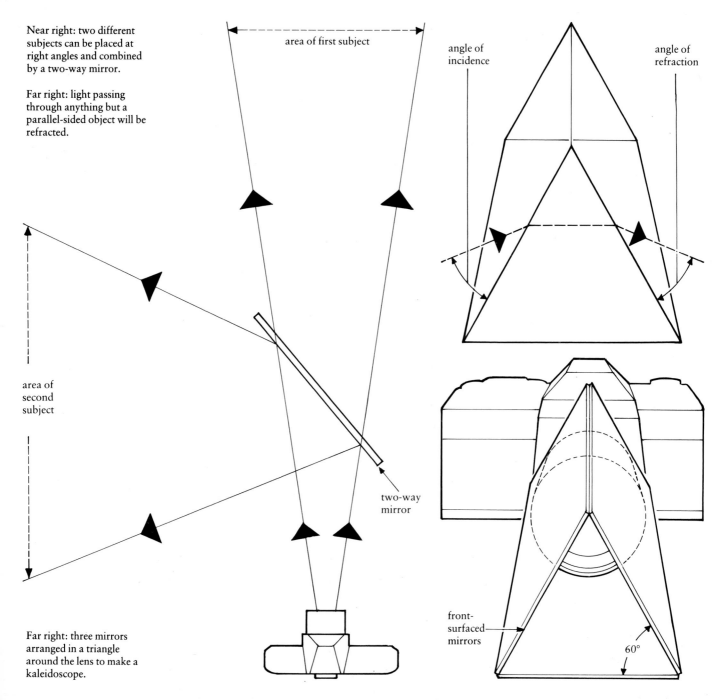

Near right: two different subjects can be placed at right angles and combined by a two-way mirror.

Far right: light passing through anything but a parallel-sided object will be refracted.

area of first subject

angle of incidence

angle of refraction

area of second subject

two-way mirror

Far right: three mirrors arranged in a triangle around the lens to make a kaleidoscope.

front-surfaced mirrors

60°

background *reflected* in the mirror. It can also be used with the mirror angled towards the sky to reflect clouds on to part of a landscape, giving the appearance of early-morning mist where none was originally present.

Using a semi-silvered mirror is the luxury way of capturing images like this. But the effect can be made to work almost as well with a sheet of plain glass. A ready-made subject on which to try that theory is a tailor's dummy in a shop window. Positioning yourself correctly, you will find that you can shoot not only the dummy but also the reflection of the street, or perhaps the sky. With shop-window dummies looking so lifelike these days, you can build up a whole set of pictures like this, apparently showing 'people' in surreal surroundings. For the effect to work best, though, some attempt should be made to match lighting on both the subjects. You can do this with your own choice of subject and a sheet of plain glass.

Once again, an example will make things clear. Let's say, you are out to combine a face with a sunset. Point your camera towards the sunset and take a reading. Set that on your camera and then place your sheet of plain glass at an angle in front of the lens. Now place your model so that his or her face is reflected in the glass in the place you require for the shot. Because your subject is a lot less bright than the sunset, you will only just about be able to see the reflection. To make the effect work, therefore, you have to light the subject with the same intensity as the sunset, and you can do that with a small flashgun, aimed at the subject's face at the correct distance for the aperture you have already set for the sunset. Work that out in the normal way: flash-to-subject distance equals guide number divided by the aperture in use. In practice, however, that might not give enough light, given that guide numbers are normally calculated for average-sized rooms, taking into account reflection from walls and ceilings. Outside, there are no such reflections, although there *is* a certain amount of ambient light on your subject that wouldn't be

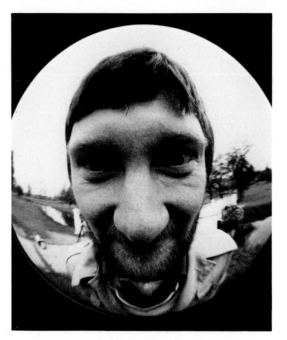

A fisheye lens, used in ultra close-up distorts the image grotesquely.

A fresnel lens, held in front of the model's face, enlarges her features and introduces yet another form of distortion.

present indoors. Depending on how strong this ambient light is, it might cancel out the inadequacies of the guide number. In any case, it is best to bracket, not by exposure on the camera, but by using different flash-to-subject distances. Start at what would be correct for the guide number in use, then halve and double the distance dictated. The flashgun must naturally be used on an extension cable, rather than in the hot shoe.

The size of the sheet of glass used is worth considering for this type of photography. If you don't want its edges to appear in the picture area, giving away the secret of how the effect was produced, then it must be as large as possible. The larger the glass, the further you will be able to place it from the camera. Alternatively, a sheet of perhaps around 1 metre square could be placed so that its presence *is* obvious, thus lending an even more unusual look to the picture.

Kaleidoscopes

Most people are familiar with a toy kaleidoscope, a small cylinder of cardboard with a hole in one end, through which the user can see an ever-changing series of perfectly symmetrical patterns. The shapes are, in fact, made by chips of glass or plastic lying along one side of the tube, the pattern they fall into being multiplied by a very simple system of mirrors. You will not be surprised to learn that a similar system can be made to multiply a photographic image. All it needs is three mirrors that together will make up a triangle to fit snugly over your camera lens. The way to find the size of the mirrors is as follows. If your camera lens is interchangeable, take it off and place it on a sheet of drawing paper, front element down. Draw a circle around its circumference. Now draw three lines of equal length, each touching the circle and each meeting the other two at an angle of 60 degrees. The length of each line is the size of mirror needed to fit the lens.

Use glass mirrors of that size, or cut mirror plastic and stick it flat on thick card, then tape the three together so that their reflective surfaces are on the inside of the triangle so formed. Fit that over the lens and take pictures. The resultant photographs will show your chosen subject in the centre, surrounded by duplicate images at different angles. The more mirrors you use, the more images are produced. It is worth bearing in mind that when you come to find suitable mirrors for making kaleidoscope attachments, it is best to use the front-silvered type. A back-silvered mirror might give ghost images from both the reflective silver and the front of the glass. On the other hand, if pure pattern shots are what you are after, these ghost images might enhance the effect.

Broken mirrors

One final way of producing distorted multiple images by reflection is to photograph the subject in a broken mirror. To get the best effect, the mirror should first be stuck with a strong adhesive to thick paper or, better, to a square of cloth. The safest way to break it is to cover it with another cloth and tap it lightly all over with a small hammer. With the top cloth removed, a series of broken segments will be revealed which, because they are stuck down at the back, will be pliable, enabling you to contort the mirror, watching the way the reflection breaks up until you have exactly the degree of distortion you require. Use of wide apertures to reduce depth of field will mean that the camera can be focused on the reflection, while the jagged edges of the mirror itself will fall out of focus and so blur and merge to make the effect more bizarre.

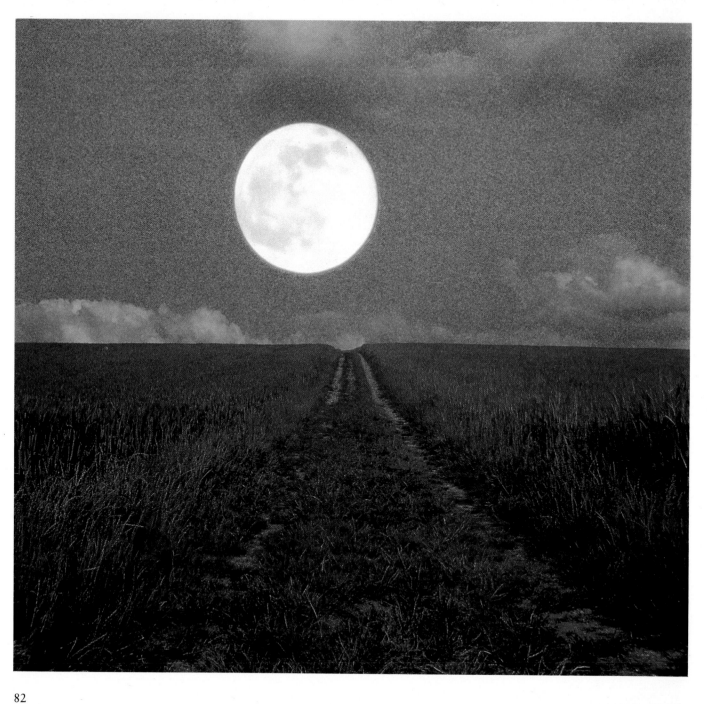

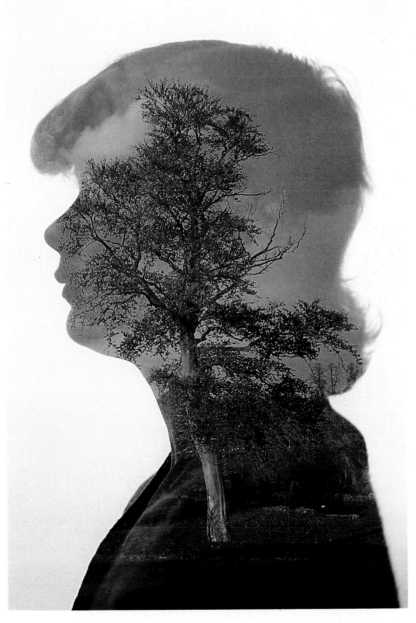

Multiple exposures

A straightforward photograph shows only one image of its subject. The appearance of two or more images on the same print, negative or transparency is, more often than not, due to a mistake on the part of the photographer or the result of a faulty camera. Used with a little thought, however, such 'mistakes' can often form the basis of interesting special-effect pictures. While certain items of specialist equipment, such as studio cameras, professional copiers and masks, are a distinct advantage to the photographer attempting multiple exposures, they are by no means a necessity. The majority of cameras can be used, once you learn a few basic techniques, and most of the accessories needed can easily be made from readily-available materials.

Cameras for multiple exposures
The most suitable camera for the job is one whose shutter can be tripped any number of times without having to wind on the film, and which uses some form of ground-glass screen for viewing, on which the position of various objects in the picture area can be marked. Top of the list for a camera that fulfils those criteria is the studio or monorail model. Such cameras ignore the fripperies more often associated with smaller models: there is no built-in metering or delayed action control for instance. And, more important for this type of photography, there is no double-exposure prevention device. They take cut film in a variety of sizes or rollfilm backs, feature bellows that allow close focusing without the need for any other accessory (useful for certain types of multiple exposure we shall be discussing later) and use a ground-glass screen directly opposite the lens for composing the picture.

Next comes the rollfilm reflex. The vast majority of these have interchangeable viewfinders that, when

removed, allow access to the ground-glass screen (convenient); some feature interchangeable backs (useful); and most include a facility for overriding the double-exposure prevention device (essential). 35 mm single-lens reflexes, on the whole, are less convenient. Some professional models have interchangeable viewfinders offering the same convenience as their rollfilm counterparts; many feature multiple exposure facilities; a good percentage, however, have neither. Which isn't to say that they can't be used for making multiple exposures. All it needs is a little ingenuity.

The problem of an inaccessible focusing screen can be overcome if the camera has an interchangeable screen facility. Even if it hasn't, it is often possible to have a special screen fitted by the manufacturers. Either way, a plain, ground-glass screen divided into squares is the most suitable. With that in place, a similar but larger grid can be drawn on a piece of graph paper, on which the relevant positions of objects seen through the viewfinder can be marked. If it is completely out of the question to change screens, then the position of the objects must be noted on a slightly more trial and error basis. Precise registration is, of course, impossible; but by using the circles of the rangefinder usually found within the viewfinder as a reference point, a fair degree of accuracy can be achieved.

To override the double-exposure prevention device on a 35 mm camera without a multi-exposure switch, the following procedure must be followed. First, use the rewind knob to take up any slack present in the cassette. Without touching the rewind *button*, usually found on the baseplate, turn the rewind *knob* gently in the direction required for rewinding the film until it comes to a stop. Now press in the rewind button. This will free the film transport mechanism in exactly the same way as when the film is being wound back into the cassette. Finally, keeping your thumb on the rewind knob to prevent the slightest movement of your film, turn the lever wind through the full throw of its normal action. This should now have cocked the

shutter while allowing the film to remain stationary and thus ready for a second exposure. The technique can be used for any number of exposures on the same frame.

When the multiple-exposure picture has been made, you will, of course, need to wind the film correctly to its next frame, and here you can run into trouble because the rewind knob on the baseplate, at this point, could still be depressed. Although it should pop out as soon as the lever wind is operated in its normal way, it might, in practice, stay in for part of the sweep. If that's the case, the film may not be advanced a full frame and the multiple exposure over which you have taken so much trouble will be ruined by yet another exposure from part of the following frame. The answer is to make one wind as normal, expose that with the lens cap in place so that no light reaches the film, and then make a second wind before taking the next shot. Since this leaves uneven spaces between frames, it is best to mark any slide film that is being sent away for commercial processing with the instruction 'do not cut'.

Multiple exposures can also be made in a 35 mm SLR by running the film through the camera more than once. Load the film in the normal way, advancing it to the first frame. Take off the lens and set the shutter to B. Press the release and hold it down. With the shutter open and the mirror up, the emulsion of the film's first frame can now be seen from the front. Take a pencil and mark the four sides of the frame directly on to the film. Close the shutter, replace the lens and wind to the next frame. You are now ready to make the first of what will be several exposures on one frame. To make the next exposure, the film must be rewound and reloaded in the normal way, and the pencil-marked square on the emulsion should be lined up in its previous place by using a combination of the lever wind and the rewind knob. As before, the film can be viewed by removing the lens and opening the shutter. This method has the advantage of allowing the photographer to make as many first exposures as

Page 82: the first of the two exposures that made this shot was taken outdoors at the bottom of a gentle slope. It was underexposed by one stop in anticipation of the final effect. The moon was added to the same frame a little later, by use of an inexpensive zoom slide-copier, using tungsten as a light source.

Page 83: here, 35 mm film was loaded into a single-lens reflex and the first frame marked as described in the text. A series of landscapes were shot and then the film rewound. In the studio, the first frame was aligned as before and a second series of exposures made, this time of a silhouette against a white background.

Two exposures on the same frame and a pretty girl becomes a ghost. The first shot was made with the girl sitting on the seat. The second shot was made from exactly the same position but with the girl moved out of the picture area.

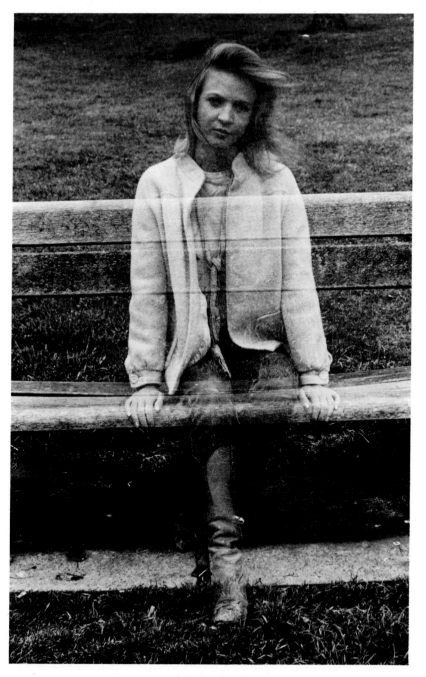

he likes on consecutive frames of film before going on to make a series of second exposures. Different combinations of aperture and shutter speed can then be used on the different frames, allowing bracketing of exposures on the first shot with standard exposures on the second or vice versa. The amount of experimentation and bracketing is limited only by the number of frames available on a single length of film.

Multiple exposures can also be made on 35 mm rangefinder cameras. Without reflex viewing, registration of one image with another is naturally less precise, but double-exposure prevention can be cut out as with a single-lens reflex. It is even possible to make multiple exposures on a Polaroid SX-70 or 600 System camera, in which the developing print is normally ejected from a slot beneath the lens. On the side of the camera, there is a catch which is pressed to open a flap for inserting .or withdrawing the film cartridge. If this catch is flipped in the brief moment between the shutter being pressed and the film being ejected, the flap drops, the electronics of the camera go dead and the print doesn't eject. The flap can then be closed again and a second exposure made. Cameras taking 126 and 110 film are usually unsuitable for multiple-exposure photography, since such models rarely feature a method of overriding the double-exposure prevention device or rewinding the film for subsequent exposures.

Types of multiple exposure

There are two basic forms of multiple exposure. In the first, two or more images are laid over one another so that, in the final picture, various parts of one picture can be seen, ghost-like, through areas of others. The effect is similar to, though not identical with, that obtained from a slide sandwich. (In a sandwich, the darker parts of one image overlay and block out the light parts of the other; in a multiple exposure, the light parts of one image are exposed *through* the dark parts of the other. More about sandwiches in the chapter on montage.) In the second type of multiple exposure, parts of the

picture are masked or lit in such a way as to include areas of unexposed film in the first exposure, and subsequent images are carefully positioned to fall within these areas.

In the former type of picture, exposures must be adjusted according to the number of shots being made on the single frame of film. This is because, as you add each new image, you are effectively adding more light. If each exposure is right for its particular subject, the final picture will naturally be overexposed. The solution is to give less than what would normally be considered the correct exposure for each image that is added to the final composite. If, for instance, two exposures are being made on the frame, each must be half the recommended meter setting; that means closing down one stop on each. If three exposures are being made, the meter reading on each must be divided by three (close down one-and-a-half stops); if four exposures are being made, the reading must be divided by four (close down two stops) and so on, according to the number of exposures involved. In the second type of multiple-exposure picture, each image being recorded in a portion of unexposed film, the overall level of exposure in the complete picture is not affected. Exposures, therefore, are metered and set in the normal way.

The straightforward way of making multiple exposures is to use the camera in its conventional way, shooting each image separately as you position it in the appropriate place in the viewfinder. Another way is to shoot each image separately to make a series of prints or slides and then to copy those on to one master frame in the camera. Equally, the two methods can be mixed, combining straight pictures with subsequent images from slides or prints. If your chosen method involves the use of prints or slides, you will need a method of copying. Depending on the quality of the result you are after, that can be as simple or as sophisticated as you like to make it. Copying stands are available commercially for copying prints. They consist of a vertical support for the camera to

ensure that it stands parallel to the baseboard on which the print is positioned and a couple of lights, either tungsten or flash, placed at 45 degrees on each side to give an even spread of shadowless illumination. Some form of close-up device is needed for the camera which will obviously need to focus closer than its normal closest focusing distance. This can take the form of bellows, extension tubes, close-up lenses or even a macro lens. In the absence of a commercially-made copier, prints may be pinned to a wall and the camera used horizontally on a normal tripod. The trick is to keep the two absolutely parallel and to make sure the lighting is even. Two small hand flashguns placed one each side, again at 45 degrees to the print, work well; or conventional tungsten bulbs in reading lamps can be used. If you have only one lamp or flashgun, try making two exposures, switching the light from one side to the other for each. Remember, though, to halve the meter reading for correct exposure.

The problem with copying is that it inevitably involves an increase in contrast between the original and the copy, something which is only overcome with any success when copying transparencies, and then only by the use of a professional slide copier. This consists of a small light table on which the slide is placed and a support with bellows attachment for the camera. A tungsten light is used beneath the slide to illuminate it for focusing, but the exposure is more often made by flash, a lead from the copier fitting the camera's synch socket. Contrast is controlled by a second flash of variable intensity which is positioned to hit the film at the moment of exposure, resulting in a small degree of fogging and therefore a loss of contrast. If such sophistication is beyond your means, there are smaller, much less expensive, slide copiers that screw or bayonet to the body of a single-lens reflex in place of the lens. With a slide in position, the whole thing is simply pointed at a convenient light source and the shutter pressed. Simpler still, if you have any close-up gear, is to tape the slide to a piece of ground glass, light it

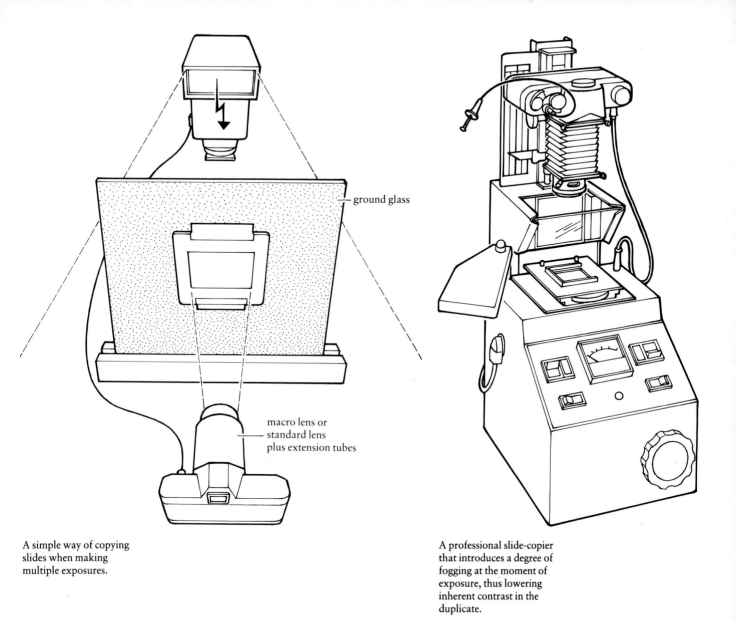

ground glass

macro lens or
standard lens
plus extension tubes

A simple way of copying
slides when making
multiple exposures.

A professional slide-copier
that introduces a degree of
fogging at the moment of
exposure, thus lowering
inherent contrast in the
duplicate.

from behind and line up the camera parallel to the opposite side. Even projectors can be used to project suitable slides on to a screen, from where the various images are photographed with a camera and standard lens.

In each of these latter methods, as well as with the print-copying method mentioned earlier, excessive contrast once again becomes a problem. That can be overcome to some extent at the enlarging stage if you are making your own prints or by use of special low-contrast copying film if you are shooting colour slides (see chapter on unconventional films). Contrast can also be lowered by pre-fogging the film manually to give a similar effect to that obtained from the secondary flash in a professional slide copier. Simply expose the film to an out-of-focus, white surface at a fraction of what would be the correct exposure, then double-expose your actual picture on to this slightly fogged frame. The amount of fogging exposure needed is best found by trial and error, bracketing by half to one stop each side of a set exposure. A good starting point for that is three per cent of the metered exposure on the white surface. That amounts to closing down by five stops. Whatever method you use for making your multiple exposures, the theory of how and why the best results are obtained remains the same. Perhaps the best way of understanding that is to look at some examples.

Subjects for multiple exposures

When shooting for multiple exposures, it is convenient to know the position of various subjects in each picture. If you are using a camera in which the image of the subject is thrown on to a ground-glass screen and the screen is accessible, the glass can be marked with a wax crayon or grease pencil. Afterwards, light polishing with a soft rag will remove the marks. If you have no access to the screen, you must position your various images in relation to reference points in the viewfinder, as mentioned earlier. Here are eight ideas for pictures that can be copied or used as a basis for your own experimentation.

1 In a darkened room and against a black background, pose a model in profile with strong side-lighting so that half the face is in shadow. Take the first exposure. Take a second exposure with the model full-face, posed in the dark area of the first exposure. The result will be the two faces on the same frame. Similar effects can be obtained by making the exposures with the model facing in opposite directions in each shot, so that the backs of the heads in the final picture seem to flow into each other. Or take a series of full-length shots with the model standing in the same position, first upright, then leaning to the left and then leaning to the right. The three different upper halves of the body will appear to be coming from the same pair of legs. Filter each exposure with a different colour to enhance the effect even more.

2 Shoot a 'ghost', by first setting your camera up on a tripod and placing your model in front of a suitable background – a brick wall, trees, or anything that presents a strong image. Take the first shot at half the metered exposure, ask your model to move out of the picture area and take a second shot at the same exposure. The result will be a picture that shows your model appearing to be transparent with the background showing through his or her body.

3 Take a picture of a suitable background such as a dramatic sky and, on the same frame, shoot a studio portrait against a black background. The sky will then record normally in the spaces that were black on the second exposure, but the face will appear combined with the clouds. This effect works best if you dress your model in black, and light the portrait so that part of the face is in shadow. The clouds will then come through stronger in the shadow areas.

4 Find a model with an attractive profile and, marking the start of the film as described earlier, shoot an entire role of your subject's silhouette, posing him or her against a white background in an otherwise darkened room and overexposing by at

The result of a double exposure against a black background. The girl was lit, for each exposure, with a light directly in front of her and just above head-height. While her features were illuminated, her back each time fell into shadow, helping the two images to merge more successfully.

least five stops on the metered reading of the white. Rewind the film, line up the marks at the start again and shoot the rest of the film on landscapes. In the finished picture, the landscape will appear in the shape of your subject's silhouette, the white of the background having washed out the rest of the scene.

5 Shoot a sunrise or sunset over some hills, exposing for the sky so that the foreground records as black. Then, in the studio, shoot another object or a person to fall within this black area. The result will show this last subject posed against the dark hills with the sun rising over them.

6 Shoot two pictures of the same scene, with lenses of different focal lengths, using half the metered exposure reading for each. The result will be a picture in which the two images flow into one another to make an intriguing abstract.

7 If you have two similar cameras with interchangeable backs, set one up focused in close-up on a slide of perhaps fire or water. Set up the second camera aimed at a model against a black background. Take the first exposure on the close-up camera, then switch the back to the second camera and make the second exposure. Your model will then appear combined with the slide. If the slide is masked and the position of that mask marked on the viewfinder to coincide with the model's face, this will result in the effect being further enhanced, giving a clear image of the face, but with the background flowing into the rest of the figure.

8 Take a series of texture screens, normally used for sandwiching with negatives in an enlarger and, having marked the start of the film, copy them onto several frames, using one of the slide-copying devices mentioned earlier. Rewind the film, align the marks and shoot again. The final pictures will show the crazed lines of the texture screens over the various scenes captured by the secondary exposures.

90

Left: a series of copies was made of a texture screen, more normally used for sandwiching with negatives in the enlarger. Later, in the studio, a series of portraits were double-exposed on to the same frames of film.

Two exposures on the same frame and from the same position, each through a different focal length of lens.

Many of these ideas involve combining pictures taken outdoors with others taken in a studio or with pictures lit by artificial light. When shooting in mono, that presents no problem. With colour, the different light sources must be balanced by filtration. (See chapter on filters.)

Using masks

The use of different-shaped masks to block out certain parts of each shot as it is taken can give a completely different look to multiple-exposure pictures. Commercially-made masks are available in set shapes, often as part of a filter system; they can also be tailor-made by the photographer from thin, opaque card to suit exactly the right purpose for a specific picture. One of the most common forms of mask is that which blocks exactly half the frame of film. In the commercial sets, this usually consists of a slat of plastic that slides half-way into a filter holder for the first exposure and then, for the second, can be removed and slid in again from the opposite side to meet exactly the same point. Alternatively, small trapdoors of card can be made and taped a lens-hood, opening one while keeping the other closed for the first exposure and changing over for the second. Either way, the device can be used for recording the same person twice on a frame, giving the appearance of identical twins. The method is simple. Place the camera on a tripod, close off the right side of the lens and place the person in the left of the frame for the first exposure; open the right side and close the left and take the second exposure with the person on the opposite side of the frame.

Alternatively, the mask can be placed so that it cuts the frame horizontally. Open the top half and make the first exposure, photographing a person filling the frame; close the top, open the bottom and ask your subject to move away before taking the second exposure. The result is a picture showing only the top half of the person you were photographing,

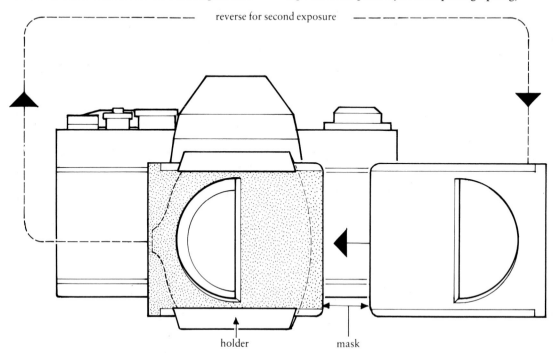

reverse for second exposure

holder

mask

Double exposure masks are available from some filter manufacturers. They enable you to shoot the two halves of one frame separately.

The identical twins in this picture are, in fact, one person. The picture is the result of a double exposure on a single frame, each through an alternate half of a specially-made mask, designed to cover exactly half the lens.

their body fading away to nothing lower down. Repeating the process, but this time asking your subject to take a pace sideways between exposures, will show the person's legs standing without a body to the side of a legless top half. A completely different effect can be obtained by switching the mask back so that it divides the picture area vertically, and lining up the join between the two sides with some thin object such as a lamp post. Make a first exposure with the right side open and with someone looking out from the right of the lamp post. Part of their body will obviously be visible from the left side too, but that will not be recorded with the mask in place. Now swap the mask to the right side and make a second exposure with the person moved out of the picture area. The final picture will show the subject's top half looking out around the lamp post, the bottom half apparently hidden behind the impossibly-narrow width of the post.

Masks are also available, or can be made, in different shapes. One set, for instance, might consist of a black spot in the centre of an area of

clear plastic or glass, coupled with a second mask that reverses the pattern to give a clear spot in the middle of a black area. Using those alternately on the camera for two exposures can give the effect of, say, a face superimposed in the centre of a field of flowers. When nothing else is available, various dodges can be employed to mask areas you wish to expose to a different image. The ends of film boxes can be cut or torn and held in place, the result being noted in the viewfinder of a reflex camera. Even a finger can be held close to, but not touching, the camera lens to make a rough mask.

Multiple-exposure photography is like so much else in the special-effects field. There are always expensive gadgets available for specialised work, but often the quick dodge or the hastily-made accessory can work as well, if not better.

Abstracts

The branch of photography we come to now is, in many ways, totally intangible. None of the subjects of these pictures will be instantly recognisable and, in some cases, they don't even exist! What we are looking at are patterns of light and shade, combinations of colour that blend and contrast in a pleasing way, composition for its own sake . . . in short, abstracts. Abstract photographs can be created in many different ways. Some of the techniques about to be described involve no more than finding new methods of showing patterns already in existence. Some, so small that they might not otherwise be noticed or seen at all with the naked eye, have been suitably enlarged to show their effect. Others, pictures of patterns that might occur once only and very briefly, have been frozen in an instant of time, the way only the camera can work that particular trick. And some are pure photography: pictures that could have been created no other way than with a camera. Once created, they can be considered as pictures in their own right, or they can be used as ingredients in other types of special-effect picture: combining them with other images by multiple exposure (see chapter on multiple exposure), projecting them onto faces (see next chapter), or maybe as part of a slide sandwich (see chapter on montage).

Physiograms

Right away, we start with a type of abstract that only the camera can show. A physiogram does not exist in its own right. It is built up by a moving light and the trails it leaves on film. In its simplest form it involves no more than opening the camera shutter in a darkened room and waving a torch about in front of the lens. Everywhere the beam moves, a light trail is left on the film, but the pattern made that way has no symmetry; it will appear as no more than a series of criss-cross lines with little or no aesthetic appeal. For a physiogram to be more

95

pleasing to the eye, a regular pattern needs to be introduced and, for that, the light must be suspended from the ceiling.

Start by taking a torch and masking its beam so that only a small circle of about 10 mm shows. Cooking foil can be used for that. Suspend the torch with a short length of string and then black-out the room as best you can. It doesn't have to be pitch-dark like a darkroom. Pulling thick curtains across windows and shooting at night will suffice. Place the camera on the floor directly beneath the light. The beam is then switched on and the torch swung in a circle. The camera's shutter is opened on B and kept open with a locking cable release. The aperture is not too important, but a stop of around f/11 with ISO 100/21° film makes a suitable place to start. As the torch swings, the pattern it creates is recorded on the film as a series of lines.

With black-and-white film the pattern will naturally print white on a black background. With colour film, the effect can be enhanced with filters, either on the light or over the camera lens. No two designs produced this way will ever be exactly the same and, with different filters in place, multiple exposures can be made to create patterns of different colours, the total number being restricted only by the number of filters you have available. Even special-effect filters such as cross-screen or diffraction-grating types can be used to bring their effect to the light. If some sort of obstruction is placed above the camera, the pattern changes again, breaking up at points where the light is hidden from the lens. A tripod erected over the lens lends itself well to this effect. Physiograms made in this way will show circular or eliptical designs, but the patterns can be changed to different forms by the way the light is suspended. A second string attached about half-way down the first and then taken horizontally to a nearby wall will restrict the swing of the light in one direction, inducing a different type of pattern. Another method of suspending the light is to make an inverted pyramid

of three strings and attach the light to a fourth which is tied to the apex of the pyramid. That restricts the swing in different directions and so affects the shapes of the patterns that are produced.

Having tried different ways of suspending the light, you can then turn your attention to the camera. That too can be moved during exposure to give yet another variation on the pattern. But, like the light, the movement should be regular rather than random. Try placing it on the outside edge of a record player turntable, and allow it to revolve while the light swings. Or build a device that will swing the camera backwards and forwards as the light moves round and round. One word of warning here, though: make sure any side arms of the contraption that support the swing are wide enough apart as to be out of the lens's field of view, otherwise they will intrude on the physiogram.

Abstracts through close-ups

Abstract patterns are all around you. The problem is that they are often so small that you fail to notice them. Flowers are a good example, the patterns on their petals showing striking contrasts or sometimes a subtle blending of similar colours that are rarely seen until one small area is concentrated on and enlarged by the camera. Other subjects that work well in close-up include colour pictures in magazines, when the dots that make up the pictures make interesting patterns; closely-woven fabrics like tweed; insects' wings; certain materials under stress, photographed in polarised light (see chapter on unusual lighting); parts of colour slides; and even the screen of a colour television whose image is actually comprised entirely of minute dots of the primary colours grouped in circular patterns around each other.

In general terms, focusing is achieved by moving the lens away from the film plane. The further the lens is from the film, the nearer it can focus on its subject. A normal standard lens will focus no closer than between 50 cm and 1 metre. To move nearer to the subject, then, a method must be found of

Page 94: photomicrography reveals abstract designs in chemical crystals photographed through a microscope. *Peter Elgar.*

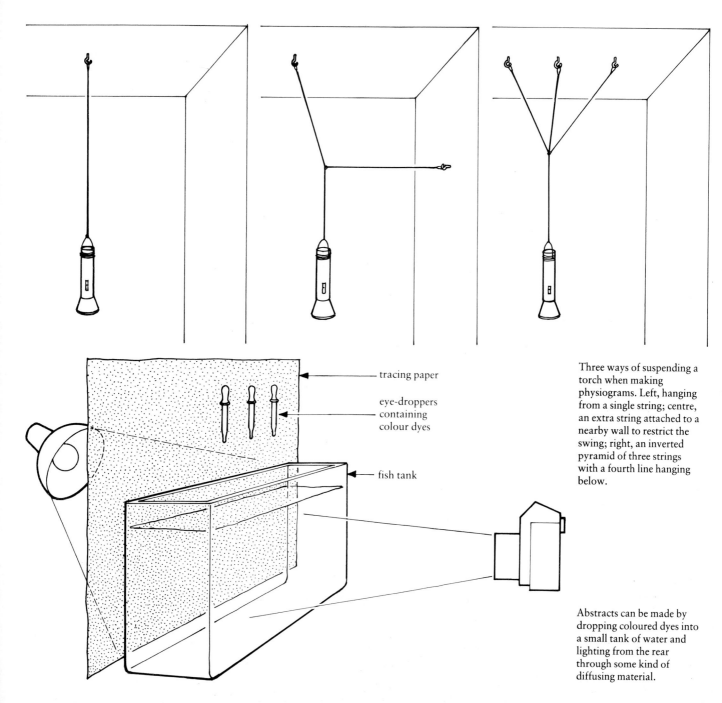

tracing paper

eye-droppers
containing
colour dyes

fish tank

Three ways of suspending a
torch when making
physiograms. Left, hanging
from a single string; centre,
an extra string attached to a
nearby wall to restrict the
swing; right, an inverted
pyramid of three strings
with a fourth line hanging
below.

Abstracts can be made by
dropping coloured dyes into
a small tank of water and
lighting from the rear
through some kind of
diffusing material.

A home-made device that holds and swings the camera during exposure, giving a different pattern when shooting physiograms.

Right: two physiograms. In the first, the light source was suspended from three strings and three exposures made, through a red, green and blue filter. For the second shot, the light was again suspended from three strings, but this time, the camera was moved laterally beneath the swinging light. Two exposures were made through red and green filters.

Right: an abstract design made through focus – or rather, the lack of it. The subject was a bush of yellow flowers, photographed through a ×25 multi-vision filter and thrown out of focus.

Far right: close-ups of everyday objects can often make unexpected patterns. This is a greatly magnified portion of a colour television screen.

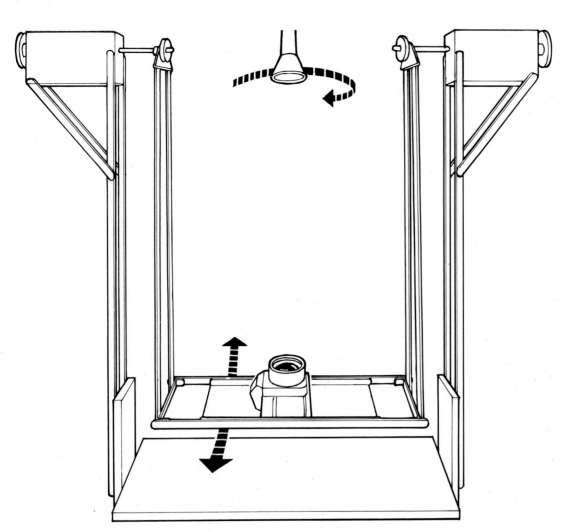

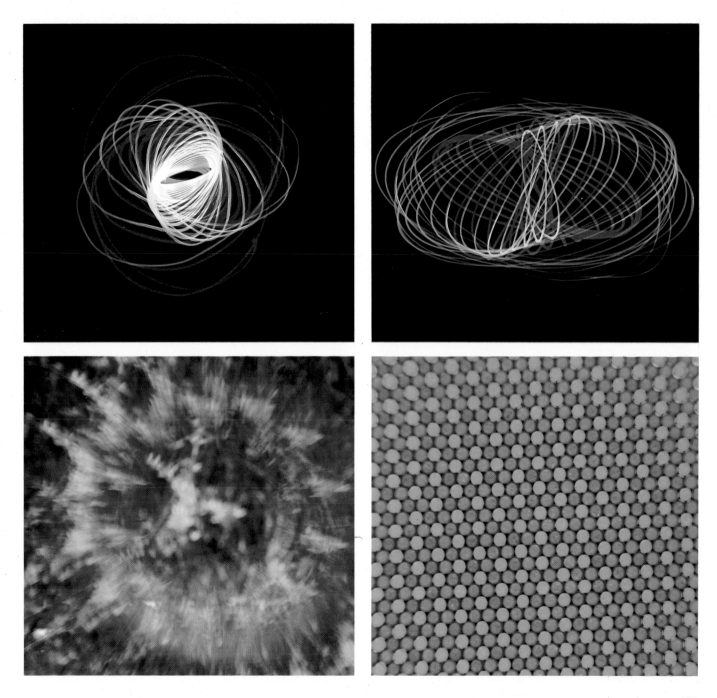

effectively shifting the lens further away from the film. There are many different methods of achieving this, but the most common are these: extension tubes, bellows, reversing rings, supplementary lenses and macro lenses. We will look at each in turn, examining briefly how it works and discovering how to get over any problems that might arise from its use.

Extension tubes are tailor-made for different makes of camera and fit between the lens and the body to give the necessary separation for close-up work. They usually come in sets of three or four, each tube of which is a different length. They can be used individually or in any combination of two or more. The problem with extension tubes is that they are rigid. There is no way to produce an intermediate magnification between one combination and the next. *Bellows* solve that problem. Like tubes, they fit between the camera body and the lens; unlike tubes, they are continuously variable in length, giving a far greater variety of separations and magnifications.

Exposure can present problems with both tubes and bellows because as you move a lens further away from the film plane, the aperture is effectively reduced. (An *f*-number is expressed as a ratio of the aperture's diameter to the focal length of the lens which, in normal conditions, is much the same as the distance between the lens and the film. If that distance is increased, with no increase in the aperture diameter, it follows that the ratio of one to the other will produce a smaller *f*-stop.) With TTL metering this presents no problem, since the meter will read and indicate the correct aperture accordingly, even if setting *f*/8 on the lens means that you are actually setting an aperture of *f*/11 for that particular extension.

Without TTL metering you must work out the exposure increase yourself. The factor by which exposure must be increased is sometimes marked on the extension tubes. On bellows, however, you must resort to a couple of formulae. The factor by

which you multiply your exposure, is the magnification plus one, all squared. Magnification is calculated by dividing length of the extension by the focal length of the lens. Here is an example. Supposing you are using a 50 mm lens on 150 mm extension. The magnification is

$$150 \div 50 = 3$$

So the exposure increase is

$$(3 + 1)^2 = 4^2 = 16$$

So if your metered exposure was, say, 1/60 second at *f*/11, it must be increased by a factor of 16, the equivalent of four stops. Your new exposure would therefore be 1/4 second at *f*/11 or 1/60 second at *f*/2.8. Those two formulae can also be combined into one, which gives the same result, though it can be a little more complicated to work out. If you want to use it, it is this:

$$X = \frac{(L + F)^2}{F^2}$$

where X = exposure increase, L = length of extension and F = focal length of lens.

Reversing rings are another method of moving in close. They are small accessories that feature a screw or bayonet fitting to match the camera body on one side and a threaded circumference on the other side the same size as the filter thread on the standard lens. With it, the lens can be removed and replaced back to front, an exercise which provides 1:1 magnification. For that, exposure must be increased by two stops.

Supplementary or *close-up lenses* fit to the front of the camera lens by way of the filter thread. Once in place, they actually convert the camera lens to one of a shorter focal length. Take a standard 50 mm lens for instance. Focused at infinity, it will be 50 mm from the film plane. Leaving it in the same position, but fitting a close-up lens that reduces its focal length to, say, 40 mm, means that you now have a 40 mm lens 50 mm from the film plane, giving a similar effect to that obtained by fitting a

10 mm extension tube. Supplementary lenses are measured in dioptres. A +1 dioptre lens has a focal length of 1 metre, a +2 dioptre lens has a focal length of 50 cm (half a metre) and so on. They may be coupled for greater magnification. Coupling a +1 with a +2 gives a +3. The advantage of these lenses is that they involve no extra exposure; the disadvantage is that the definition is reduced. It is therefore best to shoot at small apertures.

Macro lenses can be extended, usually to twice their focal length, from the film plane. Some are designed to focus as close as possible in the normal way and then to pull out a few centimetres and focus again. Others are designed to focus in one movement all the way from infinity down to their closest focusing distance. They are made in a variety of focal lengths. Once past the normal closest focusing position, the usual problems of exposure increase start to become apparent but, in anticipation of this, many macro lenses have scales marked alongside the focusing scale showing the degree of magnification, from which the appropriate exposure increase can be calculated.

One of the problems of close-up photography is that, with the camera so close, it is often difficult to light the subject. One way out of the problem is to shoot objects that are translucent and use back lighting, either directly behind the subject or at an angle from the rear. This is an area where polarised light can be particularly useful (see chapter on unusual lighting). Moving in even closer, abstracts can be made by photographing minute subjects, many of which are completely invisible to the naked eye. Which brings us to our next section . . .

Photography through a microscope
Once you get past 10× magnification in close-up work, you enter the world of photomicrography. With a suitable adaptor, any single-lens reflex can be fitted to a microscope, usually instead of the lens, but sometimes with the adaptor screwed into the lens itelf. The first way is better but, if you are forced to use the second method, the camera lens should be focused at infinity. Focusing in both cases is carried out by the microscope's own control, while viewing the subject through the camera's viewfinder. With TTL metering, exposures can be measured and controlled by use of the camera's shutter speeds. First you must find a suitable adaptor. Many of the top-name camera brands make their own but, failing that, there are a number of specialist firms that make adaptors for all purposes such as fitting lenses of one brand to cameras of another. They also make the more obscure accessories such as reversing rings and adaptors that mate two lenses face to face (another useful method of making close-ups, incidentally). Another speciality of such firms is adaptors for fitting different makes of camera to different types of microscopes.

Once the camera is in place, the procedure is much the same as when taking straightforward close-ups. Despite what you might have heard, lighting does not have to be specialised; a simple desk lamp is often sufficient. Lighting can be from above and to the side but if the subject is translucent, it is best used from below, reflecting the light back from a small mirror built into the microscope beneath the slide. One subject that you might not think of immediately for this type of photography is a normal colour transparency. Photographing it through a microscope will make an abstract and colourful pattern of the grain structure. But maybe the most popular subject for photomicrography, and one that makes excellent abstracts, is chemical crystals. They can be made from chemicals such as copper sulphate, but also from more common household substances, providing the samples are soluble in water. Sugar, salt and washing soda are just three examples that work well.

To prepare a sample for photomicrography, you must first make a saturated solution. That means adding the chosen substance to warm water until no more will dissolve. Having done that, take a small drop from the solution and place it on one of the microscope's cover glasses. The crystal

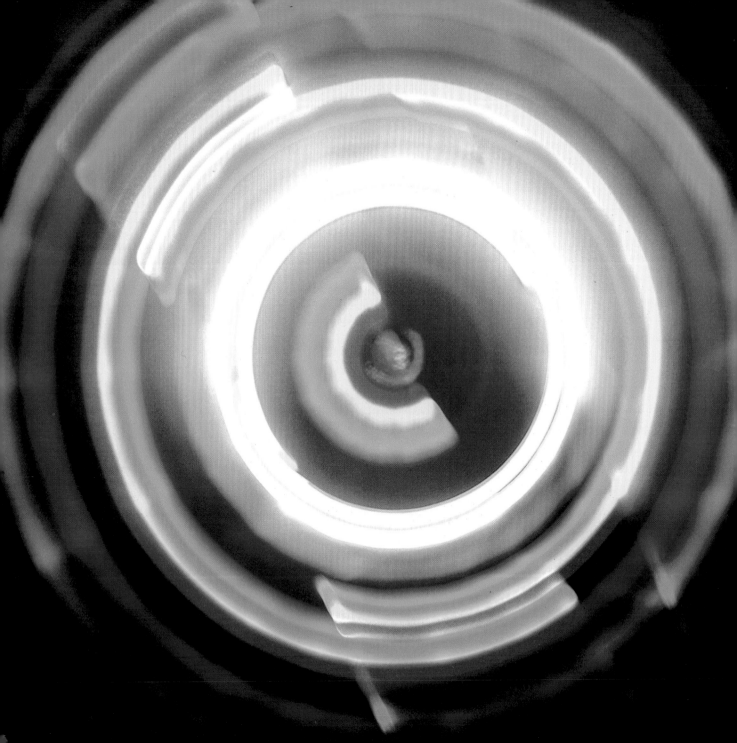

Left: a diffraction-grating filter was coupled with cross-screen and multi-image filters, aimed at a small source of light and rotated during a 1 second exposure.

Keep your eyes open and you will find abstracts all around you. This is the reflection of city lights in a wet pavement.

Diffraction paper was lit obliquely for this abstract and the lens zoomed during a 1-second exposure.

structure will soon form on the surface and can then be placed in the microscope. This is another subject which is best lit with polarised light (see chapter on unusual lighting). Rotating the polarising filters will change the colours of the crystals, enabling you to make many different abstracts from just one sample.

Abstracts through filters

In the first chapter of this book, we looked at diffraction-grating filters, designed to make spectacular patterns with colour film on point-sources of light. The normal way of using these is for the addition of a certain effect to subjects such as landscapes. But they can be used to make pictures of their own and in which the only thing in the picture is the filter effect itself. The first thing you need is a point-source of light. That can be easily arranged by making a small hole about 2 mm in diameter in a piece of black cardboard and standing it in front of a light. Set the camera on a tripod and aim it at this brightly-lit hole. With a filter in place, you will immediately see its effect strongly contrasted with a jet-black background. That in itself can make an abstract picture, but the technique doesn't end there. Two or more filters can be combined to produce a combination of their individual effects. Then multi-image filters can be added to multiply those effects.

From there, the next step is to combine movement with the filters' effects. Select a small aperture that will allow a long exposure of around 1 second and then, as the shutter opens, rotate the filters on the lens. A partial rotation will give a different result to a full rotation, but both will make circular patterns. Movement can also be introduced to the camera itself, panning it past the light to turn the filter's effect into a series of streaks. Or the camera can be removed from the tripod and moved in a random motion to give a much more irregular pattern. With so many different combinations of filters together with the many movements that are possible, the number of abstracts that can be produced this way is almost limitless.

Using water

Water can be used to produce abstracts, either by reflection or as a medium in which to make the pattern. Any expanse of water such as a lake, a river or the sea can be used, with just the movement of the water and the reflection of the sun often making a pattern of its own. Other than that, the reflections of buildings or colourful boats are worth watching for, and the more the water is disturbed the more abstract the reflections will appear. Watch too for the reflections of lights in wet roads and pavements. The best location is in a busy city street full of colourful neon signs. The signs themselves are often disappointing when recorded on film. But if you are in an area like that and it has been raining, ignore the actual lights and look down at the reflections. There could be a whole world of abstract pictures literally at your feet.

Water can also be used as a medium in which patterns can be made with coloured dyes or inks. Find a suitable transparent receptacle for the water. A small fish tank is ideal, but large jars can work as well if you can focus close enough to fill the frame with them. Set the camera up on one side and arrange a flashgun or tungsten lamp to backlight the water. The best way to do that is either by taping a sheet of tracing paper to the rear of the tank or jar and putting a light directly behind it, or by reflecting the light off a white surface such as a projector screen placed a metre or two away from the side.

With your finger ready on the shutter release, drop small amounts of ink or liquid dye into the water. An eye-dropper will help control the amount. The new colour takes a time to affect the whole area; first it will form clouds that will move around the water, creating abstract patterns that are always changing and are never the same twice. Different colours can be added either singularly or in combination with each other for different effects. Another way of using water as a basis for a design is to mix it with a little oil. Rather than make the patterns *in* the water, however, the oil will settle

out on the surface to make its design. For this effect, a small shallow dish is a better receptacle for the water than a tank or jar. Light can be positioned obliquely from the front.

Diffraction paper
This is a type of paper-based plastic foil that is readily available from professional photo suppliers. There are several different designs, but they all have a common ground in the fact that they break up the light, reflecting it back as a series of patches which can change colour according to the direction at which light strikes them. A small square of this material can be photographed to give yet another type of abstract picture. It can be shot straight-on in sharp focus for one effect, slightly out-of-focus to merge the colours more and so give a different effect, or it can be photographed with a zoom lens, changing the focal length during the exposure to give a series of multi-coloured lines all streaming towards a central point.

Abstracts are everywhere
The dividing line between any type of special-effects picture and a pure abstract image is often a thin one. Which is why some of the effects we have already discussed in past chapters, and more that we will meet in chapters to come, can be considered abstracts, just as much as those we have seen here. You'll find abstract pictures produced through unusual lighting (see chapter on unusual lighting), controlled blur (see chapter on controlled blur) and in the production of many types of distortion (see chapter on distortion and reflection, page 69).

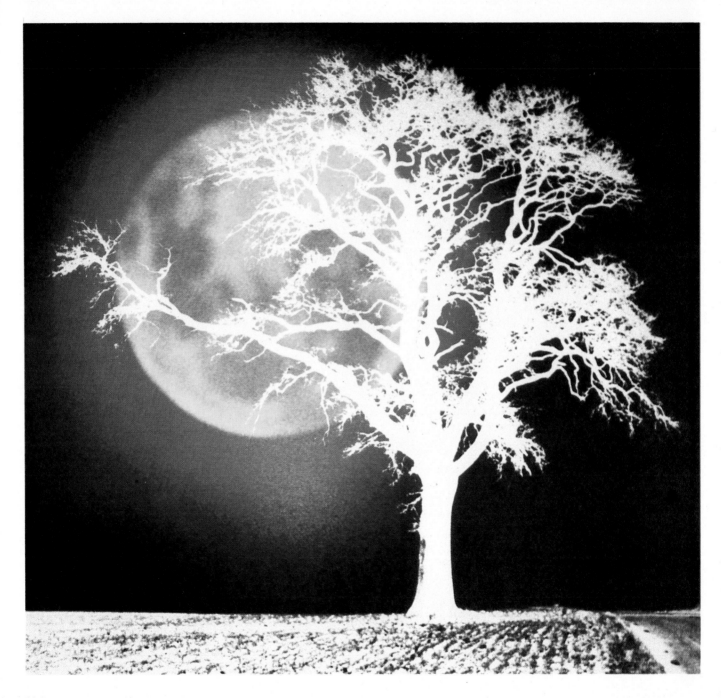

Using projectors

One of the most useful accessories a special-effect photographer can own is an ordinary slide projector. It can be used for making abstracts, for combining parts of two or more different slides, for adding unusual lighting to portraits, for putting images in places they would never ordinarily be seen, for adding texture to a picture, for placing models into exotic or surreal locations, for distorting images . . . and all this from a starting point that involves no more than the simple projection of a colour slide or two.

Projectors as light sources
A projector gives out a narrow, hard beam of light. That makes it straightaway a useful addition to a lighting range, where it can be used as a small spotlight, especially for subjects like table-top photography. With larger subjects such as portraits, a projector can be used to pin-point accurately lighting effects on various parts of a face; for instance, a slash of light across the eyes in an otherwise dimly-lit model. It can also be used to introduce coloured effects by projecting coloured gels bound in standard slide mounts on to the subject. With two or more projectors, various parts of a face or body can be lit with different colours, each one precisely focused to fall on the features exactly where the photographer wants them. In the absence of coloured gels, slides can be taken of various strongly-coloured objects shot out of focus to give an overall, even tone. Alternatively, slides that already contain areas of even tone can be projected out of focus on to the face. Skies, walls and the like all provide suitable subjects for the treatment.

If the projector is sharply focused on the subject, a completely different effect is obtained. The original slide can be of anything you like, providing it is of a strong and therefore recognisable shape or pattern. A face or a nude, parts of bodies like hands or feet,

non-human objects like shoes or bags, light-coloured fruit . . . anything and everything make good subjects for this technique. Having decided on your subject, select a slide with a strong pattern to it. A brick wall maybe, or a close-up of some woven texture such as rush matting can be taken specifically for the purpose. Equally, slides of clouds, leaves, water, tree branches or complete abstracts (see chapter on abstracts) can be used.

One method of using this idea is to combine human and non-human subjects; for instance, clouds or abstracts projected on to faces or bodies. Conversely, a slide of a face makes an interesting picture when projected on to something like the distinctive shape of an apple. Alternatively, completely non-human subjects can be combined: bricks with boots maybe, or clouds with fruit. Or, for a different result again, two live subjects can be used. Try shooting pictures at a zoo of animals whose features fall in a similar shape to those on a human face – members of the cat family for instance. Shoot to fill the frame with the head as far as is possible and then project the animal face on to a human face, positioning the eyes on the live subject and the projected image to coincide.

Whatever the subject and the slide, the technique is the same. The projector is focused on the subject in the same way as it would be on a screen and the picture taken with the camera as close as possible to the projector to prevent too much distortion of the projected image. Remember to use tungsten-balanced film or an appropriate filter (see chapter on filters) for accurate reproduction of the tones when shooting in colour. Pictures shot in this way work best against a black background, when the subject will appear to be made of the substance depicted in the slide; a brick-built face for instance. A different effect can be obtained by placing your subject against a white wall or screen and projecting on both the subject and the screen. That way, the subject will appear to be part of, and combined with, the overall picture or pattern coming from the projected slide.

Projectors for multiple images

If a second projector is owned, or can be borrowed, two can be used to create multiple images. The two projectors are set up with a camera, preferably on a tripod, between them, all as close together as is possible for comfortable working conditions. Different slides are projected from each projector and the result is photographed straight from the screen. The theory of the type of pictures produced this way and the way in which the individual slides combine is much the same as that behind the production of multiple exposures. Images can be arranged to overlay each other or positioned so that the light parts of one image fall within the dark parts of another. If more than two projectors are used, more than two images can of course be combined. It is even possible to make multiple images this way using a single projector and making a series of exposures on the same frame within the camera. In that case, the images are arranged and marked in the viewfinder in exactly the same way as described in the earlier chapter on multiple exposures (pages 83 to 93).

The advantage of using two or more projectors to make a combination image is that you can see exactly what you are doing as you go along. If one projected image is too bright for the desired effect, the light level of the offending projector can be cut back by neutral density filters or by making a series of different apertures in black card and holding each one in front of the lens until the effect is right.

Similarly, parts of images can be masked with sharp, clear lines on the transparency itself or with a more blurred outline by holding the mask in the projector's beam. The disadvantage is that if a slide made this way is projected larger than the original image sizes of the slides that made up the composite, the surface of the original screen might become noticeable. Another disadvantage is the contrast build-up which happens with any form of copying, but which can, to a certain extent, be reduced by pre-fogging (as described in the chapter on multiple exposures, page 83).

Page 106: a small piece of ground glass was used with an ordinary projector to make this shot. First, the moon (previously shot through a red filter) was projected from the rear and photographed, then a lith negative made from a colour slide of the tree against a blue sky was taped into position, back-lit with white light and a second exposure made. The white of the tree has burnt out the original image of the moon, giving the impression of being in front of it.

Page 107: an ordinary slide projector can be used as a light source, colouring its beam with gels in slide mounts. Here, two projectors were used for the coloured effects on the face and a rim light was made with a spotlight to the rear of the model.

Projectors can be used for combining images on slides with real objects. For this shot, a girl's face was projected on to an apple and the result photographed with a camera just beside the projector.

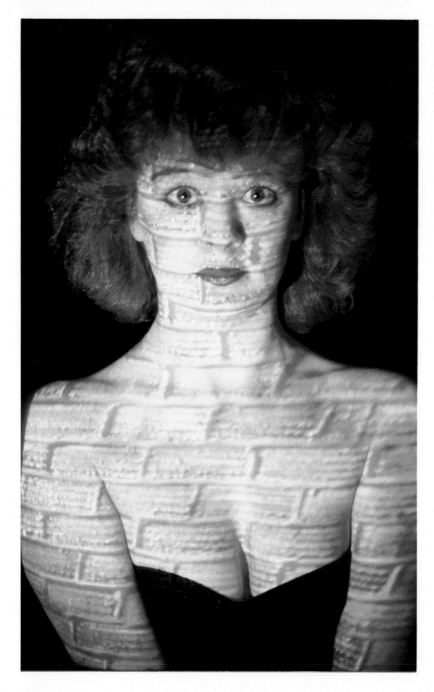

Abstract patterns or recognisable images can be projected on to faces. Here, the girl has been lit by a slide of a brick wall projected from just beside the camera.

Right: texture can be added by means of a projector. For this picture, a colour slide was projected on to a sheet of A4 typing paper and the resulting image photographed from the opposite side.

If shooting in colour, tungsten-balanced film must of course be used, and exposure calculations are best made with an incident-light meter, held against the screen at a neutral tone in the picture and pointed back towards the camera. In the absence of such a meter, the camera's TTL system can be used, providing allowances are made for any over-bright or particularly dark parts of the image. If in doubt, take an average reading from various key points in the picture and then bracket.

Texture and distortion

Normally, a projector is used to throw a picture on to a screen and the surface of that screen is designed not to interfere with the reproduction of the image in any way. But if a 'screen' whose texture *does* affect the projected image is chosen and the result re-photographed, the picture produced becomes yet another special effect spun off from the use of a projector. The type of texture induced into the picture depends on the material used. Rough walls, polystyrene tiles, blotting paper, light-coloured sandpaper are just four ideas to start from. The effect doesn't necessarily rely on the slide being projected from the same side as the camera, either. Grease-proof paper can be stretched across a small frame of cardboard and a slide projected from one side, its image photographed from the other. The smaller the original image, the coarser the texture induced from the paper. The technique can be tried with any reasonably translucent material, but remember when working this way to put the slide into the projector back to front for a correct image on the camera side. Increased contrast from copying can be dealt with as before.

Another form of texture that can be illustrated by use of a projector is the actual grain on the film. To use that to its best effect, project a large image of a slide, but only photograph a small area of the image, e.g. a face from a full-length shot. Projecting and re-photographing can be from the same side or opposite sides of the screen as mentioned above or, for a different way of handling the idea, try using a photographic enlarger as the projector. Put the slide

into the negative carrier and project it directly into the camera body with the lens removed. Focusing is carried out by the enlarger controls and, if the camera is flat on the baseboard, the result must be viewed by means of a right-angle finder, or by using a reflex camera with a waist-level finder that is naturally at 90 degrees to the lens. Since there is no lens, and therefore no aperture, exposure must be controlled by the shutter speed of the camera. An aperture-priority shutter system can be used with the camera's TTL meter.

Projecting and re-photographing an image can also produce distorted images. For this effect, rather than trying to keep camera and projector as close as possible, they are positioned a good way apart. If the projector is placed to the side of the screen at an angle of, say, 30 degrees instead of the more traditional 90 degrees, the picture will appear small at the point on the screen nearest the projector and open out to a larger size on the opposite side. The image is therefore distorted and part of it can be re-photographed accordingly. That's the theory; the practice proves there is a problem. Projecting an image like this at an angle to the screen means that different parts of the screen are at different distances from the projector. That makes it impossible to keep the entire image all in focus at any one time. Although there is no way to cure this problem completely, the amount of the image in focus can be increased by projecting the image through a smaller aperture. A small hole in a piece of black card held in front of the lens will do the trick. That way, just as small apertures on a camera lens increase the depth of field, a small aperture on the projector lens ensures that more of the image will be in focus. This of course also reduces the intensity of the image, but that can be compensated for by increased exposure at the camera.

Back projection
We have already touched on back-projecting a slide and re-photographing the image from the front. That is the most elementary form of back projection. On a different level, the technique can

Distortion can also be induced by projection. The projector is simply placed to one side of the screen so that its image is projected across the surface from an angle. The camera is placed in front of the screen in the place that might normally be occupied by the projector.

be used in the studio to combine live models or small sets with slides shot on location, giving the appearance that the subject in the studio is actually part of the location slide. A back projection screen must be translucent so that the slide projected from behind can be seen clearly from the front. Commercially-available screens are made of specially-formulated plastics or sometimes opal glass or fresnel lenses. The image is supplied by a purpose-built projector with a wide-angle lens to give the maximum picture size from the shortest throw. Operating at short distances from the screen, however, sets up a hot-spot in the image that must be countered by a graduating filter in the light path. If room allows it, a projector with a longer focal-length lens can be used, shifting the projector further from the screen and thus cutting out the hot spot. The problem here, though, is one of space. The best of both worlds is found by using a long focal-length lens and 'folding' the projector's beam with a system of front-silvered mirrors. On a less ambitious scale, a normal household projector may be used, coupled with smaller screens, made from greyed wax or gelatin coating on glass or clear plastic, or even from thick tracing paper stretched across a wooden frame. If no mirrors are used in the system, the slide must be transposed in the projector to appear the correct way round from the front of the screen. If mirrors are used in the system, slides may or may not have to be reversed, according to the number of mirrors.

The simplest form of back projection comes from placing an object in front of the screen, projecting a suitable slide from the rear and photographing the result from the front, exposing for the slide on the screen. The object will then record as a silhouette in front of the scene shown in the slide. The next step is to bring the object out of the shadows and into the light. If you are working with a full-size screen and the subject to be photographed is a person, there is only one way to do this. The person must stand some way in front of the screen and be lit predominantly from the side, using snoots and barndoors to keep the light from falling on the screen. The exposure for the subject lighting must then be matched to that for the background slide. If you are using tungsten lighting, that means careful adjustment is needed until the two exposures are the same. Lighting your subject with flash is easier. It is just a matter of finding the right aperture for the flash and coupling that with the correct shutter speed for recording the projected slide. Remember, though, that if you are shooting in colour, the colour temperature of the two light sources are different and one must be adjusted to match the film stock by use of the correct filter (see chapter on filters).

If the subject is solid it can be lit more ambitiously with both front and back lighting, a double exposure being made to combine the background and foreground. The subject is lit in the best possible way and in front of a black background. That can either be something like a black velvet curtain over the screen or, if it is more portable, the screen and the projector behind it can be removed completely. With the subject lit just the way you want it, the first exposure is made. The curtain is then removed or the screen and projector placed in position and, with the main lights out, a second exposure is made on the same frame for the background. The subject is in silhouette for this second exposure, so its original lighting will not be affected. Another advantage of this method is that the focus can also be adjusted from the subject to the screen between exposures, so that both appear sharp in the final picture.

If someone is being photographed against a back-projected slide, it is necessary to cut off their feet in the picture, otherwise they will be seen to be standing on the bare studio floor, rather than in the lush meadow or on the mountain path that might be depicted in the scene behind them. The alternative is to build a set in front of the screen to match up to the scene in the picture: for example, the rail of a boat against a slide of the sea, or some sand against a beach scene. With smaller versions and models, whole scenes can more easily be built

Perhaps the simplest form of back projection: a silhouette made by placing twigs in front of the screen and exposing only for the projected slide.

Right: a home-made back projection screen and an ordinary projector combined the sunset with the model monster. The monster was lit to match the background and photographed first against black, then the screen placed in position, the slide projected from the rear and a second exposure made.

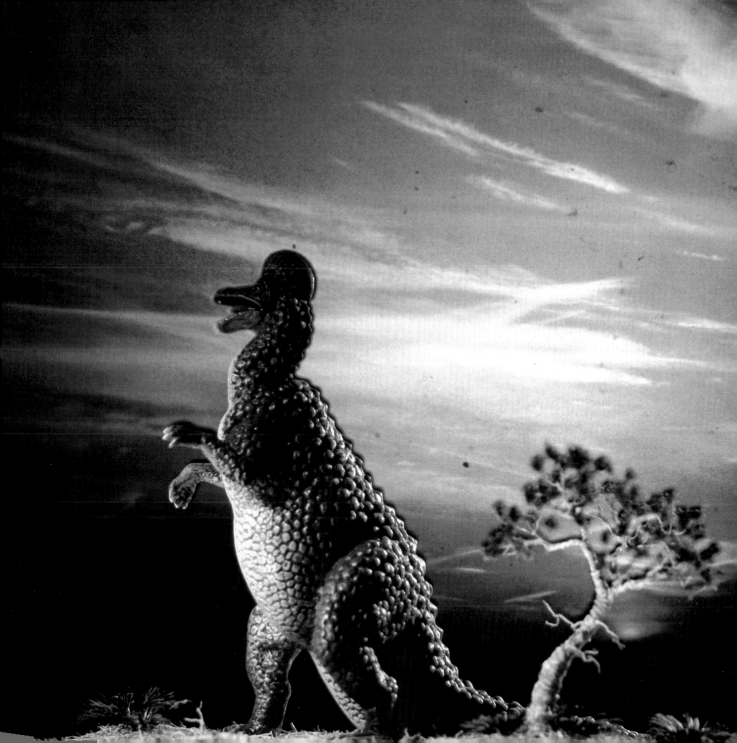

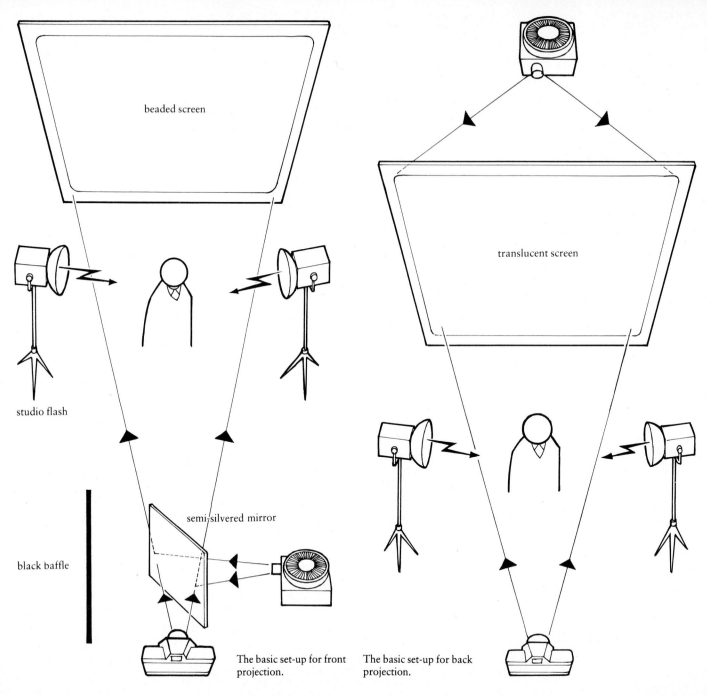

beaded screen

studio flash

black baffle

semi-silvered mirror

The basic set-up for front projection.

translucent screen

The basic set-up for back projection.

up in front of the screen to match the background. An even simpler method of using back projection is to project on to a small piece of ground glass, using a small projector and some close-up device on the camera. Images from slides can then easily be combined with silhouettes or perhaps faces made up on lith film taped to the glass. Such pictures are not necessarily confined to black silhouettes. A negative image, also produced on lith film, can be lit with white light from the rear and then removed and double-exposed with a straight slide. The white of the first image will then burn out its shape into the scene shown in the slide, making what is, in essence, a silhouette in reverse.

Front projection

Pictures produced by front projection are very much like, but superior to, those that come from back projection. The process, however, is more convenient, more compact and a lot more expensive. There are three basic constituents in a front projection unit: a special screen, an unusual projector and a semi-silvered mirror. The screen is constructed from minute glass beads with a very high refractive index. The spaces between the beads are filled with black. This is known as an auto-collimating screen and, unlike normal screens, it reflects back an extremely high percentage of light *only* in the direction at which the light hits it. In other directions, the reflection is almost zero. In use, then, a slide projected on to the screen can be seen clearly only from a position directly behind the projector lens. A few paces to either side gives the appearance of the image fading. The projector is mounted at right-angles to the screen, its beam reflected from the semi-silvered mirror positioned at 45 degrees to the lens. This type of mirror reflects some light as normal, while allowing some more to pass through. It therefore follows that the camera can be set up behind the mirror to see through it to the screen, and the camera and projector lenses can then be adjusted until they are effectively on exactly the same axis. A black baffle is placed directly opposite the projector to trap light from its beam that has passed through the mirror and, similarly,

to prevent the camera from picking up any unwanted reflections.

A slide is placed in the projector and a subject is placed in front of the screen. That subject is then carefully lit so that as little light as possible falls on the screen. Because of the screen's special properties, the best part of any light that *does* fall on it is reflected back directly towards its source rather than at the camera, so that the projected picture is not unduly affected when viewed from the camera/projector viewpoint. The subject naturally throws a shadow on to the screen but, because the camera and projector lens are in the same plane, the shadow is exactly hidden and so masked by the subject. The slide is actually thrown on to the model as well as the screen. But because the level of reflectance on the model is a lot lower than that on the beaded screen, and because the model is being lit by independent lighting to match the brighter level from the screen, any image of the slide on the model is killed by over-lighting. Viewed from the camera position, the model appears to be standing in front of the scene depicted on the slide in much the same way as with back projection. When the picture is taken, the tungsten light in the projector that has been used for viewing the slide goes out, and is replaced by a flash tube which throws the picture on to the screen at the moment of exposure. Like professional slide copiers, the image is also slightly degraded by a secondary flash designed to help reduce contrast. The subject will usually be lit by studio flash units and so pictures, when working in colour, can be taken on daylight-balanced film.

The system can be used for putting models into backgrounds that might normally be too costly to reach. Locations that might otherwise be uncomfortable or impossible for a model can also be faked, e.g. a nude in the snow or the appearance of someone falling from an aeroplane. The latter one can be produced by starting with a slide of an aeroplane high in the frame, turning it on its side so that it appears to the left of the screen, and asking

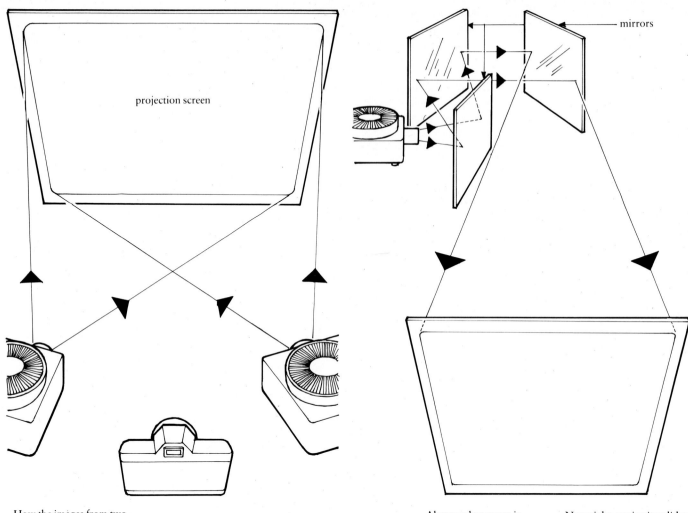

projection screen

mirrors

How the images from two
projectors can be combined
and re-photographed.

Above: when space is
restricted, mirrors can be
used to fold a projector's
beam, thus allowing a
long-focus lens to be used
for back projection.

Near right: projecting slides
on to a live subject and
re-photographing the result.
If the background is white,
the subject will appear to be
a part of the slide. With a
black background, the
projected image will cover
only the subject.

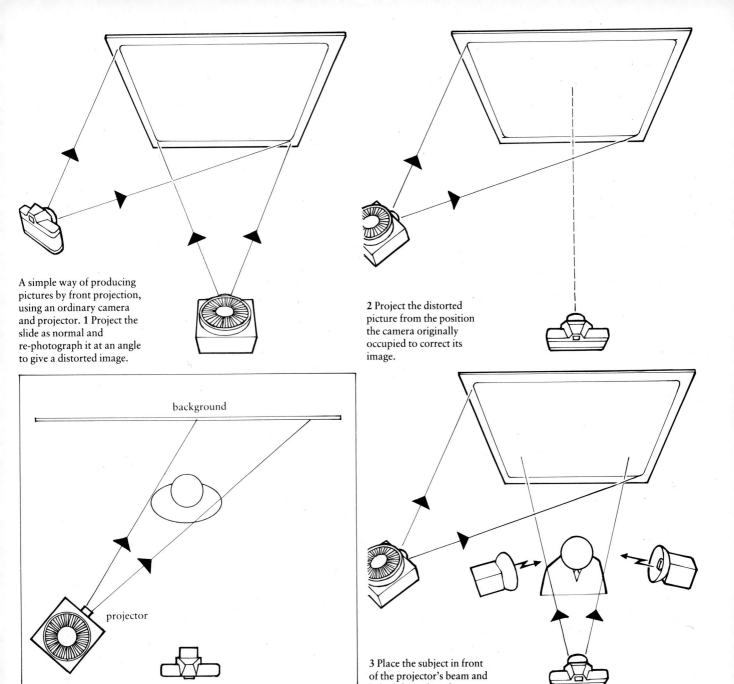

A simple way of producing pictures by front projection, using an ordinary camera and projector. **1** Project the slide as normal and re-photograph it at an angle to give a distorted image.

2 Project the distorted picture from the position the camera originally occupied to correct its image.

background

projector

3 Place the subject in front of the projector's beam and light it from the sides.

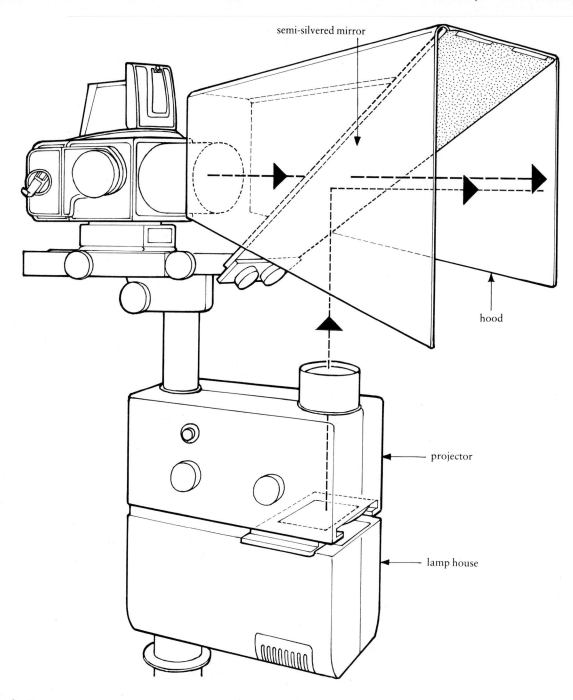

semi-silvered mirror

A professional front-projection unit uses a semi-silvered mirror to put the camera lens and the lens of a special projector on the same axis.

hood

projector

lamp house

the model to jump in front of and to the right of the projected image of the plane, shooting at the peak of the jump. When the final picture is turned back so that the aeroplane appears to be flying in the correct direction, the model will appear to be falling horizontally from below.

Apart from jumping into the frame, the only other method of producing a full-length picture of your subject must, like back projection, involve the building of a set in front of the screen. Unlike back projection, flats can be made from screen material and stood in front of the model so that the figure can appear to be in front of some objects and actually behind others in the final picture. Similarly, if it is necessary to have a lighting stand in the picture to, say, give a rim-light to the model's hair, pieces of the screen material can be stuck on to the stand and it will seem to disappear into the background.

Front-projection units like the one described above can be hired by the day as part of the equipment in some professional studios. A less expensive method, though one that obviously does not give the same high quality, can be tried with a normal household projector and screen. The basis of the idea is simply to project the slide on to the screen at an angle and position the subject a good way in front of it so that light from the projector does not reach the subject and light on the subject does not reach the screen. The two light sources are adjusted until the exposure is the same and then, if shooting in colour, the picture is taken on tungsten film. Or, with the correct filtration and exposure, the subject can be lit by flash. The main problem is that with the projector throwing its beam from the side, the image on the screen will be distorted. That won't matter if the background is some sort of an abstract design, but for the picture to appear normal, a specially distorted slide must be used. That can be effected by choosing a suitable background slide in advance and, with it projected straight at the screen, re-photographing it from an angle, using a small aperture to allow for the depth of field across

the screen. This produces a distorted image on the slide. When the front-projection picture is to be taken, the projector is set up in the position previously occupied by the camera. The distorted slide is then projected on to the screen. But because it is being distorted again from the positioning of the projector relative to the screen, the two distortions cancel out, giving a normal-looking image. The final effect is far from perfect, contrast build-up from a slide being re-photographed twice not helping matters. But for many the lack of quality is more than offset by the equal lack of expense that might otherwise be incurred by use of a professional front-projection unit. And the whole thing makes an interesting exercise, something the special-effect photographer is always happy to become involved in.

Panoramic pictures

If the human eye were a camera lens, it would be a fisheye; its field of view is between 150 and 170 degrees. The 'shape' of the view we see of the world is in a ratio of around 1:2½. Conversely, the field of view of a standard 50 mm lens on a 35 mm format is 46 degrees, and the ratio of a normal 35 mm frame, widely accepted as the shape a picture should be, is 1:1½. We see in a panoramic format, so why don't we take pictures that way too? The cinema recognised the fact back in the early 1950s when Cinemascope first hit the scene. Yet for just about every other artform – painting, sketching, photography and even television – the conventional format has always had a ratio of around 1:1½. In photography, of course, we have wide-angle and fisheye lenses. But all they do is open up the field of view: as the width grows, so does the depth, and in the end they may have more of the subject in the frame, but that frame is still stuck in the old 1:1½ ratio.

The question of how to make photographs match the view seen by the eyes is one that has fascinated photographers almost since the dawn of photography itself. The first panoramic camera made its appearance in 1845, only six years after the announcement of the Daguerreotype Process, the first practical method of photography. Built by Frederick Martens, it took pictures on curved metal plates and gave an angle of view of 150 degrees with a picture ratio of 1:3. It worked by means of a clockwork-driven lens mount that pivoted at the time of exposure, in much the same way as one of the few panoramic cameras available today. In fact, just about every current method of taking panoramic pictures had been tried with varying degrees of success before the first decade of the 20th century had passed. Here are some of the more modern methods available to today's photographers.

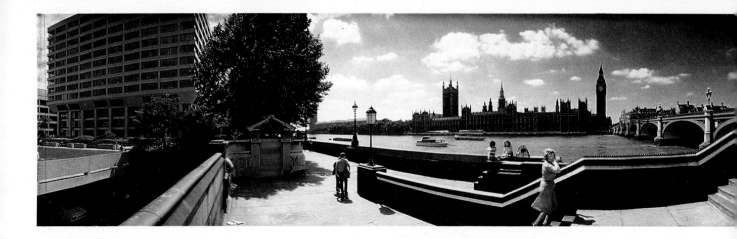

Special cameras

The cameras still made for panoramic photography are few in number and high in price. They follow three different principles: rotating camera with travelling film, pivoting lens and cropped format. The first of these types looks somewhat unconventional compared with a normal camera. It usually comprises an oval-shaped body mounted on a sturdy handle. It has a control for apertures, including a 'closed' position but, to outward appearances, no shutter-speed control. Lenses are usually wide-angle and fixed focus. Inside, the layout is as unconventional as the outside. There are models available for both 35 mm and 120/220 rollfilm, producing image widths of 16 cm and 38 cm respectively, a format ratio of around 1:6½.

The film is slotted into a holder on one side and taken across a slit that runs vertically down the film plane, to be attached to the take-up spool opposite. It's that slit, the only place through which light from the lens is allowed to reach the film, that controls the effective shutter speed. This is known as a linear or slit shutter, and there is a choice of different widths, each a part of a thin curve of metal. The wider the slit, the slower the effective shutter speed, and one must be screwed into place across the film plane before the camera is loaded.

To use the camera, the aperture control is shifted from its 'closed' position to the stop required to give the correct exposure with the 'shutter' slit in use. As soon as the aperture is open, it exposes the film through the slit to give a thin stripe that is naturally overexposed within a fraction of a second. The shutter release is then pressed and the camera revolves on its handle through a complete 360 degree circle. While that is happening, the film is wound past the slit at the same speed. The effect is to 'spray' the picture on to a length of film. When the circle is complete, the camera automatically stops and the photographer closes the aperture. The system is smaller in scale than, but is otherwise identical to, that employed in the Kodak Circut, a vintage camera still used by some school photographers today to produce those amazing 180 degree pictures full of schoolchildren.

Using cameras like this involves a rethink on what is considered conventional composition. It's no use merely looking at the scene in front of you: like the camera, you must turn in a complete circle, taking notice of all sides. Standing, for instance, with your back to a wall and a magnificent landscape in front of you is of little use: half your picture would show nothing but wall. Similarly, the camera cannot be used at eye-level. That way, as it revolved, half the

Page 122: the special camera that took this picture had a lens designed to pivot about its central axis at the moment of exposure. The result is an image that is slightly distorted with subjects at the centre of the frame appearing closer to the camera than those at the edges.

A complete circle is covered in this picture, taken with a camera that revolves at the moment of exposure, the film moving at the same time and in synch across a linear shutter.

picture would show your out-of-focus face. The photographer must position himself below the camera, either by holding it above his head or, for better results, by mounting it squarely on a tripod and crouching below the lens's field of view.

To make the best of a 360 degree panoramic landscape, the camera must be pointed *away* from the main subject of interest. This is because objects in front of the camera that are the start and end of its travel will record at the edges of the elongated frame. If you want your main subject to record in the centre of the frame, it must be recorded halfway through the cycle. Hence the reason for pointing the camera in the opposite direction at the start. For best results, these cameras should actually be allowed to make two complete circles before stopping. The best part of the picture can then be cropped out of the final 720 degree view. This method also obviates the problem of losing a small part of the picture in the overexposed slits at each end of the frame.

Pictures do not have to be confined to the horizontal format. The camera can be turned on its side to photograph a tall building, in which case, half the final picture, showing the scene opposite the main subject, will be upside down. It can also be

pointed down towards the ground from some high viewpoint, in which case half the picture so produced will show nothing but sky. A certain amount of distortion is apparent in the final pictures. Long, straight subjects such as large buildings or walls appear to curve away to tapering points at each side as the wide-angle lens scans their length from its single viewpoint. But the fact that the whole picture is of such an unconventional shape – showing the scene in front, to the sides and behind all in one plane – will, by its very nature, often disguise the fact that there is any distortion present.

The second type of panoramic camera looks more like a conventional model, although one with a very different-looking lens mount. Pictures in this type of camera cover an angle of view of around 140 degrees with a format ratio of 1:2½. The only model available takes 35 mm film and produces an image 59 mm wide. The lens is pivoted at its centre and the film plane is curved. At the moment of exposure, the lens rotates about its axis, projecting an image to the film via a slit attached to the rear element of the lens. Apertures work in the conventional way and shutter speeds are controlled by the speed of the lens movement. The pictures show some distortion, objects in the centre of the

frame appearing larger than similar-sized objects at
the edges.

The only type of panoramic camera that doesn't
show distortion in the picture it produces is one
which works on a cropped format. The theory is
this. Take an extra-large-format camera, fit it with
a 90 mm lens (wide-angle for that particular
format) and then redesign the whole thing to take
rollfilm right across the centre of what would
normally be the large-format film plane. The result
is a negative or transparency measuring 6 × 17 cm
(nearly 1:3). Despite its unconventional format,
this type of panoramic camera is nearer than any
other to normal design, shutter speeds and
apertures being operated in the normal way.

Special lenses
Anyone who has been to the cinema has seen a
panoramic picture. Cinemascope, launched by 20th
Century Fox in the early 1950s, gives a format of
1:2¾. However, unlike panoramic forms of still
photography (and, indeed, some of the now
discontinued movie systems), the process does not
rely on extra-wide film travelling through the
projector. Instead, the panoramic image is
'squeezed' on to a standard 35 mm cine frame by
use of a special lens on the camera, and then
'expanded' on to the wide screen by a similar lens
on the projector. The lens that works these wonders
is known as an anamorphic, and it can be used as
successfully in still photography as in cine.

An anamorphic lens, as we mentioned when
dealing with its mechanics in the chapter on special
lenses, actually has two different focal lengths, one
horizontally, the other vertically. It is mounted on
the camera with what appears from the front to be
elliptical elements aligned in an upright direction.
The magnification in the horizontal plane is then
less than that in the vertical plane. The degree of
that difference depends on which type of lens you
are using. Different lenses are designed for giving,
for instance, 1:1½, 1:1¾ or 1:2 ratios. If you are
using a 1:2 ratio lens, the magnification in the

horizontal plane is only half that in the vertical
plane. The result is a distorted picture whose image
is squashed to half its width, while retaining the
correct height, thus taking in a far greater angle of
view than would otherwise be possible on a
standard negative. That negative is then enlarged
via another anamorphic, but one which this time
has been turned through 90 degrees to squash the
height, while retaining the same width. The result
of that is an image whose width-to-height
proportions are now correct, but whose format is
panoramic. Similarly, transparencies can be taken
and projected through anamorphic lenses to give
wide-screen slides.

Anamorphic lenses are available simply to replace
the standard lens on a single-lens reflex. Less
expensive and far more common, however, are the
type that work as supplementaries screwing into
the filter thread of a standard lens. The same
anamorphic can then be used with a suitable
adaptor on the enlarger or projector. In use, the
anamorphic is set to the hyperfocal distance for the
camera lens to which it is attached, and focusing is
effected by use of the camera lens. This will work
for perhaps ninety per cent of the time. To move in
closer, or when working at wider-than-average
apertures, the anamorphic must be focused on the
same distance as the camera lens.

Joining prints
Panoramic pictures can also be shot with a normal
camera and standard lens by taking several shots
one after the other on negative film and joining the
final prints together to make one super-wide
picture. The only accessory needed is a sturdy
tripod and a spirit level. The tripod is first set up
and adjusted so that it is standing absolutely level.
The camera is mounted, either horizontally or
vertically, and a number of pictures are taken, the
camera panned through a set distance between
each. The scene is lined up in the viewfinder each
time so that there is an overlap between each shot, a
strip to one side of the first picture being repeated
in the second and so on until the panorama is

An anamorphic lens on the camera squeezes the image on the negative, which is then expanded by another anomorphic at the printing stage. The result is another method of making panoramic pictures.

A twin-lens reflex was used to make this panoramic picture, but any other type of camera can be used to similar effect. The extra-wide angle of view is the result of taking six exposures and later joining the prints together in a single strip. *Paul Bennett.*

complete. The prints are made as normal, then trimmed with a sharp knife or scalpel and matched side by side until the panorama is complete. The technique can be used either with mono or colour prints. That's the theory in brief, but here are eight extra tips to help you make better panoramas.

1 If you are shooting a complete 360 degree picture, the tripod must be kept absolutely level. If your finished panorama is only going to show a segment of a circle, then the camera can, under certain circumstances, be tilted a little as required to compose the picture. This tilting will introduce a degree of distortion, making horizons appear to curve, and so the technique should not be tried with pictures in which certain subjects are recognisable as always being straight – buildings in cityscapes, for instance. More often than not, however, this method of panoramic photography is carried out on landscapes where hills make an uneven horizon and the distortion will not be noticed. Watch out

for trees, though, and make sure they are always growing straight in the picture.

2 Shooting with the camera in a horizontal position will result in fewer joins in the final picture than if it is shot with the camera vertical. The vertical format, on the other hand, gives you more depth to the picture.

3 Standard lenses work well, but the effect can often be accentuated by use of a wide-angle. If you *do* use a wide-angle lens, allow a larger area for overlap, so that you can cut off the final print any distortion caused by the lens at the edge of each individual frame. Leaving it in will give your panorama a strange, uneven look.

4 Clouds that are often considered an essential ingredient in a normal landscape can sometimes ruin a panoramic picture because they change their position in the sky between shots and so make it

Butting prints together to make a panoramic picture. The prints are cut along natural lines in the picture and mounted on stiff card for the end result.

impossible to match up the prints for the final panorama. So shoot on cloudless days and never be tempted to use a filter in black-and-white photography to enhance the sky.

5 At the matching stage, the prints can be trimmed one of two ways: either straight or along natural lines in the picture such as roads or hedges. The second method is the better as it helps to disguise the joins. To make it work, cut the first picture along its natural lines, lay that on top of the second picture and cut along the edges to make the two mate more perfectly.

6 Holding the knife or scalpel at an angle when cutting will ensure that slightly more base than emulsion will be cut away from the print, making a better join.

7 Always butt prints; *never* overlap them.

8 Mount the prints on card, using a slow-drying

glue that leaves you time to slide the prints around and so match them better. When it is complete, trim the whole thing top and bottom to give two straight parallel edges.

Cropped formats
We have already looked at a panoramic camera which slices a 6 cm wide negative or slide out of a much larger format. Now let's see how that concept can be reduced in size, and a similar-shaped picture produced far less expensively, by transferring the idea to a smaller original format. Rollfilm cameras, taking eight shots to a roll of 120 film, were produced in abundance during the first half of this century. Some were elementary, no better than snapshot cameras; others were extremely sophisticated, offering top-class lenses, focusing facilities and a good range of shutter speeds. Despite the fact that many of these cameras have become collectors' items, they can still be bought in second-hand and antique shops for a relatively low price. The eight-on format gives a negative or slide

measuring 6 × 9 cm, and this makes a suitable starting point for cropping to a panoramic shape.

If you have access to one of these cameras, usually in the traditional shape of the old folder, load it with any modern 120-size film and shoot in the normal way. When composing your picture, however, look through the viewfinder and think panoramic; position your principal subject along a strip across the viewfinder's centre and ignore any objects top and bottom of this strip which will not appear in the final picture. If the end product is a print, it can simply be trimmed to give a panoramic format. If you are working with reversal film, the transparency so produced can also be trimmed and mounted in two standard 35 mm slide mounts side

by side that have had part of their margin cut away to extend the conventional aperture to one edge. Slides so produced and mounted give a picture-format ratio of 1:3½.

Better quality is obtainable if, instead of using a vintage camera, a modern professional rollfilm camera is used. Many of these today give a 6 × 7 cm format which, although 2 cm narrower in width, can still be cropped and mounted in adapted 35 mm mounts to give a ratio of around 1:2½. Using such a camera has the added advantage of offering the photographer the chance of using a wide-angle lens, not usually possible with a vintage folder, and that can add to the panoramic effect being created. Since these relatively large rollfilm

When composed correctly, any scene can be cropped to a panoramic format. A 9 × 6 cm picture taken on 120 rollfilm, cropped to fill two 35 mm mounts side by side, is particularly effective. It also helps if the original picture is shot with a wide-angle lens.

A panoramic contact sheet, made by taking 30 consecutive pictures in five strips of six. The camera was moved from left to right, bottom to top between exposures.

formats can be cropped to a panoramic format, it follows that similar cropping can be applied to the standard 35 mm frame. And, using a 35 mm camera, lenses with wider-than-standard focal lengths can be used to aid the effect. The drawback is that the more a 35 mm frame is cropped, the more quality suffers from any extra enlargement, either through printing or projecting. The convenience of starting with a larger format is that the resultant negative or slide can be the same depth as a standard 35 mm frame, but with far greater width.

Panoramic contact sheets
Another type of panoramic effect can be created by producing a contact sheet that is, in fact, one large picture of a suitable subject split into a number of frames – 36 in the case of 35 mm, perhaps the best format for this technique. To build up the composite, the camera should be mounted on a tripod and levelled horizontally, though not vertically. Choosing a suitable subject (a landscape or a tall building, for instance) point the camera to the lower left of what has been chosen as the final, overall picture. Take one shot and then pan the camera horizontally to the right until some reference point at the right of the first frame is now just out of the left of the second frame. Make a second exposure. Repeat this until six exposures have been made, and then return the camera to its original position and tilt it until another reference point at the top of the first frame is just out of the

bottom on this, the seventh frame. Make another series of six exposures. Repeat this action until six strips of six pictures have been taken. Process the film as normal and then make a contact sheet with frame number one in the bottom left and subsequent numbers reading left to right, bottom to top. The result will be what appears to be one picture, recorded as 36 small fragments of the total.

When thinking through the reasoning behind the method of taking a composite like this, it might at first seem that, since the film in most 35 mm cameras is wound from left to right, the second frame should actually be shot to the left of the first, rather than to the right. If that's what you have been thinking, you have forgotten one thing: the camera lens records its image on the film upside down.

Slit shutters and circular subjects

Earlier in this chapter, we looked at a camera that revolved while the film moved to make a panoramic picture; in the chapter on distortion and reflection, we dealt with a less sophisticated method of moving 35 mm film through a camera to produce an abstract blur. Putting the two together, you might see how a rather crude form of panoramic picture can be made in this way. To recap briefly: the film is loaded and wound through the camera without being exposed. It is then wound back by means of the rewind knob, with the shutter open and the image reaching the film via a narrow slit positioned in front of the lens or at the film plane. If, now, this film movement is coupled with camera movement in the same way as it is in the revolving panoramic camera, a super-wide picture of up to 360 degrees can be attempted. The camera must be mounted on a tripod and levelled. Then, as the film is wound backwards, the tripod head is panned, through an arc or even a complete circle, in the same direction as the film is being wound. That's anticlockwise for a standard right-to-left rewind. Naturally, on the specialised camera, these two movements are precisely synchronised to give a perfect panoramic picture. Such synchronisation is

all but impossible outside of pure luck when trying the technique manually. But, even with the two movements differing, interesting effects are produced, as parts of the picture record almost naturally, while others appear to expand or contract according to the speed of the two movements. The effect is best practised on negative film, where small discrepancies in exposure can to some extent be adjusted at the printing stage. On reversal film, where accurate exposure is more important, the correct degree of movement in film and camera is almost impossible to calculate.

This method of moving the film past a slit can also be used for making a completely different type of panoramic picture in which, instead of the camera being in the centre of the circle, it is pointed at a circular subject and all sides of that subject are recorded on an elongated frame. For this, the camera remains stationary, but the subject is revolved in synchronisation with the moving film. There are cameras made specifically for this purpose, in which the film movement is synchronised with a turntable on which the object to be photographed is stood. They are known as periphery cameras. On a more amateur scale, a small object can be placed on a record player turntable and the film rewound through the camera as before in an endeavour to match the speed of the wind with the revolution of the turntable. Alternatively, all sides of a person's head can be recorded on a single strip of film by asking the person to turn through a complete circle as the film is wound behind a suitable slit. Again, the effect is best tried on mono film, unless you have access to one of the specialised cameras that have been purpose-built for this type of photography.

Soft focus

There is no such thing as soft focus. On the face of it, a bold statement, considering the popularity of the effect that has come to be known as 'soft focus'. Either a picture is *in* focus or it is *out* of focus. A soft-focus picture appears, at first sight, to be both. The edges of the image are fuzzy, in the way they become when a picture is out of focus. But closer examination will show that the picture, while not entirely sharp, *is* in focus.

So what actually is 'soft focus'? It is diffusion, the breaking-up of light rays from their normal straight lines into random directions so that, although an image is correctly focused, the rays that produced that image have not hit the film straight-on. Instead, they have hit the emulsion at varying angles, spreading the image slightly so that where light meets dark, the highlights are spread into the shadow areas, giving an impression of softness. Which is the reason the term 'soft focus' has come about. And who are we to argue? You can't fight tradition and so, throughout this chapter, we will refer to the effect by its commonly-accepted name.

(Although this book deals essentially with special effects in the camera, rather than in the darkroom, it is worth briefly digressing at this point to mention that soft focus induced at the printing stage gives a different effect to that produced at the taking stage. The reason is this. Soft focus spreads highlights into shadow areas. The highlights on a negative are the shadow areas on the print. Using a soft-focus attachment on the enlarger, therefore, produces a print which reverses the effect, spreading shadow areas into highlights.)

Soft focus is used a lot in portraiture where it not only gives a more feminine look to pictures of young girls, but can also be used to help cover up small skin blemishes. It isn't, of course, confined to

portraits, and it can work equally well with landscapes, flowers, still-life, or with any other subject that warrants the treatment. The methods of producing the effect are many and varied, but whichever technique is used, three points hold equally true:

1 Best results are obtained with subjects that contain bright highlights and strong contrasts between the tones of the picture.
2 Side- and back-lighting exaggerates contrast and so helps to accentuate soft focus.
3 Diffusion in general nearly always lessens as a lens is stopped down, and so the effect usually works best at medium-wide apertures, starting at around $f/4$ or $f/5.6$ and opening up from there to increase the degree of softness.

Having chosen the right subject and arranged the picture so that it is lit the best way for soft focus, there remains only the choice of method for breaking up and diffusing the light. The process is fairly simple, but the many methods range from the use of lenses to lighting and from filters to black nylon stockings!

Soft-focus lenses
Perhaps the most expensive way of obtaining soft focus is by use of one of the specialist lenses made for the job. Many of these not only give a soft-focus effect, they also allow the photographer to control the *degree* of softness. Although it is not the purpose of this book to go into great depths on the subject of optics, a brief account of what goes on inside a compound lens will help you to understand how a soft-focus lens works.

In theory, light rays from a set point on a subject should be focused by a lens to meet at a single point in the image. In practice, it is impossible for a single, simple lens to be focused so accurately. The result is an image of the subject which, in ultimate detail, fails to follow the exact shape of the subject and does not fall in the exact place that mathematics decrees is correct. These imperfections are known as aberrations. They are reduced by

computing and building compound lenses, comprising several elements, each one countering and correcting aberrations in the other until the image is as near perfect as it is possible to get. There are many different types of aberration, all influenced by a range of factors: distribution of power among the lens elements, the shapes and thicknesses of those elements, the material from which the lenses are made, the position of the aperture stop in the overall design and the separation between the elements. This last factor is the one that concerns us most.

A variable soft-focus lens works by purposely introducing a measured degree of spherical aberration, one of the many types. The way it does that is to shift elements within the lens as the softness control is turned. The more aberration introduced, the softer the effect on the image. The effect increases with the size of aperture in use, decreasing as the aperture grows smaller. Many soft-focus lenses, therefore, can be used as normal

Page 134: more soft focus, this time from a special device that introduces wedges of clear perspex around the edges of the lens. The accessory is adjustable for different degrees of the effect.

Page 135: another way of inducing soft focus is to use a filter designed for the job. One has been used on this picture, shot against the light to accentuate the effect. *Frank Peeters.*

Left: a special lens, designed to introduce varying degrees of aberration, is used for making a soft-focus portrait.

Right: floating elements in a lens give a variable degree of soft focus. With the elements in their 'correct' place (top), all light rays converge on the same spot, giving a sharp image. With the two rear elements moved, light rays entering the lens at different points converge and focus in different places, making the image appear soft. The degree of softness varies with the amount by which the elements are displaced.

Two types of soft-focus filter. The dimpled type (left) gives its effect irrespective of the aperture in use; the effect with the concentric circle type (right) differs with the aperture.

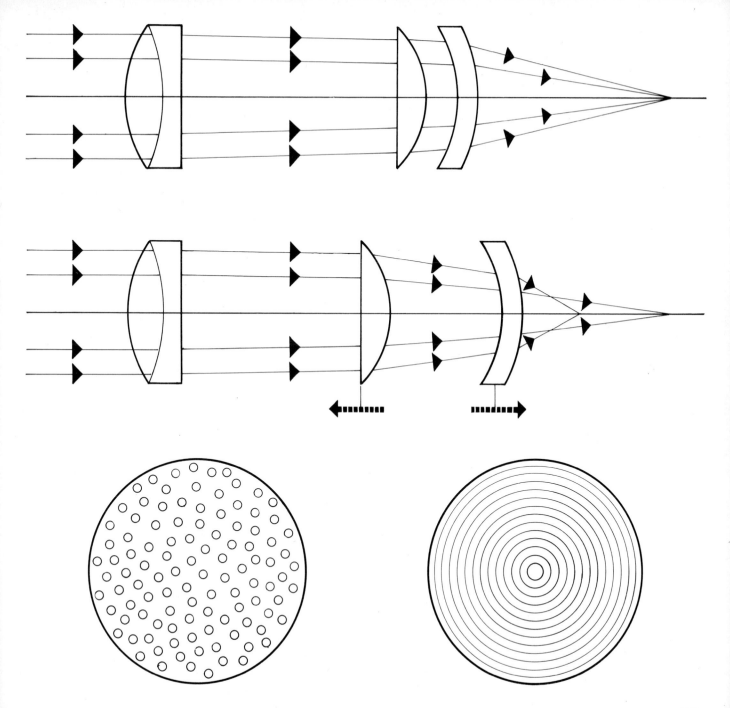

at their smaller apertures, only giving the soft effect at their wider stops. If a lens has, say, five degrees of soft focus and they operate at the two largest apertures, it follows that no fewer than ten different gradations of softness can be introduced to the image. Because shifting the elements in the lens also alters the focal length, the focus changes as the softness control is adjusted. Therefore the degree of softness required must be set before focusing is carried out and, if the softness control is then altered, focus must also be changed.

Soft-focus filters

These are probably the most popular method of obtaining soft focus. There are several types of commercially-available soft-focus filter, each giving slightly different effects. They comprise glass or plastic with some sort of pattern etched into the material to break up the light rays on the way to the lens. The way the pattern is etched controls the final effect. If the pattern is made up from a random array of small spots, either in the form of dimples or deposits actually on the glass or plastic, the soft focus is achieved irrespective of the aperture in use. If the pattern on the filter is made up from concentric rings, the effect is more pronounced at wide apertures than at the small end of the scale, and can therefore be controlled to some extent.

A different kind of diffusion comes with a fog filter. This one is covered with a series of minute white spots interspersed with clear areas. The effect is of soft focus as the light is broken up by the spots while, at the same time, a white mist-like veil covers the entire image. Different strengths of filter give different degrees of diffusion ranging from a light mist to the appearance of thick fog. The effect of these filters is reduced as the lens is stopped down.

Cross-screen and diffraction-grating filters can also be used to some extent for soft focus. They are designed to produce certain special effects from point-sources of light (see first chapter), but if no such sources are present, the way they are etched will break up light and so diffuse the overall image.

Some centre spot filters are actually made from mild close-up lenses with a clear spot in the centre, allowing a sharp central image but giving a fall-off in focus to a softer look at the edges.

Many of the filters mentioned above are available in a combined form. Fog filters can be found with central clear spots, again to give a sharp image in the centre of the frame but with a diffused fog-like effect towards the edges. Similarly, straightforward soft-focus filters of the etched circles or dimpled variety can also be found with a central clear spot so that their effect is only apparent at the edges of the frame. All these work best at medium-to-wide stops like $f/4$ or $f/5.6$. Wider apertures destroy the sharp centre while smaller apertures destroy the soft edges. Fog filters are also available in graduated forms, offering a thicker concentration of the effect at one edge, gradually dispersing towards the other. They are best in landscape photography, where they can be used either to affect only the sky or, inverted, to give a misty effect to the lower part of a picture.

Other accessories

Apart from lenses and filters, there is another type of soft-focus accessory available that fits to the front of a camera lens. It consists of what appears to be a large iris, mounted in a plastic holder. The iris has a number of blades and, as a ring on the holder is turned, they move to meet in the centre. Turn the control the other way and they retract to the outside edge. This allows the photographer to obstruct as much or as little of the lens as he likes, varying the control as desired and according to the aperture in use. The device gives a soft edge to the picture with a sharp central image.

Do-it-yourself soft focus

Despite the proliferation of commercially-available soft-focus devices, some of the best effects are created by home-made gadgets. All that is really needed is some method of degrading the image, and that can be arranged by shooting through all sorts of different materials. Here are six suggestions.

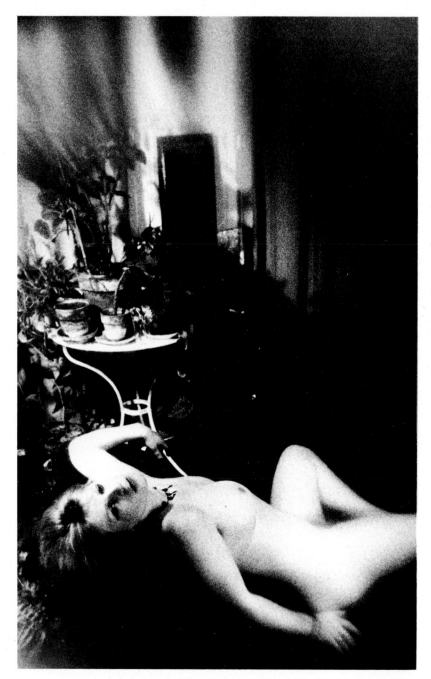

Black nylon over the lens induces a soft diffusion to the image without adding any colour cast to the original.

A thin smear of petroleum jelly on a clear filter or piece of optically flat glass softens the edges of the image. *Frank Peeters*.

1 Perhaps the most popular way of achieving soft focus with minimum cost is to shoot through a thin layer of petroleum jelly. Using a clear filter such as a UV or skylight, smear a very small amount of jelly around the edges, leaving a clear spot in the centre. If no filter is available, use a piece of optically flat glass (negative carriers from enlargers are a good source or, if you can still find any, try old photographic plates with the emulsion removed by bleach or fixer) and hold it in front of the lens as you shoot.

2 Petroleum jelly isn't the only substance that can be coated on to clear glass to give soft focus. Some others worth trying include hair lacquer, sprayed on from an aerosol and allowed to dry; clear adhesive applied in a series of concentric circles and then allowed to dry; and steam from a kettle if you are working in a studio, that is allowed to condense into tiny water droplets. Solid opaque shapes applied to a filter work too. A black spot painted or stuck into the centre of the glass and positioned so that light has to travel around it to reach the lens gives yet another method of achieving a soft-focus effect.

3 Next on the list comes black nylon. A piece can be cut from an old pair of stockings or tights, stretched tightly over the lens and held in place with a rubber band. The reason for using black is to prevent a colour cast in the picture if you are working with colour film. With mono, the problem obviously does not arise. But with colour film, any colour other than black (and that includes white) will veil the picture with its own tone. Equally, of course, that very effect can be used to its own ends. A piece of light-brown nylon stretched over the lens will give not only soft focus, but also a sepia effect, lending a vintage appearance to your pictures. If the subject is chosen accordingly, that effect can be extremely attractive. Merely stretching the material over the lens will soften the whole picture, but if you would prefer to show a clear central spot with misty edges, a small hole can be made in the nylon with a burning cigarette end. But beware. Make the

hole before you attach the nylon to the lens to prevent the cigarette accidentally touching the front element. Other materials that work well when used this way include net, chiffon, silk or any substance that is relatively translucent.

4 Small pieces of plastic make another departure point for do-it-yourself soft focus. You need a piece that is lightly frosted. Examples of this can be found in commercially-available slide pockets, the type that is made to hold a number of transparencies in their mounts for filing purposes. Those designed for medium-format slides are better than the 35 mm versions, because they have larger apertures of plastic to cut out. In the absence of frosted plastic, clear plastic can be used and rubbed with a mild abrasive to scratch the surface. Either type can then be mounted in a card slide mount and held in front of the lens with a suitable filter holder (see chapter on filters). Again the effect can give an overall softness, or a small hole can be cut in the centre for a sharp central image. About 6 mm is a good diameter to try at the start, shooting at a wide aperture.

5 A lens hood can be pressed into service to help with some soft-focus effects. Crumpled cellophane stretched across the hood gives one effect, adhesive tape with a gap in the centre gives another.

6 No accessory at all is needed for yet another form of soft focus (one of the best as it happens). All you need is your own breath. Compose your picture and then, just before taking it, breathe lightly on to the front element of the lens. Using a single-lens reflex, you can watch the effect through the viewfinder, shooting a sequence of pictures as the mist gradually clears. Often it will clear from one side of the lens first, gradually spreading across to the other side, giving selective soft focus that changes second by second as you watch.

Most of the above techniques involve cutting down light transmission as the effects are created. Extra exposure is therefore inevitable, but you can

A selection of soft-focus devices, both simple and sophisticated. At the top, the most expensive is a variable soft-focus lens that is designed to induce varying degrees of aberration to the image; bottom row, left to right: a commercially-made soft-focus accessory that introduces wedges of clear perspex around the lens; an ordinary lens hood with strips of adhesive tape stretched across it; a soft-focus filter; and, on the camera, a piece of black nylon held in place with a rubber band around the lens.

usually rely on a TTL meter to correct the problem automatically. In the absence of TTL metering, the appropriate soft-focus device can be held over the cell of a hand meter to show the difference in exposure that will be needed.

Soft focus through blur
Soft focus, as we have seen over the preceding pages, is actually a correctly-focused image in which the highlights have been forced to expand into the shadow areas. That effect can also be attained through pure camera technique, using no accessory in front of the lens whatsoever. The accessory you will need, however, is a sturdy tripod. Set the camera on the tripod, aimed at your chosen subject, and switch to multiple exposure if your particular model has such a control. If it hasn't, use the method described before for overriding the double-exposure prevention device (see chapter on multiple exposures). Now shoot

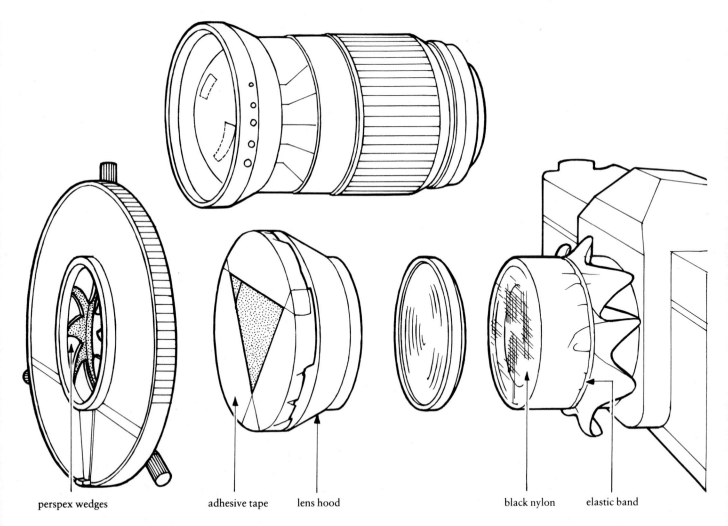

perspex wedges adhesive tape lens hood black nylon elastic band

two pictures of the subject, on the same frame, one sharply focused, the other out of focus, using half the metered exposure for each – that's one stop less. The degree by which the second shot is taken out of focus controls the final effect.

A variation on that idea can be taken with a single shot if a long shutter speed of around 1 second can be used. For that reason it works best in a tungsten-lit studio, although outdoor shots can be taken by use of neutral density filters. The camera is sharply focused on the subject and then, as the exposure is made, the lens is smoothly turned out of focus. In the studio, the effect can be made even better by combining tungsten and flash light. The flash is used to illuminate the object itself, while the tungsten is used best as a backlight on, say, the hair in a portrait. The final picture then shows a sharp subject surrounded by a halo or blur. The colour temperatures of the light sources must of course be adjusted when shooting in colour.

Soft focus through lighting

One of the causes of soft focus is flare, which is when light reflects back and forth across the elements within a compound lens, reducing contrast. In the studio, that can be induced and controlled by placing a light out of camera range but with its beam shining back obliquely into the lens. Ask an assistant to move the light about as you watch its effect on your subject through the viewfinder of a single-lens reflex. Used in the right way, the technique can give an easy and inexpensive way of controlling the amount of softness required in a portrait.

Natural soft focus

And finally, don't forget Nature's own soft focus. Mist and fog provides that, although such weather conditions are not completely ideal for shooting. They need something extra in the way of lighting; and that can only be provided in this instance by the sun. If you are out to shoot on a misty day and there is no sign of the sun, try to find a hill to climb. As you get further towards the top, you will

Top left: one soft-focus accessory that costs nothing at all is your own breath. Breathe lightly on the lens and take the pictures as the mist gradually clears from its surface.

Above: some of the older, uncoated lenses when shot into the light give a degree of flare that can be annoying to the perfectionist, but which gives a pleasant soft result for the special-effect worker. This picture was taken with a 1936 camera that sported a fairly simple lens even for its day.

Right: light shining into the lens induces flare, which gives another form of soft focus.

Bottom left: two shots on the same frame, one in focus and the other slightly out, give another method of making soft-focus pictures.

probably find the sun becoming clearer and clearer, as the mist gets thinner. There will come a spot where both sun and mist are in evidence, and that is the best place for pictures.

That brings us back to one of the first points made in this chapter: soft focus works best with side- or back-lighting. So don't shoot with the sun behind you, since it will reflect back off the moisture particles in the air that make up the fog and spoil the picture. Rather, try to shoot with the sun from the side, picking out some detail in a landscape that has been isolated by the mist. Or shoot directly into the sun, using it as it shines through the mist at your principal subject, or combining it with silhouettes of trees and the like. But don't be tempted to combine this natural soft focus with artificial soft focus from one of the lenses or filters we have looked at. Soft focus is an effective technique when used with care and kept to a minimum. Start using too much and you'll soon find out how easy it is to have too much of a good thing.

Controlled blur

Ordinarily, a photographer does everything in his power to obliterate blur. A steady camera and a correctly-focused lens are two of the most elementary steps towards better pictures. But for the special-effect photographer, blur can be beautiful if it is used in the right way. That doesn't mean he can afford to be careless. We're not talking about blur by accident, but rather about ways in which to control blur to make different and interesting pictures. There are two very distinct types of blur. One is caused by movement, the other by focus; or rather, the lack of it. In the first, the blur takes the form of lines moving away from various objects in the direction of the movement. In the second, the entire image is affected, the blur spreading softly in all directions from each object in the picture.

Blur through movement
This type of blur can be introduced into a picture in four ways: by allowing the subject to move while the camera remains stationary, by moving the camera with a still or moving subject, by changing the focal length of a zoom lens during the exposure, and by moving the film across the focal plane while the shutter is open. All have one thing in common: the almost mandatory use of extra-slow shutter speeds. For straightforward photography, the slowest speed likely to be needed can usually be compensated for by use of a small aperture. But here, we could be talking about exposures of whole seconds, rather than fractions, outdoors on a sunny day; speeds which are far too slow for correct exposure, even with the smallest aperture available. A different method of control must therefore be found.

The obvious way is to load the camera with extra-slow film, but that isn't as easy as it might at first seem. The slowest black-and-white films

readily available have speeds of around ISO 32/16°; the slowest colour negative films are only ISO 100/21° and the slowest colour reversal films are rated at ISO 25/15°. Since most standard lenses close down to no smaller than f/16, the slowest shutter speeds you are likely to be able to use in a conventional camera with standard lens, loaded with non-specialist film on a normal, sunny day, is ⅓₀ second for mono or colour reversal stock and ¹⁄₁₂₅ second for colour negative stock.

One answer is to use more specialist films. Kodak make a mono copying film, available only in sheet form, called Gravure Positive Film 4135. It is produced mainly for technical and scientific photography where a blue-sensitive emulsion is of importance, and its speed is a mere ISO 8/10°. It would, of course, be next to useless for conventional photography, but could be of considerable interest to the special-effect photographer. On the colour reversal side, Kodak make Photomicrography Colour Film 2843 in 35 mm cassettes. Its speed is ISO 16/13° but it must be processed in the now-outdated Ektachrome E4 chemicals. Another way to use slow shutter speeds is in low-light conditions. In the studio, this presents little problem, but outdoors, lower light often means a lack of contrast that the photographer might not want. The best answer to the problem is to use filters to reduce the amount of light reaching the film.

In mono photography, you can use normal filters with strong filter factors, providing you remember the effect they are going to have on various tones within the picture (see chapter on filters). Such filters can also be combined for stronger effects. A red and green or red and blue together reduces the effective exposure considerably. The combination of red, green and blue, gives a filter which, in theory, should be completely opaque but which actually lets just a minute amount of light through. By this point, reciprocity failure makes it impossible to judge exposures by filter factors, and a good deal of trial and error must be employed

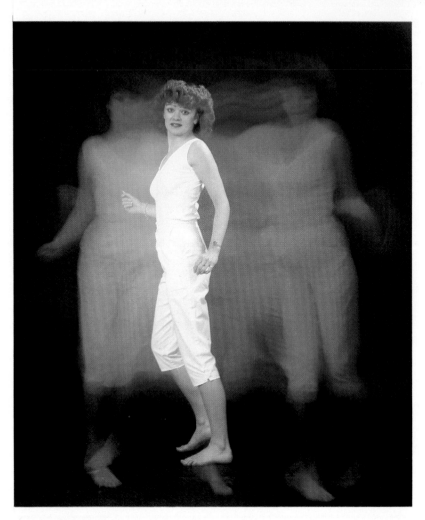

Flash and tungsten lighting have been mixed for this picture. The camera was stationary on a tripod and the subject was moving. The flash has frozen her movements, while the tungsten light, with its warm cast on daylight film, has recorded them as a blur.

Page 144: long exposures on moving subjects lead to blur; water appears to turn to fluffy cotton-wool. If the available light on the subject does not allow a long enough exposure, neutral density filters can be used. For this shot, the effect has been created by using an exposure of 1 minute at *f*/16. *John Russell.*

before the right exposure is found. A better solution is to use neutral density filters. In colour, you can use only neutral density or polarising filters, unless you want to induce a colour cast to your picture. Their application and how to calculate exposures with them has been covered earlier (see chapter on filters).

Subject movement

Let's look now at the sort of pictures that work well with a stationary camera and a moving subject. One of the most obvious is running water. A stream rushing over rocks or a waterfall photographed with a fast shutter speed will result in every drop of water being captured in sparkling detail. But going for a longer shutter speed will make the water appear like white cotton wool. With a fast-moving subject like this, $1/30$ second will record the effect, but the longer the shutter speed, the more 'fluffy' the water will appear. A landscape that includes plenty of clouds and trees, shot with a shutter speed of one or two seconds on a day when there is a strong breeze, gives an interesting effect. Most parts appear sharp, but the tips of trees blur as they move in the breeze; clouds turn into streamers of white.

Shooting at night can give another method of using slow shutter speeds and recording blur through subject movement. Busy roads make good subjects. Using a tripod and with a shutter speed of around $1/15$–$1/8$ second, moving vehicles can be made to record on film as blurs amid, perhaps, other stationary or slower-moving traffic. Using longer speeds of as much as 15 to 30 seconds, coupled with small apertures of around $f/16$–$f/22$, the vehicles themselves will vanish, leaving only trails of light from their white headlamps and red rear lights. Turn-indicators will record as orange dashes.

In the studio, slow speeds can be used with low tungsten light. A straightforward portrait, taken at a shutter speed of around 1 second, gives a soft effect from the inevitable movement of the subject. Extend the shutter speed to two or three seconds

and encourage your subject to make positive movements during the exposure, e.g. moving hands over and away from the face. And take care with the catchlights. During long exposures they move and make patterns around the subject's eyes. For full-length, try photographing a dancer against a black background and in light that requires a shutter speed of perhaps five seconds to record the blur of the movement. A girl in a light, floating dress will give good results, and the appropriate aperture can be calculated in the same way as it would be if the subject were standing still. For a slightly different effect, allow your dancer to move as before under the tungsten light but, during the course of the exposure, freeze her action with flash. The result will be a sharp image of the dancer, surrounded by softly blurred impressions of her movements. If you are shooting in colour, the tungsten lights or the flash should, strictly speaking, be filtered to match each other. The picture can, however, be enhanced by shooting on daylight stock and leaving the tungsten lights unfiltered, thus giving a correct cast on the sharp image of the dancer and a warm cast on the blur around her. Exposures for this technique should be calculated by finding the right aperture for the flash and coupling that with the correct shutter speed for the tungsten light.

Camera movement

Panning with action is one of the most common techniques to utilise camera movement. It is most often used in sports photography when racing cars or maybe runners are seen sharply defined against a blurred background. Such pictures always convey a strong sense of movement. In theory, panning is simple: select a slow shutter speed, somewhere around $1/15$ to $1/60$ second, depending on the speed of the action you are photographing, couple it with the appropriate aperture and follow the movement, keeping your subject in the same place in the viewfinder as you press the shutter release. In practice, there are a few tips that help to make the job easier. Start by taking up a comfortable, relaxed stance, holding the camera to your eye, your elbows

well into your body for maximum steadiness and *facing the point at which you aim to end the pan.* Turn back towards your subject and, with an easy, fluid movement, follow it past, squeezing the shutter release roughly half-way through your movement and *continue to follow the subject after the exposure has been made.*

Notice the two statements in italics. The first is important because, if you don't pre-plan where you are going to end the pan, it's all too easy to find yourself following the subject, only to discover you need more movement than expected. If your body can't turn any further, you'll miss the picture, and the strain you put on yourself as you try to force that little extra movement will destroy the smooth action of the pan. The second statement is just as important. Don't stop moving the moment you press the shutter, as otherwise, again, you could interrupt the smooth action needed for this type of photography. And, if your reactions aren't good enough, you might find yourself stopping at the exact moment the shutter is open, destroying the effect completely.

Surprising as it might at first seem, panning with action isn't necessarily confined to moving the camera in the same direction as the subject. If your reactions are quick enough, try panning in the opposite direction, catching the subject as it enters the centre of your viewfinder. Subjects such as racing cars, photographed in this way, turn into distorted impressions of their true selves in which the car appears to have been squashed laterally. Another variation on movement during exposure is to track the camera with a subject moving towards you. At a slow shutter speed, try shooting out of the back of a car window at another vehicle that is matching your own speed to the rear. That will give the effect of a sharp subject with the road and background blurred on all sides around it. As with the panning shot, pictures will give a strong impression of speed, even if the subjects were actually moving fairly slowly at the time the shot was taken.

With shutter speeds of several seconds the camera can, with practice, be moved in any direction to give a special effect. Try moving it vertically when photographing tall buildings or in a circular motion when photographing something with a circular shape, a bed of roses for instance. The resulting pictures won't be true to life; instead they will show an *impression* of the subject, and no two pictures will ever be the same.

Camera movement can also be employed for shooting cars at night on a busy road. For the previously-mentioned method, the camera was kept still on a tripod and the movement of cars' lights used to make the picture; with this method, the theory is basically the same, the difference being that the shot is made with the camera hand-held in a moving car. Stop the lens down to its smallest aperture and give exposure times of around 20 seconds for the best effect. The white and red lights of cars on the road will still register but now, as a bonus, the overhead lights, usually orange in colour, will also turn into trails as the car – and the camera – move past them. The result is a picture with trails of different colours moving in a shaky blur towards a common point around the centre of the image. The idea works best in colour. Back in daylight, yet another type of blur can be introduced into a picture by using a slow shutter speed and twisting the camera so that it rotates about the axis of the lens at the moment of exposure. The picture so produced will show a fairly sharp centre with circles formed from the blurring of objects around the central object, the effect growing more pronounced towards the edges of the frame.

Camera movement can be introduced to any type of picture, but it is most effective when used to enhance a subject that is naturally involved in speed, thus suggesting a degree of movement to the viewer. Just *when* to use the effect relies very much on the photographer's intuition. The final result of this technique is difficult to visualise until you have had some experience of it. But once you have tried the technique and seen a few results, you will begin

Camera stationary, lens stationary, film stationary; this time only the subject was moving and the effect recorded with a slow shutter speed of 1/15 second.

to know exactly what you can and cannot get away with, and just how far you need to slow down the shutter for the best effect.

Lens movement

Another way to put the feeling of movement into an active shot is to change the focal length of a zoom lens during the exposure. The lens should be focused on a subject that is relatively small in the viewfinder and dead-centre in the frame with the lens set at its widest angle and then, as the shutter is pressed, the lens should be smoothly zoomed towards the telephoto end of its range. The picture will then show the subject barely sharp with lines of blur emanating from all sides, the effect becoming more pronounced towards the edges of the frame. If the lens is zoomed in the opposite direction, the subject will be larger in the frame, with the blur lines moving into its centre. The first method gives a better result and the effect works best on subjects such as racing cars, motorbikes, footballers, runners etc., i.e. subjects that are moving, or appear

A completely abstract pattern is made from the blur of moving lights on a motorway, taken with a 15-second exposure from a moving car. The red and white lights are cars, the orange streaks come from overhead street lighting.

Zooming a lens during the exposure on a subject not normally associated with action gives a more abstract impression.

Here, the lens has been zoomed from wide to tele during a 1-second exposure. The subject was lit obliquely with a small flashgun, while a tungsten light at the rear has expanded the profile during the zooming action.

to be moving, towards the camera. In fact, they don't even have to be moving at the time the shot was taken; the picture will still give an impression of speed. Coupling this zooming action with the panning action mentioned earlier will give yet another effect, resulting in an impressionistic view of the subject that borders on the abstract.

Switching the technique to an *obviously* static subject can take away the impression of speed simply because the viewer won't associate that particular subject with movement. The shot then becomes more of a pattern picture. Lights at night make a good example. Once again, start with the lens at its widest focal length, but this time give a short exposure before you start to zoom. That way, a neon sign, for instance, will record sharp in the centre of the picture and lines of light will be drawn out all around it to duplicate its shape larger towards the edge of the frame. Using filters and multiple exposures (see relevant chapters) will enable you to build up a composite on a single frame to turn the most mundane lights into colourful abstracts. Fireworks too can be photographed this way to make exploding rockets look more spectacular than they actually were. The technique can also be used in the studio with a portrait. Position one of the subject's eyes dead-centre in the frame, and the lines of blur will then appear to emerge from its centre.

Yet another variation is to light an object in a darkened studio with a tungsten light directly behind so that the subject blocks the light from the camera. That will draw a rim-light around the subject's profile. Now, with the lens set at its widest angle, an exposure of around 1 second is made with flash at its start to light the subject from the front, the lens being zoomed towards the telephoto mark while the shutter is open. That will give the effect of a sharp subject in the centre of the frame with a bright profile of light expanding from all sides. Using the same technique, but zooming from telephoto to wide angle during the exposure will give you a sharp subject filling the frame, and lines

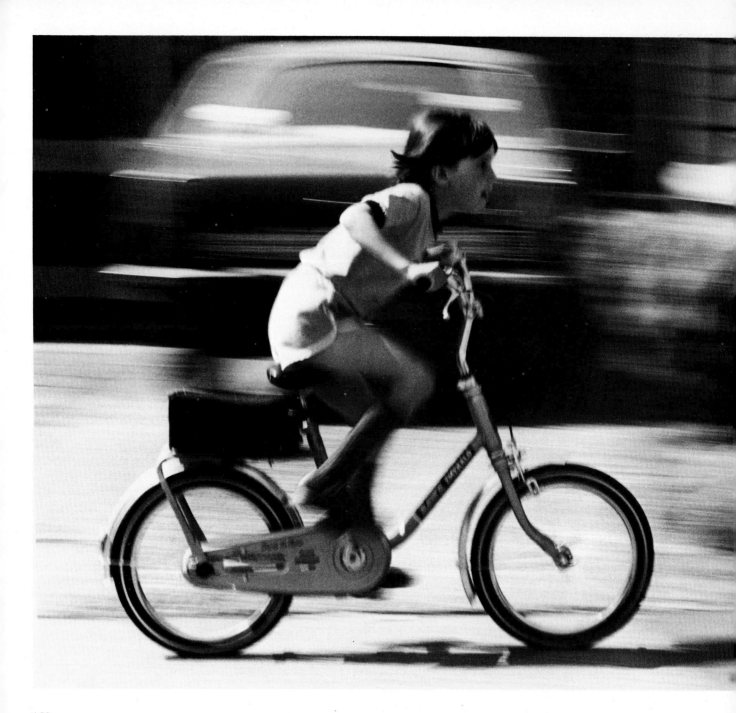

Left: one of the most common uses of deliberate blur: panning with action. For this example, a shutter speed of 1/60 second was used with a 100 mm lens on a 35 mm format.

Right: zooming a lens during a slow shutter speed gives a strong impression of action with the right subject.

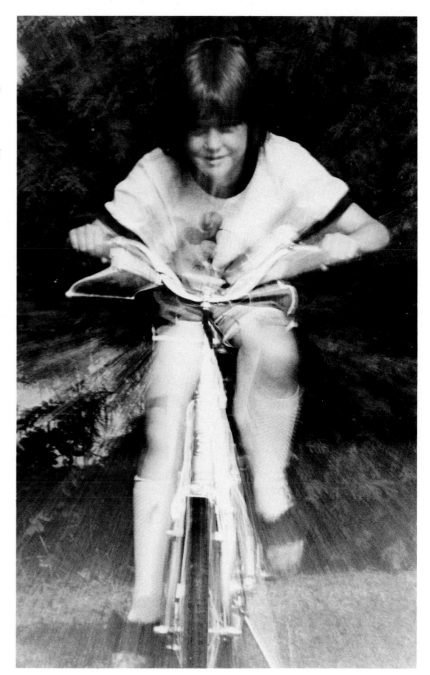

Here, both the subject and
the camera were stationary
at the moment of exposure.
The blur has been made by
the movement of the film
across a linear shutter.

A different type of blur comes from simply setting the lens out of focus, though it is advisable to retain enough focus to make the subject vaguely identifiable, as is the case with the flamingoes in this shot.

of light moving in towards its centre. The aperture used should be the correct one for the flash; the shutter is opened only for the duration of the zoom movement.

Film movement

One of the more unusual techniques for producing controlled blur is to move the film while keeping the camera still during an exposure. And that brings us back to a technique that we have met no fewer than three times before. A slit shutter, as we have already seen, can be used for controlling blur, making abstracts and taking panoramic pictures, each of which has its own chapter. With some knowledge of those techniques, it isn't surprising to find that it can also be used to produce a controlled form of blur.

To recap briefly, there are two methods of operating a slit shutter: one with a purpose-built camera and the other with a more conventional 35 mm model that has been adapted with a slit, either on the lens or at the film plane. With the purpose-built camera, the film automatically travels across the film plane at the moment of exposure, while the camera revolves on its handle. The two movements are synchronised and the system is most often used to take panoramic pictures. With an adapted 35 mm camera, the film is first wound right through without being exposed, then the exposures are made by opening the camera's shutter and winding the film back with the rewind knob. Full details of the method have already been covered in the chapter on distortion and reflection.

If either a purpose-built camera or one adapted for the technique is held still and only the film allowed to move, one small strip of the picture becomes elongated along the width of the wide format to produce a blurred abstract. With the purpose-built camera, that means *not* holding the handle or mounting it on a tripod since that will involve the camera revolving. Instead, the camera's *body* must be held, allowing only the handle to revolve. For convenience sake, it is often best to operate the camera upside down.

Whichever type of camera is involved, it can also be used aimed at subjects such as moving traffic. If the movement of the subject can be synchronised with the movement of the film, the subject will record as a sharp image against a blurred background, similar to the effect obtained with the straight panning technique mentioned earlier. The effect can be enhanced by actually panning while the film moves. In either case, the subject should be moving in the opposite direction to the film.

With an adapted 35 mm camera, the technique is best tried with the camera mounted on a tripod. With the purpose-built camera, that might not be possible as the tripod bush will be probably be on the base of the revolving handle. When using an adapted camera, exposure is very much a matter of trial and error, but if you are trying for the sharp subject against a panned background effect, a good starting point for experimentation is around 1½ rotations per second on normally-moving traffic about 8 metres from the camera.

Blur through focus

Finally we come to a totally different kind of controlled blur: that which is produced by means of the camera's focusing control. Take a reflex camera and look through the viewfinder at a sharply-focused subject. Now slowly turn the focusing ring and watch as the image begins to blur. The subject diffuses and spreads; highlights expand into shadow areas, taking on different shapes that grow larger as the lens is thrown more and more out of focus. When the image is only just out of focus, it presents an annoying image, one that could be seen in the final picture as nothing more than what it is: a badly-focused photograph. Someone looking at it might assume it to be merely a piece of bad photography. But take the focusing ring a few degrees more and you get something different; a picture which is too far out of focus to be considered unintentional and one that begins to

have an appeal of its own as a more abstract pattern. At this stage, though, there should still be enough focus there to show what the subject is. Taking the idea further, the subject can be thrown so far out of focus that the subject becomes completely unrecognisable, turning into nothing more than a soft, abstract blur. That's the point to study the effect carefully and decide whether you are making a picture which works successfully as a pattern shot or whether it is devoid of composition or purpose. Only by being honest with yourself at this stage will you produce a worthwhile result.

With this type of blur, it is best to go for subjects that are fairly small in the frame, thus allowing their image room to expand as the lens is thrown out of focus. Work with subjects where colours contrast strongly with the background. This is especially important when using the effect with black-and-white film. If you choose two colours for subject and background that are bound to register as a similar tone of grey on the film, the effect will be totally lost. Shoot objects with distinctive shapes that can still be recognised for what they are even when a good way out of focus. How much of the picture is actually in focus relies on the depth of field of the lens. That depth of field is controlled by three main factors:

1 The aperture of the lens in use. The larger the aperture, the smaller the depth of field. Best results, therefore, come from using wide apertures at fast shutter speeds and checking the effect on a depth-of-field preview button if the camera has one. If not, check it out on the scale around the lens.

2 The distance of the subject from the lens. The further the subject is from the camera, the greater the depth of field. So the effect works best with subjects close to the camera.

3 The focal length of the lens. Long focal-length lenses make distant objects appear closer. That makes the depth of field appear narrower. For best results, therefore, use a medium or long telephoto.

A point source of light such as the reflection of the sun on the sea is not actually recorded on film as a point, but as a minute circle, due to imperfections in even the best lenses. This shape is known as the circle of confusion and it can be used to advantage for the photographer after controlled blur. On a sharply-focused picture, the circle is too small to be seen with the naked eye. But as the image is pushed more and more out of focus, the circles of confusion expand until they can be seen quite clearly, especially with lenses in the larger focal-length range. Used in the right way, they can add interesting patterns to your blur shots. You can also control their shape with masks. If, for instance, a triangle, diamond or star is cut out of a piece of black card and this is held in front of the lens, the circles of confusion will take on the chosen shape.

Many of the special-effect pictures dealt with in this chapter *could* look like nothing more than incorrect focus or bad camera shake. So when you get to the final result, analyse it carefully. Remember that there is often a very fine dividing line between bad technique and good photography. Never try to justify mistakes by claiming them to be special effects; instead *use* the techniques at your disposal to take an otherwise good picture and make it better.

Montage

In this, the last chapter, we come to a type of special effect which, strictly speaking, is not made in the camera. It is an after-effect; the physical, rather than the photographic, combination of prints and slides. But the results are often best when pictures are shot specifically for the purpose, and the techniques involve copying of both prints and slides. For these reasons, montage can loosely be thought of as a camera effect, and thus justifies its inclusion within the pages of this book. What we are looking at here are methods of mounting two or more prints together to make a single, composite image, plus ways to combine slides in a single mount for a similar effect. The pictures so produced are often surreal and sometimes become nothing more than patterns.

Print montage techniques

Prints can be combined in two ways: by laying one image over the other, or by butting the pictures side by side. For both, the photographer should have some sort of preconceived idea of how the final picture will look. When parts of prints are overlayed, there should be one master print on which the whole thing is put together. This forms the basic background to the picture and it should first be stuck down to a piece of stiff card. To get the scale of the auxiliary images right, the appropriate negatives can then be placed in an enlarger and sized up on this master print. Alternatively, all the pictures that are to be combined can be projected by the enlarger on to a single sheet of writing paper, where they can be enlarged or reduced as needed for the right effect, and their outline traced round to get an idea of how the finished composite will look. The various images can then be printed to each appropriate size.

Each image is cut out separately, using small, sharp scissors or an artist's scalpel. To make the join

between these and the master print less obvious, the edges should be slightly chamfered by rubbing them gently on a sheet of fine emery paper until some of the printing paper's base has been worn away. If the edges are then blackened on the rear of the chamfered print, the join will be less noticeable. Do this by placing the print face down and rubbing the edges round with a pencil, if you are using a fibre-based paper, or marking ink if you are using resin-coated. The various pieces of prints can then be assembled to make the final composite, sticking each down in turn. A slow-drying, rubber-based gum is the best type. It allows you to move the prints around for a few moments after mounting, and if any gets on the surface of the picture, it can be rubbed off when dry.

The second method of mounting montages is to butt the prints together. For this to work well, each print must have a perfectly straight side or, if it varies, its shape must be matched exactly by the print to which it will be butted. To ensure this, take the two pictures that are being matched, lay the edge of one over the edge of the other and cut both prints together. As before, the prints should be mounted on stiff card, using a slow-drying, rubber-based gum.

Whether montages are mounted by overlay or butting, the end result will be more effective if it is copied on to a master negative or transparency. Methods of copying are covered elsewhere in this book (using duplicating film, chapter on unconventional films; avoiding contrast, chapter on multiple exposures; taking close-ups, chapter on abstracts).

Print montage subjects
The subject of a montage can be as simple as combining the head of one person with the body of another (the head of a male friend on bikini-clad body is usually good for a laugh), or as complicated as you like to make it, combining perhaps half-a-dozen images in a single picture. Certain pictures can often be taken from your files, but by

Page 158: two identical slides bound together slightly out of register produce moiré patterns around the central subject.

Page 159: a straight slide sandwich, using a portrait that had been overexposed by one stop to make the skin tones more pale, bound with a correctly-exposed slide of tree branches.

Left: a montage of prints can also be used to make a pattern. For this example, the same picture (originally shot with the camera at an angle) was printed four times, twice the correct way round and twice reversed, then the four prints were stuck down to create the final effect.

far the best results will come from thinking first of a suitable idea and then shooting pictures specifically. One common mistake often made by the newcomer to montage work is to try combining several images, all lit in different ways. So, when shooting subjects specifically for the job, try to match the lighting. If, for instance, you are combining a studio-shot figure with a landscape taken outdoors, look first at the lighting on the landscape. If it was taken with the sun from, say, a 45 degree angle to the left, shoot your studio picture with the main light in this same position.

Overlaying images usually produces a way-out type of picture in which reality is strangely twisted for the necessary effect. A completely different effect can be made when butting pictures together. One result of this has already been seen in the chapter on making panoramic pictures; another is to make a pattern picture by repeating and combining different versions of the same negative. Here's an example. Take a picture of a landscape, but with

the camera tilted so that the horizon runs diagonally across the frame. Back in the darkroom, make four prints, two straight from the negative as it stands and two with the image reversed (negative in the enlarger, emulsion side *up*). Then, using the techniques for butting prints together, mount the four prints in a two-by-two square so that the edges of each horizon meet and make a diamond shape in the centre.

Other examples can be made by combining pictures shot at different angles or by shooting just part of a subject and combining its repeated images: half a tree, shot with the trunk divided top to bottom along the edge of the frame, makes an interesting montage when the original print is butted against a mirror-image of itself. A third type of montage can be made by combining prints with non-photographic objects. A picture of a girl might be surrounded by real leaves or flowers and the effect copied. Or a more surreal effect can be produced by combining totally dissimilar objects:

Right: prints can also be combined with real objects like tree bark, leaves and flowers as in this case, to produce an overall montage effect. The picture on the far right shows how the picture on the near right was made. *Nigel Holmes.*

small gears and cogwheels, taken from an old clock and layed down over a face, for instance. When it comes to copying this type of montage, you could have trouble with focus, since the objects are three-dimensional. The answer is to use a large print to start with so that the camera can be positioned a decent distance from it and then to use the smallest aperture on the widest focal length lens available. These three precautions will help you achieve the maximum possible depth of field and so keep everything in focus.

Slide sandwich techniques

Take two or more slides and place them together in the same mount, so that parts of one image can be seen through lighter parts of the other. That makes a slide sandwich. But, as you may have guessed, there is slightly more to it than that. First, you must find the right *type* of slide. As with print montage, the slides can be taken from your files, but best effects result from shooting specifically for the job in hand – especially since, unlike print montage, slide sandwiching involves exposures.

In theory, slide sandwiches can be made from as many slides as you like. In practice, they work best with only two. The more slides you put together, the denser the final result begins to look, and that's where exposure comes in. For the best results, the slides to be sandwiched should be slightly overexposed, making them lighter individually, but bringing them back to a more natural density when combined. If the two subjects are to be represented as being of equal important to the final picture, then they might both need to be overexposed by one stop; but try different variations at the right exposure, half-a-stop more and one full stop more, then switch the slides around to find the best effect. Never underexpose for a slide sandwich. At other times, it is necessary to overexpose only one of the slides. If, for instance, you are out to show a face that appears to be melting into a sky, it would be best to shoot the sky at the right exposure and then to overexpose the face by various degrees to give the required effect. Don't forget that slide

sandwiches rely, for their effect, on parts of one slide being seen through others; so, unless you are aiming for a specific effect, don't go for dark backgrounds. Unlike multiple exposures, pictures should be shot, where possible, against light backgrounds to allow the sandwich to work. Pictures should also be composed so that the dense part of the first image coincides with the lighter part of the second one.

This is made doubly difficult because of the way that slide sandwiches are best mounted. Because all film has a certain thickness and because the emulsion, and therefore the image, is actually on one side only, the best results are obtained when the two slides are mounted emulsion to emulsion. If they are mounted back to back or emulsion to back, the projector might find it impossible to focus the two images simultaneously. So, when the slides are shot for this purpose, remember that one is always going to be reversed and, when matching light parts in one to dense parts in the other, *one* of the shots must be thought of as its mirror-image. Like print montages, slide sandwiches can be copied to make a final single print or transparency. They can also be placed in an enlarger and printed in the normal way.

Slide sandwich subjects

Faces with landscapes, figures with flowers, trees with skies; those are just a few of the many subjects that can be combined for successful sandwiches. Abstract slides (see chapter on abstracts) or close-ups of textured surfaces combine well with human subjects, adjusting exposures to make one or the other the dominant image. Straightforward slides can also be combined with lith negatives or positives. The lith film can either be predominantly clear with a black silhouette combined with perhaps an abstract or a slide of the sky; or it can be predominantly black, with a clear image, through which the normal slide is seen.

A completely different effect can be produced by introducing a moiré pattern to slide sandwiches.

A lith positive of a face sandwiched with an original slide of the sea turned on its side gives an almost marble-like look to the face.

This is an effect which is produced when two identical images are placed together, but very slightly out of register. The result is a sharp central image, surrounded by what appears to be a tunnel of circular patterns made from the subject around the centre. For the effect to work properly, the two slides must be identical. That means copying one or shooting two slides in the first place, using a tripod to prevent any change in the camera position between exposures. Because both images must be equally dominant in the final picture, each shot should be overexposed by one stop. The two slides are then placed together and moved slightly around the central point. If you are using slides shot specifically for the purpose, this is one place where they must be mounted with the emulsion of one to the back of the other. Alternatively, if you are copying the slide, it can be reversed at the taking stage, allowing them to be mounted emulsion to emulsion for correct viewing.

Like so many of the pictures dealt with in this book, this particular result is one that is hard to visualise until you have seen a typical result. Unlike normal straightforward photography, we are not dealing with reality, but with fantasy, producing images on film that might never be seen in real life. When you get to know the various techniques and have seen some of the results they produce, you can begin to envisage the way certain pictures *should* turn out. But one of the many wonders of this type of camerawork is that you never know for certain. Very often, when the film is processed, you find yourself confronted with an unexpected image, completely different to the way things were when you took it and often totally unlike the way you had imagined it might be. The result is sometimes wrong, often frustrating, but always it's different. And that is a major part of the appeal of producing special effects in the camera. It is one of the very few branches of photography to give you the opportunity of creating pictures that can be truly described as unique.

Glossary

Aberration Any deviation from optical perfection in a lens.

Ambient Surrounding light, as opposed to that from any artificial light source.

Aperture A variable gap behind or between the elements of a lens, adjustable to control the amount of light reaching the film. The size of the gap is measured in *f*-stops, each of which allows through twice or half the light of its neighbour.

Aperture priority A form of camera automation in which the user sets the aperture and the camera selects and sets the correct shutter speed.

Axis Hypothetical straight line drawn from the centre of a lens, out towards the subject at 90 degrees to the camera.

Back-silvered mirror A traditional mirror in which the silvering is on the back of a sheet of glass. Reflections, therefore, are seen *through* the glass and in the silvering. This type of mirror can cause problems optically, since ghost reflections might be caused by the glass itself.

Barndoors An accessory that fits to studio lights, sometimes on floods, but more usually on spotlights. Two 'doors' close horizontally across the light and another two close vertically across it. Opening and closing the barndoors helps control the shape and direction of the beam, making it possible to light one part of a subject accurately, while masking an immediately adjacent area.

Bracket Applied to exposures, usually one stop each side of that which is considered to be correct exposure. Allows for inaccuracies in metering.

Catchlight The reflection of a light in the eye of a person being photographed.

Complementary colours Any two colours which combine to produce black, white or grey. The complement of red is cyan, blue is yellow and green is magenta.

Compound lens One made up from several elements or individual lenses. Together they produce the required focal length, while each helps to cancel out aberrations in the others.

Concave lens A lens that is thicker at its edges than at its centre.

Converging verticals An optical illusion that gives the impression that straight lines move together as their distance from the viewer, and therefore the camera, increases. The effect can be seen by looking up at tall buildings or along the length of straight railway lines.

Convex lens A lens that is physically thicker at its centre than at its edges.

Depth of field The amount of a picture that is in focus each side of the point of actual focus. Dependent on aperture, camera-to-subject distance and focal length of lens in use.

Dupe Duplicate transparency taken from an original.

Element Any one of a number of component lenses, both convex and concave, that make up a compound lens.

Emulsion Light-sensitive chemicals suspended in gelatin and coated on a suitable base to record a photographic image.

Field of view The width or the depth of the total subject covered by lenses of different focal lengths.

Film plane The area in a camera occupied by the film at its place of exposure.

Focal length The distance between the centre of a lens and its sharply-focused image when the subject in focus is at infinity. Used to calibrate and identify different lenses and usually measured in millimetres. The longer the focal length, the greater the magnification.

Format The size of the negative or transparency produced by different types of camera.

Front-silver mirror A mirror on which the silver coating is on the front of the base material, obviating the necessity of viewing the reflection through glass and thus cutting out ghost images.

Gel Large sheet of coloured gelatin, used to filter light sources or, in a smaller form, to filter the camera lens.

Hot spot A circular spot in the centre of an image that is brighter than its surrounding area.

Hyperfocal distance The distance between the camera lens and the nearest point in focus when the lens is set to infinity. With the lens re-set to this distance, the image will be sharp from half the hyperfocal distance right through to infinity.

Incident light The amount of light actually falling on a surface, as opposed to that which is reflected. To take an incident light reading, the meter's sensitivity is reduced with a baffle and the meter pointed away from the subject, back towards the light source.

Interneg A negative made from a positive image and used as an intermediary stage in the production of the final picture.

ISO International Standards Organisation. A scale on which the speed or sensitivity of a film is measured.

Kelvin Unit of measurement on the colour temperature scale to indicate the actual colour of different light sources, most of which might appear to be white to the human eye, but which will be recorded more accurately as different colours by colour film.

Lith film Slow, fine-grain, high-contrast material, designed primarily for copying documents and which, when used in combination with the right developer, will record only highlights, thus giving an image of pure black and white, with no intermediate greys.

Macro Officially, any magnification of an image between 1:10 and 1:1. Often incorrectly used to describe any kind of close-up photography.

Monorail camera A studio camera built around a rail along which the front and back panels can slide for focusing. The panels are linked by bellows and

Page 164: two slide projectors can be used to combine images. Both the bubble and the girl that made up this combination were first photographed against black backgrounds. Each slide was then put into a different projector, placed one each side of a tripod-mounted camera. The projectors were adjusted until the combined image looked right on the screen, from which the final picture was shot.

Page 165: a house plant photographed through bevelled glass becomes the victim of diffraction, distorting its true shape.

can each swing, shift, tilt, rise and fall as needed for different effects.

Pan As applied to cameras, the movement from side to side, keeping the camera horizontal, while following a moving subject.

Parallax The difference in the view seen by the lens and the viewfinder in a non-reflex camera.

Point-source A small source of light.

Programmed automation A form of camera automation in which the camera selects and sets both shutter and aperture for the correct exposure.

Ratio As applied to picture shapes, the relationship between the width and the depth of a picture. The smaller dimension divided into the larger gives the ratio against one, e.g. the standard 35 mm format of 24 × 36 mm gives a ratio of 1:1½.

Reciprocal Mathematically, the number concerned divided into one, e.g. the reciprocal of 2 is ½.

Reciprocity failure The speed of a film is calculated for the use of an average range of shutter speeds from 1 second to 1/1000 second. When used at much longer or shorter shutter speeds, the film speed will appear to be slower than indicated. This loss of sensitivity is known as reciprocity failure.

Refractive index When light passes through anything but a parallel-sided object, it will leave travelling in a different direction to that which it entered, the degree of 'bending' being greater the more the sides are angled. The degree by which the light is 'bent' is the refractive index.

Shutter priority A form of camera automation in which the user sets the shutter speed and the camera selects and sets the correct aperture.

Shutter speed A variable control over the length of time light is allowed to fall on the film during the exposure. Measured in whole and fractions of a second, each of which is twice or half the duration of its neighbour.

Simple lens A single element lens.

Single-lens reflex A camera whose viewfinder incorporates a system of mirrors and prisms to preview the picture actually through the taking lens, thus eliminating parallax.

Snoot A conical-shaped attachment for a light that reduces the diameter of the beam and allows it to be concentrated on a small area of the subject.

Spectral component One of the seven main colours that make up white light. These are red, orange, yellow, green, blue, indigo and violet.

Standard lens One whose focal length is approximately equivalent to the diagonal of the film format it serves. The lens that is traditionally supplied with any camera.

Stop Another word for aperture.

Table-top photography The studio photography of small sets and models.

Track The movement of a camera towards and away from the subject.

TTL metering A method of metering built into certain cameras, in which the exposure is measured directly through the lens.

Tungsten light Other than flash, the basic artificial light source used in photography. Tungsten is a chemical from which the lamp's filament is made. When an electrical current is passed through it, the filament glows with an intense light.

Zoom lens A lens of variable focal length, in which the image remains in focus through the range.

Index